dream houses

University Press of Florida

Florida A&M University, Tallahassee
Florida Atlantic University, Boca Raton
Florida Gulf Coast University, Ft. Myers
Florida International University, Miami
Florida State University, Tallahassee
New College of Florida, Sarasota
University of Central Florida, Orlando
University of Florida, Gainesville
University of North Florida, Jacksonville
University of South Florida, Tampa
University of West Florida, Pensacola

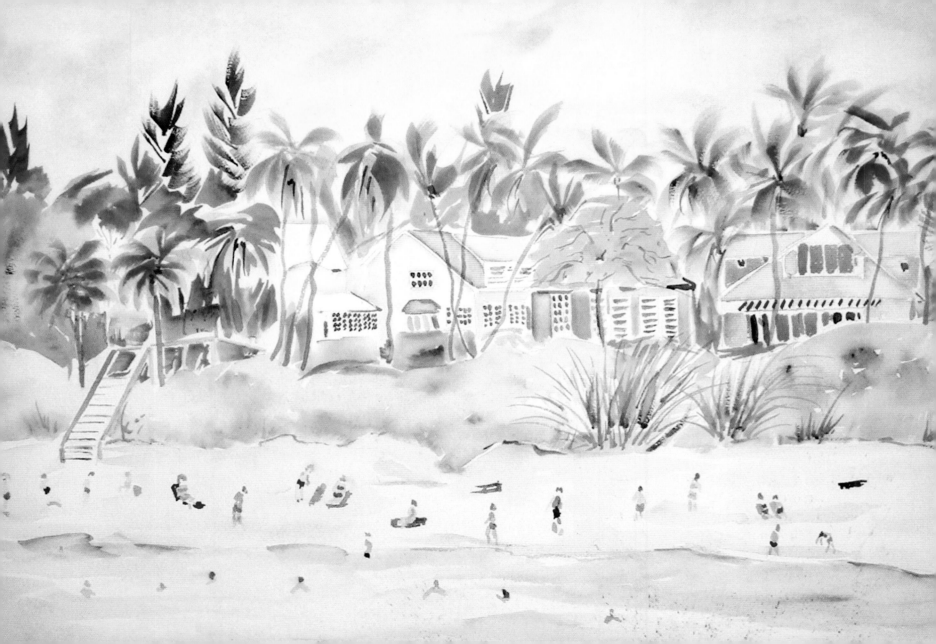

Text by Joie Wilson & Photographs by Penny Taylor

dreamhouses

HISTORIC BEACH HOMES
& COTTAGES OF NAPLES

UNIVERSITY PRESS OF FLORIDA

Gainesville · Tallahassee · Tampa · Boca Raton · Pensacola
Orlando · Miami · Jacksonville · Ft. Myers · Sarasota

Copyright 2011 by Joie Wilson and Penny Taylor
Printed in China on acid-free paper
All rights reserved

16 15 14 13 12 11 6 5 4 3 2 1

Frontispiece: The magical essence of Naples is captured in this colorful and
happy watercolor painted by Emily Gutchess, a delightful woman who
graciously shared her home, Coconut Cottage, and her artwork for this book.

Library of Congress Cataloging-in-Publication Data
Wilson, Joie.
Dream Houses : Historic Beach Homes and Cottages of Naples /
text by Joie Wilson; photographs by Penny Taylor.
pages cm
Includes bibliographical references and index.
ISBN 978-0-8130-3573-4 (alk. paper)
 1. Vacation homes—Florida—Naples—Pictorial works. 2. Seaside
architecture—Florida—Naples—Pictorial works. 3. Historic buildings—
Florida—Naples—Pictorial works. 4. Naples (Fla.)—Buildings, structures,
etc.—Pictorial works. I. Taylor, Penny (Penny A.), 1949– II. Title.
NA7575.W55 2011
728.'370975944—dc22 2010042339

The University Press of Florida is the scholarly publishing
agency for the State University System of Florida, comprising
Florida A&M University, Florida Atlantic University, Florida
Gulf Coast University, Florida International University, Florida
State University, New College of Florida, University of Central
Florida, University of Florida, University of North Florida,
University of South Florida, and University of West Florida.

University Press of Florida
15 Northwest 15th Street
Gainesville, FL 32611-2079
http://www.upf.com

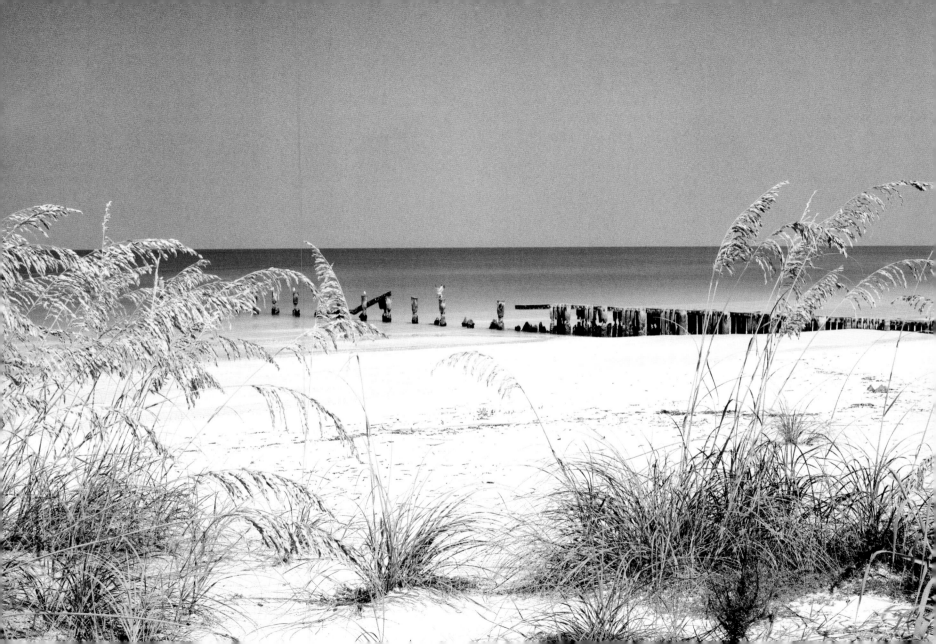

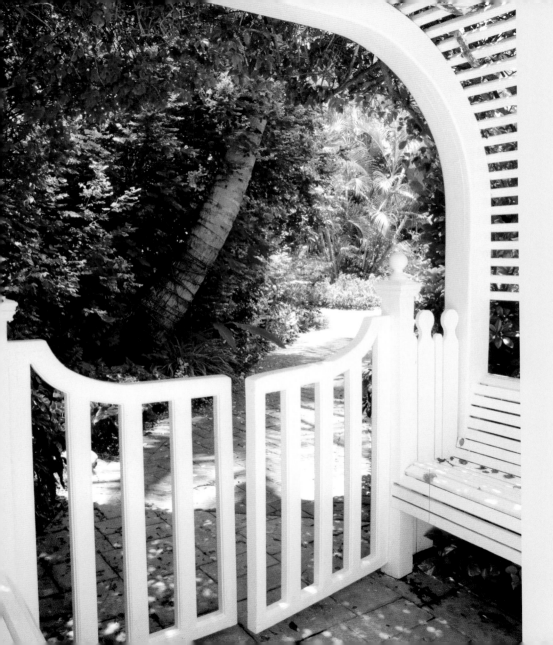

Contents

facing Dori, the papillon, and
Stasha, the great dane, are poolside
at Bone's Rest. Tiffany's Cottage is
in the distance, across 11th Street,
at left.

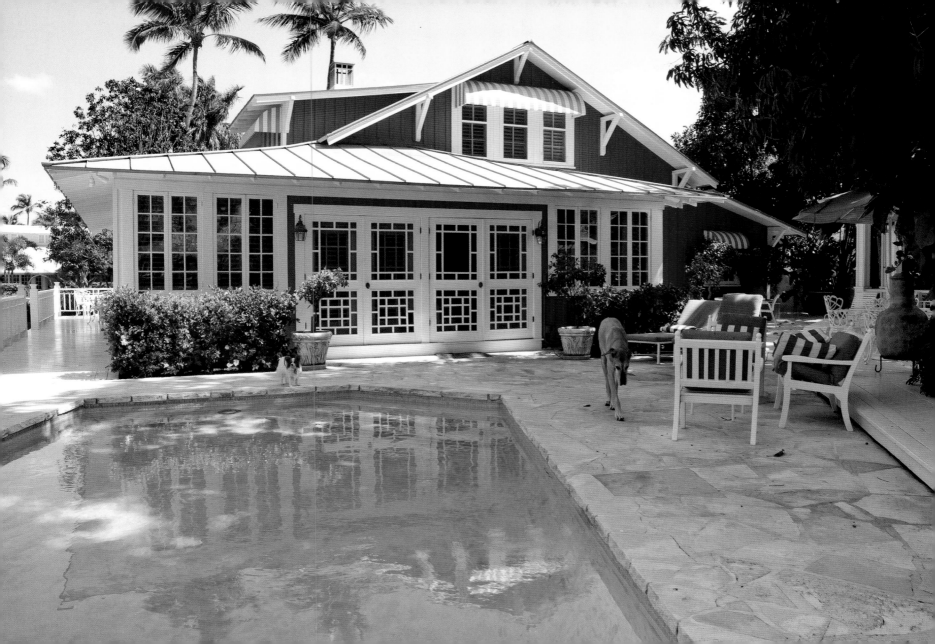

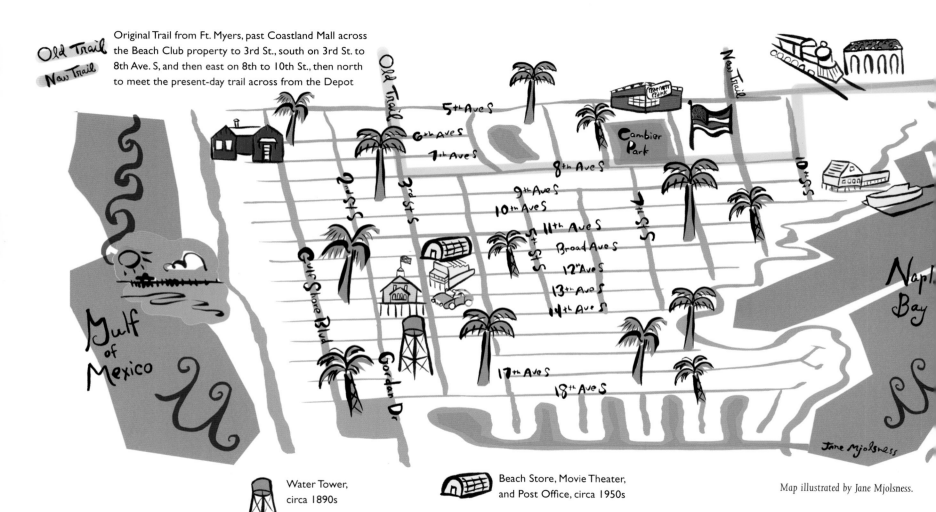

Original Trail from Ft. Myers, past Coastland Mall across the Beach Club property to 3rd St., south on 3rd St. to 8th Ave. S, and then east on 8th to 10th St., then north to meet the present-day trail across from the Depot

Old Trail
New Trail

New Trail

Old Trail

5th Ave S
6th Ave S
7th Ave S

Marriott Bank

Cambier Park

8th Ave S

2nd St S

3rd St S

9th Ave S
10th Ave S
11th Ave S
Broad Ave S
12th Ave S
13th Ave S
14th Ave S

4th St S

7th St S

10th St S

17th Ave S
18th Ave S

Gulf Shore Blvd

Gordon Dr

Gulf of Mexico

Naples Bay

Jane Mjolsness

Water Tower,
circa 1890s

Beach Store, Movie Theater,
and Post Office, circa 1950s

Map illustrated by Jane Mjolsness.

Introduction

Hill School, beach block of 6th and 7th Avenues, for winter residents' children, circa 1940s

Naples Depot, completed 1926

Turner Marina, circa 1940s

City Hall, city incorporated 1923

Naples Hotel, spanned 3rd to 2nd Street from Broad to 14th Avenue, built in 1888 and torn down in 1962

First bank started in 1949 by Clarence and Mamie Tooke

Crayton Company Store and gas station, circa 1922

Naples is known worldwide for its stunning beaches, cosmopolitan ambience, and captivating architecture. Ten miles of white beach frame Naples to the west, and to the east Naples Bay wraps the land and flows into the Gulf of Mexico. Old Naples is nestled between these two bodies of water that have always been catalysts for the community.

Today this sleepy fishing village has transformed into a cosmopolitan destination known for fashionable shopping, exceptional restaurants, breathtaking homes, and artfully landscaped streets. The diversity of dwellings in Naples offers visual delights on every street. In Naples the building of dream homes is a daily occurrence, and each time a new structure breaks ground it is often at the loss of one of Naples' historic homes. This volume captures the history of the original beach cottages of Naples, houses that in the next decade may well become extinct due to land value escalation. The cottages captured in these pages have witnessed the past century, survived hurricanes and land development, and endured despite the frenzied economic growth of a geographically finite community. Even so, the future of these cottages is unknown, as Naples has no regulations for the preservation of

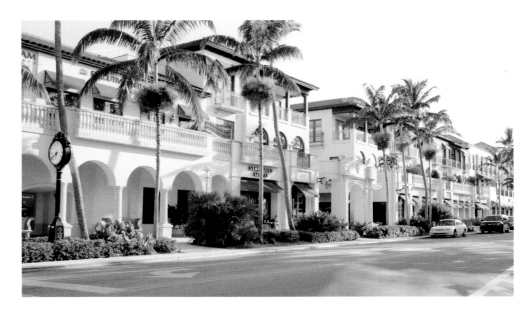

World famous for shopping and dining, Naples' 5th Avenue South.

Each era has a story to tell, and the Naples cottage designs that express the lifestyles of the early beachcombers and their hideaways have a joie de vivre that has more impact than any square footage caveat. Naples was originally created as a getaway, a hideaway, an escape from the demands of commerce and the inconveniences of harsher climates. The island feeling created by the Gulf and Naples Bay, the exotic foliage, the subtropical climate have always inspired creativity in architecture and interiors. The colorful interiors and family traditions encompassed by these dwellings are as essential to their legacy as their construction dates. Residents and visitors appreciate that the small and unique neighborhood known as Old Naples offers a memorable experience every day of the year.

Naples and the original village, Old Naples, have distinctively different identities. For many residents and visitors, Naples is a golf mecca, with gated communities and beach high-rises. The 5th Avenue South and 3rd Street shopping districts in Old Naples blend the earliest retail buildings with contemporary storefronts.

Venues that have the designation of "Avenue South" and "Street South" define the village of Old Naples. Only one home featured in this publication reaches south to Gordon Drive—a boathouse on Champney Bay that shares a distinctive history with a compelling architectural present. The others are "in the zip code," as addresses in Old Naples are described: that is, the 34102 zip code. An anonymous resident likes to say, "I don't venture beyond the zip code."

these significant and historic dwellings—some that have been here for over 100 years.

The average year of home construction in Naples is 1987, compared to 1961 for the rest of Florida and 1913 for the country as a whole. Naples' residential buildings are in a tear-down and rebuild trend; taken together, both Naples and Collier County are consistently recognized as one of the top growth areas in Florida and in the United States. Naples' residential land is finite, with 80 percent of Collier County's environmentally sensitive land protected from development.

Naples had a low-key beginning. Fishing camps first brought visitors to the region, but it wasn't until the late 1890s that Naples achieved its status as a resort town. The Naples Hotel was built in 1888, and the 20-room hotel established Naples as a vacation destination. For many decades the hotel was the social center of the community. Also in 1888 the Naples Pier was built as a landing and docking entry. Supplies and visitors were transported from the pier to the hotel and the center of the village. The Naples Pier, an iconic landmark, was rebuilt after hurricane damage in 1910, 1926, and 1960. For many years, the Naples Post Office stood on the pier.

Naples was platted in 1887 by the Naples Town Improvement Company, a group of investors that included Walter Newman Haldeman, founder of the *Louisville Courier-Journal*. When the company went bankrupt, Haldeman, a man with great vision, purchased it in 1890. He was Naples' first developer. John Stuart Williams, a United States senator, joined Haldeman in the creation of Naples. Early visitors were drawn to the area for its unlimited fishing waters, Everglades hunting, and the enticing climate. Naples was accessible only by water; a barge from Fort Myers offered ferry service. Visitors arriving by boat were shown designs and patterns painted on the roofs of houses so they would know which house to travel to once on land. There were no named streets or house numbers.

Naples was one of the first planned communities in Florida. Designed in the late 1880s with a vision toward the future,

left *The Naples Hotel was known as "Haldeman's Clubhouse." Luggage was transported to the hotel from the Naples Pier by a manually pushed rail car on tracks. (Photograph courtesy of Lodge McKee.)*

right *Haldeman House around 1900. Roof designs enabled early visitors to identify landmarks from the water. (Photograph courtesy of Lodge McKee.)*

An alley's treasures . . .

intimate charms of a barefoot beach community where most daily destinations are just a few blocks away.

As designated in the earliest plat, all of the 27 East–West streets in Old Naples offer beach access, providing 70 percent of the beach access in Collier County. The unusually wide 60-foot streets, established in 1885, provide ample green space between residences and traffic. Homes are set back from the street with gracious lawns and lush plantings. Most streets still have the early alleys that allowed for private entry to residences, guesthouses, carriage houses, and servants' quarters. Today the alleys provide for rear driveways, parking, and service areas.

Abundant foliage graces Naples' streets and residential properties. Surprisingly, this tropical paradise was at one time stark, with sand streets which were eventually paved with shells.

In response to 1950s Naples' sandscape, Fred Lowdermilk, city manager under Mayor W. Roy Smith, created the tree plan, distinguishing each street with a signature tree variety. For example, 1st Avenue South is haven to queen palms; Gulfshore Boulevard south of 5th Avenue is lined with coconut palms. Royal palms, Sabal palms, and many other tropical species distinguish certain other streets. In the past, a city nursery maintained replacement trees of the same age and variety so damaged or diseased trees could be seamlessly replaced. Many of these landmark trees thrive today.

Naples at present has just over 50 homes built between 1895 and 1955 that have historical architectural significance.

the original village is still intact with strict guidelines enforced to keep the village residences single-family homes. As seen in the well-known communities of Seaside, Celebration, and Windsor, the planning concept of new urbanism that captivates development in Florida is inherent in the original village of Naples. Today Naples is a textbook example of new urbanism—a human-scaled walking community with all the

They comprise a kaleidoscope of architectural forms, ranging from simple vernacular fishing cottages to substantial homes designed by leading architects of their eras. Famous in Naples, the Timken House was built by Mr. Henry Timken, founder of Timken Roller Bearings; at the time he built the stately Mediterranean villa designed by Phineas Paist on the beach at 8th Avenue South, he was considered one of the ten wealthiest men in America (Baum 38).

The majority of the cottages built in Naples share defining architectural elements. Among the most identifiable are front porches, double-hung windows, high-peaked gable roofs, shed roofs on porches and dormers, and wood siding, including vertical board-and-batten siding, lap siding, or decoratively trimmed siding. Roof overhangs are deep, allowing windows to be open even in rain. The earliest roofs were wooden shake, metal, barrel tile, or an early form of asphalt shingle arranged in patterns. Diamond-shaped patterns of these early shingles are still seen on some of the cottages today.

Naples' historic cottages predated insulation and air conditioning. Porches, high ceilings, and numerous windows enhanced indoor circulation of the Gulf breezes; interior wood floors, ceilings, and paneling were allowed to darken with age, creating shaded interiors that provided relief from Florida's brilliant sunlight. Many of the cottages were used in the winter season, and fireplaces were the principal and often the only heat source.

Until the late 1920s when Tamiami Trail opened and the

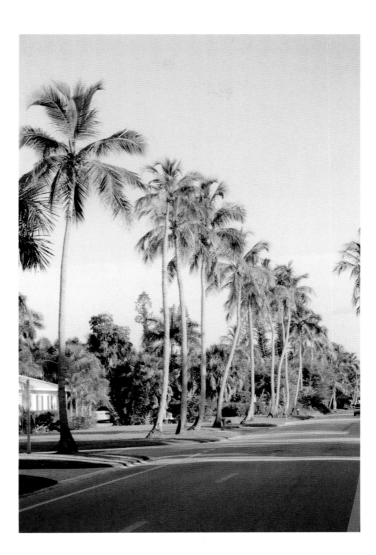

Gulfshore Boulevard's iconic coconut palms.

Naples is an ideal community for walking, as this sidewalk on Broad Avenue suggests.

railroad arrived in Naples, all building materials were brought to Naples by barge. While some homeowners imported lumber, Florida offered plenty of cypress, longleaf yellow pine, and the related Dade County pine, and much of the lumber was cut and milled locally. Many of the original pine floors are still in mint condition; this particular pine species is naturally impervious to termites.

Tabby was used for early footings. This indigenous building material was made by burning shells to create a bonding agent that, when mixed with beach sand, produced a concrete-like substance.

The beauty of Naples' historic homes comes from their intrinsic simplicity. Crafted in a vernacular style that is a unique combination of unadorned Victorian and Florida cracker, these homes resonate an approachable hospitality. Unlike the East Coast of Florida that thrived in flush economic times, Naples was not readily accessible and offered no amenities other than a magnificent beach and spectacular sport: boating, hunting, and fishing. As much as its being out of the way, Naples' slow growth was the result of a form of camaraderie marketing, where friends that came to visit became the next residents. Separating main houses from staff cottages and guesthouses, the alleys created their own social microcosms.

Most historic homes, regardless of time and place, share the following traits. First, they have survived structurally. Some of the homes were built to last from the best local materials and have easily stood the test of time. Others—remnants of social and economic downturns—have fortunately survived because

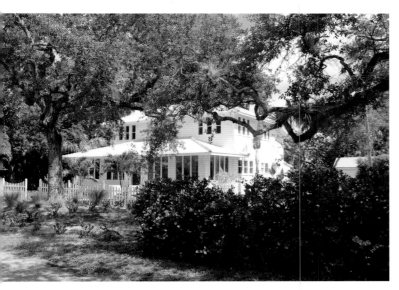

Live oaks frame the Wedding Cottage.

adventure to craft this charming and magnetic beach community. As one longtime resident describes Naples of the past "there was a fabric of the familiar." We are fortunate that this surprising and inspiring collection of homes not only endures but endures as one of the most valuable visual and historic legacies of one of America's premier coastal communities.

Welcome to an insider's view of some of the most distinctive and historic resort homes in Florida today. Here, we see the craftsmanship of nameless pioneers alongside the work of leading interior designers of their day. World-renowned collections and beach walk treasures are equally at home in these cottages of Naples. We hope you enjoy the views!

there were no economic means to tear them down and rebuild. Often, they have a connection to nature—the result of necessity. Historic dwellings encompass intimate spaces that speak to efficiency of scale and to human scale. Human needs were addressed as part of the equation for survival, warmth, security, and protection from the elements. Old Naples cottages share all of these defining features.

Naples was a beautiful wild haven in the late 1800s and early 1900s; those who came here must have had a bit of bravery, in some instances quite a bit of money, and a sense of

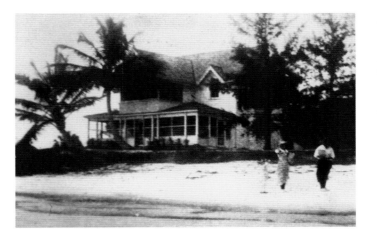

Rose Cleveland's Cottage. Rose Cleveland was the sister of U.S. president Grover Cleveland, who served 1885–1889 and 1893–1897. (Photograph courtesy of Lodge McKee.)

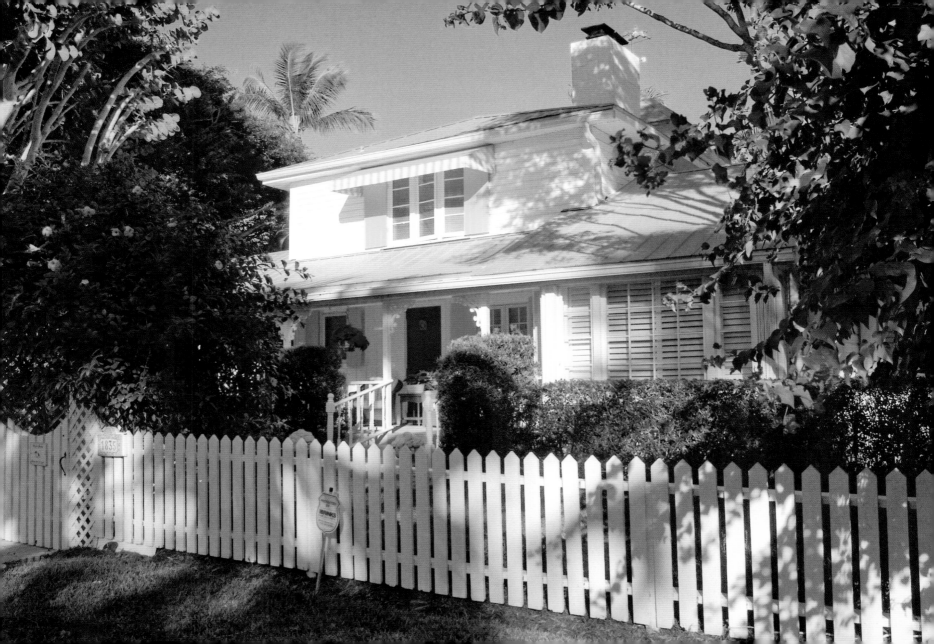

Alamanda Cottage

Alamanda Cottage is named for the brilliant yellow alamanda flowers that cover the front trellis facing Gulfshore Boulevard. Di Koestner, the owner with her husband, Mark, planted the flowers when she purchased the house in 1995. Alamanda yellow is the signature color of the house with its bright yellow shutters.

Familiar with Naples, Di wanted a historic cottage there. Maggie Ford was the first owner of this circa 1930 home, and in the 1950s Di's mother, Virginia Fox Uihlein, a young woman at the time, would ride her bike down to visit with Maggie on the porch of Alamanda Cottage.

Recalling coming to Naples to find a home, Di said, "I saw this house and didn't want to live anywhere else." Di's earliest memory of Naples as a young child is chasing the mosquito spray truck, now nicknamed the DDT truck. Her family was one of the original families in Naples.

Alamanda Cottage is a beautiful example of a two-story Naples vernacular cottage. The pine board-and-batten exterior walls, pecky cypress interior walls, the fireplaces on both levels, and the pine floors are original. The house has three front doors off the entrance porch. One opens to the living room,

The living room with the original board-and-batten interior walls.

facing *Alamanda Cottage on Gulfshore Boulevard.*

A koi pond enhances the kitchen entry.

one to a bedroom, and the third opened to what was once a small office.

Over time these rooms have been opened to each other for interior passage. A previous owner added a wing to create a master bedroom and bath and a garage. The original land parcel included the lot adjacent to the house that faces 18th Avenue South. Di and Mark have enhanced the outdoor living spaces, screening in the side porch and creating a rear court-yard with koi pond and new garden walks. They also remodeled the kitchen in 2007.

The Koestners fill the house with family, friends, and their much-loved pets. The porch seems to be the favorite gathering place; it truly evokes the feeling of Old Florida. The art and architecture of Key West have provided much of the design inspiration for the home.

Di Koestner spent many spring vacations in Naples at the winter home of her grandparents, Mr. and Mrs. William B. Uihlein of Milwaukee, Wisconsin. Their circa 1940 home was located at 2500 Gordon Drive and designed by renowned architect Russell Thorn Pancoast. Pancoast designed the Hub at the University of Florida and the Bass Museum of Art in Miami. Pancoast was the grandson of Miami Beach pioneer John Collins.

That family home changed hands several times. Mr. Uihlein sold it to Morton Downey, who sold it to Ray Lutgert. Miles Collier purchased the home and eventually tore it down. Mr. Uihlein, president and chairman of Schlitz Brewing Company, came to Naples in 1937. He was responsible for

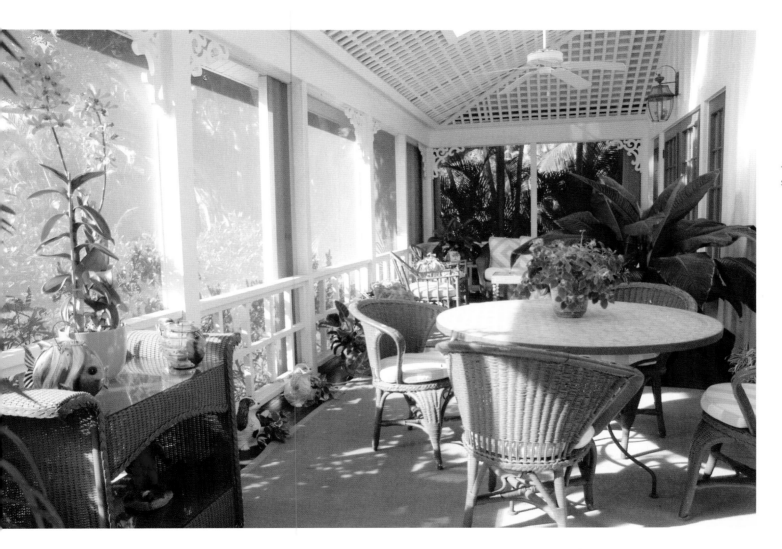

Alamanda side porch with southern exposure.

Architect Russell Thorn Pancoast's rendering of the William B. Uihlein home, 2500 Gordon Drive. (Image from the collection of Di Koestner.)

bringing freshwater to Naples, designing its first water treatment plant and buying the bonds himself. Mr. Uihlein would not let the city pay interest on the money. In 1946, he received the following tribute from the City of Naples in recognition of his service: "Now therefore be it resolved, that, William B. Uihlein be and he is hereby named as Honorary Mayor of Naples, Florida for life." His granddaughter Di still has the

original certificate. Eight years later, in 1954, the city named the water plant after Uihlein. The plant was taken down in 1978.

Alamanda House reminds Di of her parents and grandparents and their roles in Naples' early civic life. This happy, colorful home is a reflection of several of the many dynamic personalities that make Naples a unique community.

Artist's Cottage

At a chance meeting one morning at Tony's Café over coffee, a mutual friend introduced me to Dona Steele. An artist and resident of Steamboat Springs, Colorado, Dona lived in the Artist's Cottage in the early 1990s. A longtime Naples resident, she remembered when there was topless sunbathing on Vanderbilt Beach in the '70s and '80s. As our conversation turned to the original cottages, she said that she had once lived in one and had archival pictures. What a discovery!

This raised cottage, which sadly no longer stands, was built in the 1940s as part of the original school in Naples. When Dona lived there, it had been adapted as a residential duplex. The cottage was built of Dade County pine, with Dutch siding and large brackets that supported the overhanging eaves. The cottage did not have central air when she rented it; she recalled that as long as the windows were open to catch the Gulf breezes, the interior was comfortable. The only heat source was the original fireplace.

Because several artists lived in this charming cottage during the 1990s, it was christened the Artist's Cottage.

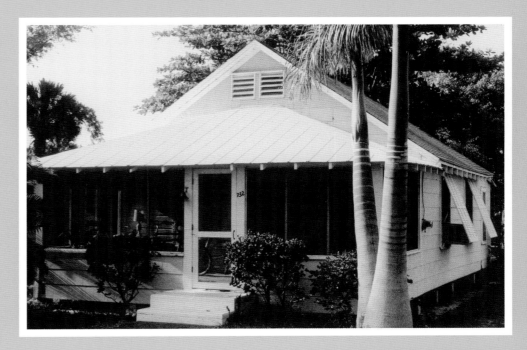

The Artist's Cottage.

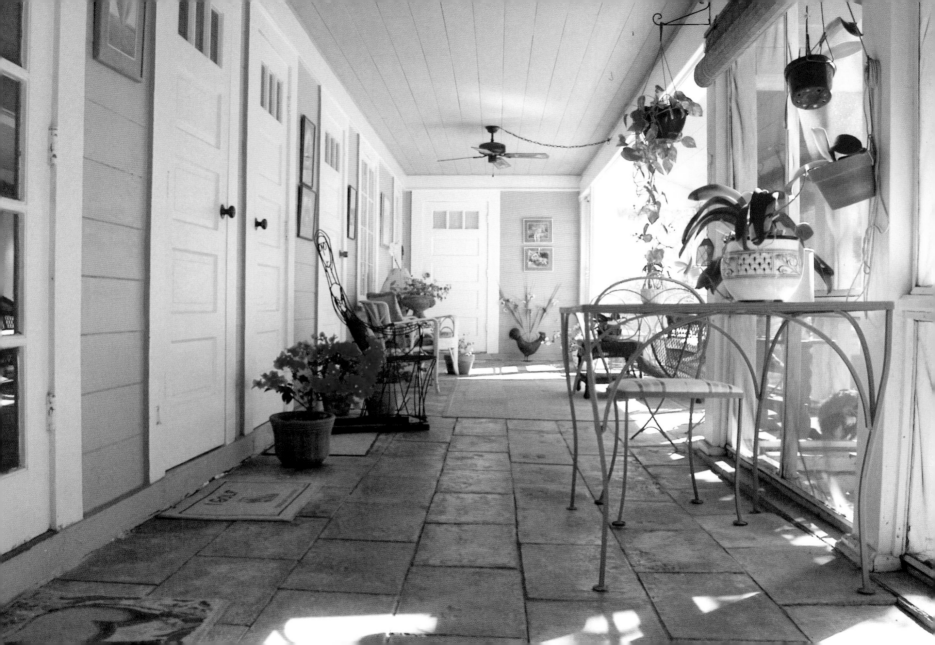

Bahama Cottage

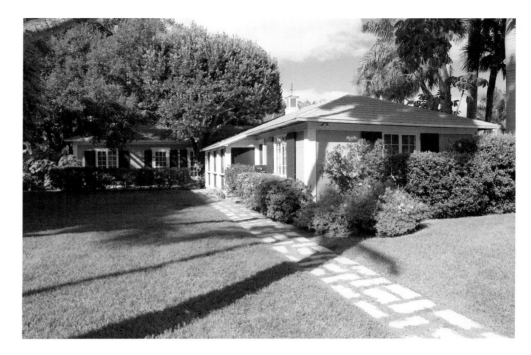

Toni Tuttle, owner of this colorful Bahamian-style cottage, walks her dogs Mingie and Suki to the beach every day and says to herself, "Aren't I lucky to have my house in this location in this wonderful city." Her parents, Paul and Eva Fenton of Middlebury, Connecticut, bought the home in the 1950s from Sewell and Jinny Corkran. A serendipitous side note, Toni and the Corkrans' daughter-in-law, Jinny, had been classmates at Connecticut College in New London, and after graduating they shared an apartment in Manhattan. Toni worked at *Look* magazine and Jinny at Macy's. When Paul Fenton died in 1988 the house went to Toni and her sister, who subsequently relinquished her share. The cottage has been in the Donald Tuttle family since that time.

Built in 1939 of cedar, the home centers on the back porch that serves as the central hallway of the house, with the bedrooms, dining room, powder room, linen closet, kitchen, and living room all opening from the outside area. The home is less than a block from the beach, and this type of floor plan creates a wind path for the refreshing Gulf breezes.

Toni does most of her entertaining on this inviting porch, which she widened by four feet in 1990. The only drawback to this delightfully quirky floor plan is that she has to keep keys to all of the rooms in her pocket and unlock each room as she comes and goes. Both the panel doors and French doors on the porch are original. Another unique design element is the front tabby walkway.

The house has been flooded twice: the first time by Hurricane Donna, when the water was level with the fireplace mantle, and the second time during the very wet summer season of 2005. These events are remarkable, as the house is three

Western exposure of Bahama Cottage.

facing *Bahama Cottage porch, to which all of the bedroom doors open.*

15

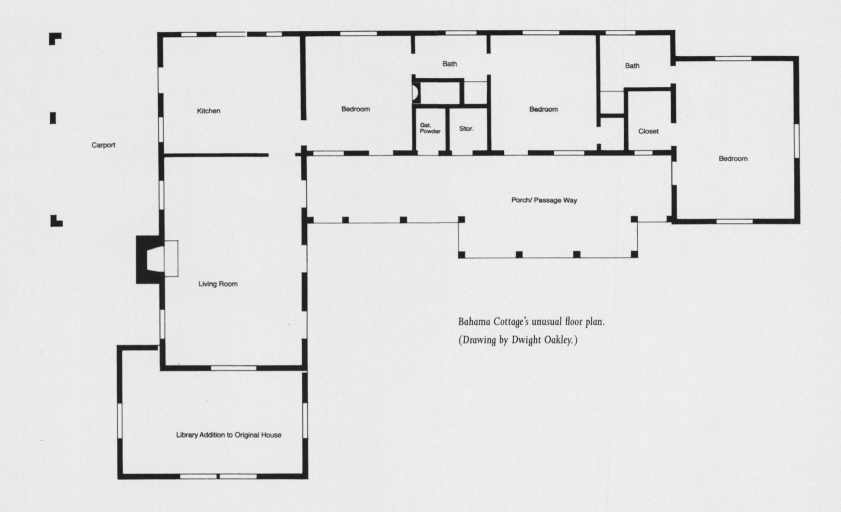

Bahama Cottage's unusual floor plan.
(Drawing by Dwight Oakley.)

Carport

Kitchen

Living Room

Library Addition to Original House

Bedroom

Bath

Gst.
Powder

Stor.

Bedroom

Porch/ Passage Way

Bath

Closet

Bedroom

feet above sea level. In 2005, the water reached 21 inches above the foundation; the watermark registered by the City of Naples is still visible by the garage door entry.

The guesthouse, christened "The Hut" by Toni's granddaughter, has its own address: 87½ 6th Avenue South. Guesthouses are allowed in Naples only when the original property arrangement includes one, so each guesthouse is a cherished part of the visual landscape. Historically, guesthouses often were built for the principal family to reside in during the Naples season, allowing owners to rent their main home for supplementary income. New homes built today cannot have guesthouses on the property.

During our meeting, Toni remembered when Naples had only two restaurants in the 5th Avenue area: the Pub and George and the Dragon. "So much has changed," Toni said. "I hope that the best of what was can somehow be preserved so that others may enjoy what attracted so many of us to this charming, unique city many years ago." Pausing a moment she added, "Naples still has its alleyways, its cottages—although few and far between—its pristine beaches, and a certain ambience of its own. I hope Naples can continue to reflect the charm of its past in this era of rapid change."

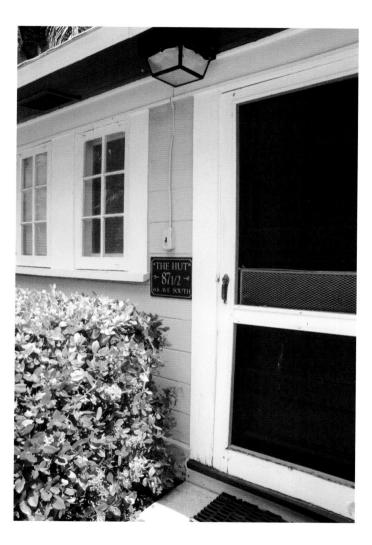

"The Hut" guesthouse, street number 87½.

Blue Water Cottages

This pair of mirror image rental cottages owned by William C. Scherer was built in 1951 and has been in the family since the 1960s. Though the documented history of the cottages is sketchy, their architectural history speaks for itself: they are virtually unchanged since their construction. With their original shingles and windows, these cottages have survived at least six hurricanes.

The most noteworthy architectural element at Blue Water Cottages is the dominant, beamed, barn-style roof that joins the east and west cottages and creates both covered parking and outdoor living space. The roof with its exposed heavy beams and framing is unique in Old Naples, and these cottages are the only two in the city that are joined in this manner. A vintage carousel rooster hangs from the beams and adds a touch of whimsy to the back entrance.

I rented the beach-side (west) cottage for a year, starting in the spring of 2008. In the months I lived there, I enjoyed front porch company, a luxuriously scaled cast iron tub—all the unique charms of a vintage dwelling. I looked out the windows at midnight and saw palm fronds silhouetted in the moonlight. I walked to the street and saw the Gulf at the end

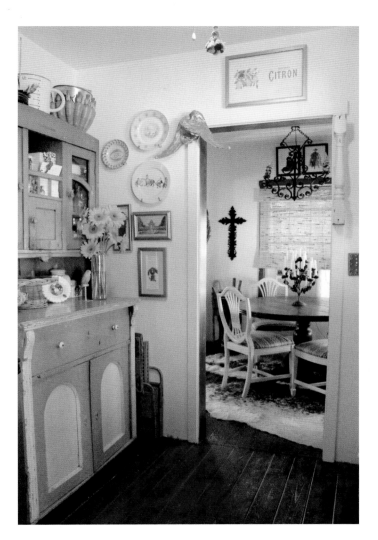

Kitchen and dining room of Blue Water Cottage West. Unlike many of Naples' cottages that are rented seasonally and furnished, this one was available unfurnished on an annual lease, allowing author Joie Wilson to add her own personal touches.

facing Blue Water Cottage *West. This cottage and its sister cottage are diagonally across from St. Anne's Catholic Church. Local lore has it that these cottages once served as parish housing. The author found a small cross nailed to one of the entry door frames, a nice touch from a former resident.*

Joie Wilson's living room at
Blue Water Cottage West.
Joie's distinctive design talent
transformed this plain room
into a space of visual richness.

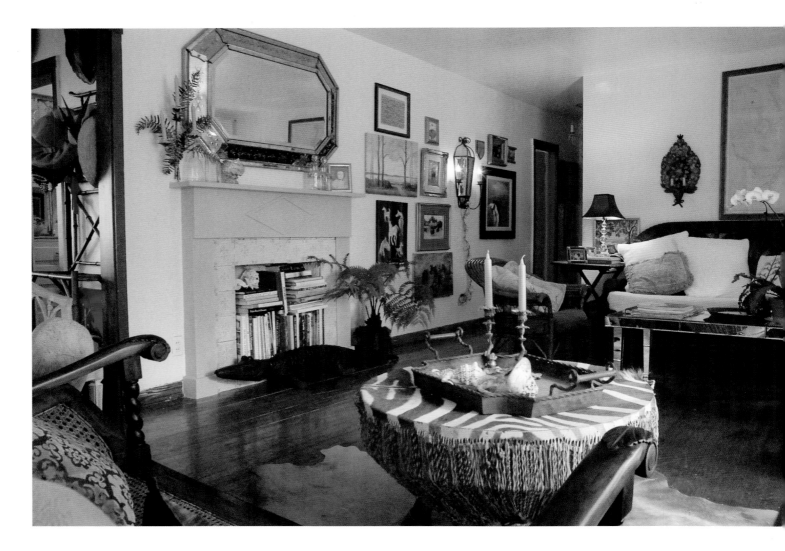

of the next block. Down the alley I met friends who offered coffee at 6:30 in the morning, neighbors who came over and helped hang a swing. In the community, I talked to strangers who drove by often to see the fresh paint and new plantings and who were delighted with the wooden seahorse on the mailbox post. This special rental, offered at a courtesy discount through the Scherer family's Excel Real Estate brokerage, inspired simple decorating, with sheeting material for living room curtains and bamboo blinds at all of the windows. The kitchen was furnished for beach entertaining, with two tiny refrigerators and an ice maker but no stove.

When I woke up each morning, I felt as if I were living in a movie set, as if I had landed in the faded lobby of a hotel in the tropics. Pecky cypress moldings, the original tiled fireplace, and Dade County pine floors speak to the craftsmanship of this simple cottage. High ceilings, paddle fans, filtered sunlight, and vintage furnishings created an inspiring setting for writing this book.

The redecoration of Blue Water Cottage West was a favorite topic of conversation among people in the neighborhood, at the coffee shop, and at cocktails. The cottage's fast transformation from a fishing retreat into a charming home seems to have met a shared need for immediacy, while stirring our fascination with a past accessible to us only in these memorable cottages just steps from the beach.

Vibrant coral swirl wallpaper and an antique Venetian pink glass mirror were added by Joie Wilson to give the vintage shell pink tile a touch of glamour.

Bone's Rest

"Living in this house is like being on vacation every day," said Dr. Leslie Schultzel, owner and orthopedic surgeon—hence the name Bone's Rest.

True to form, Dr. Schultzel's guesthouse on the property is called Bone's Guest and his home in the Rockies, Bone's West. Les added a pavilion to his Naples property in 2000, featuring a hand-carved sign of a skull and crossbones, along with the house moniker. Just as on many boats, the center floor joist on the main floor is slightly elevated, so that the planking on either side slopes to facilitate water drainage in case of flooding.

Bone's Rest features many of the iconic architectural elements of vintage Florida cottages: side gables, shed dormers, and multilight casement windows. Crafted of Florida pine and cypress, the original floors and pecky cypress walls are still in remarkable condition. Windows on the sides of the front porch are also original. Bone's Rest was built in 1921 and was at one time owned by Dr. Baum, the first physician in Naples.

facing *Master bedroom, with board-and-batten walls, pecky cypress ceiling, and, of course, Dori, the Papillon.*

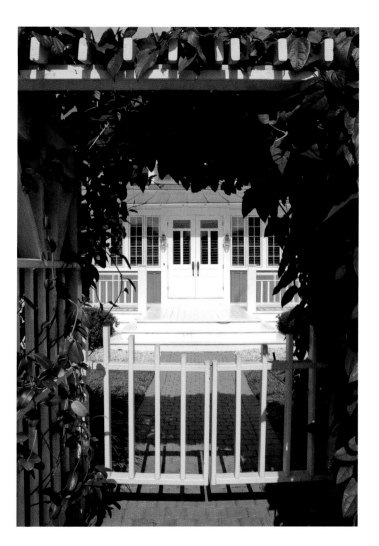

A shady arbor leads the visitor to Bone's Rest.

Sunset is one of the most
magical times in Naples,
as this front-porch view of
Bone's Rest shows.

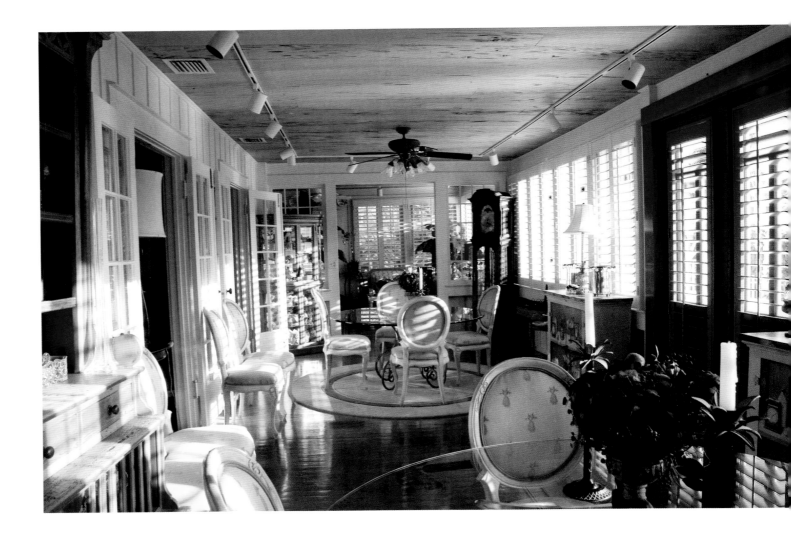

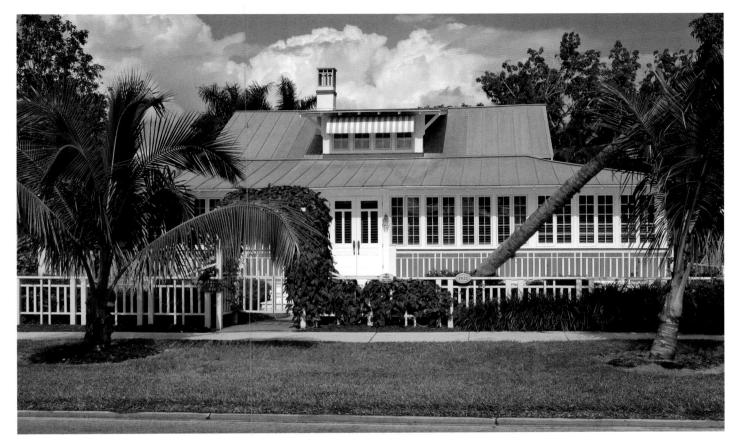

Bone's Rest facing Gordon Drive. This inviting cottage has been painted every hue in the rainbow, almost!

Many Naples residents express their love of color in how they paint their charming dwellings. Bone's Rest, in less than 20 years, has been painted salmon, lavender, blue, and now an antique brick that Dr. Schultzel, an evolving fly fisherman, refers to as River Trout Red. Visitors to Naples shouldn't miss this treasure.

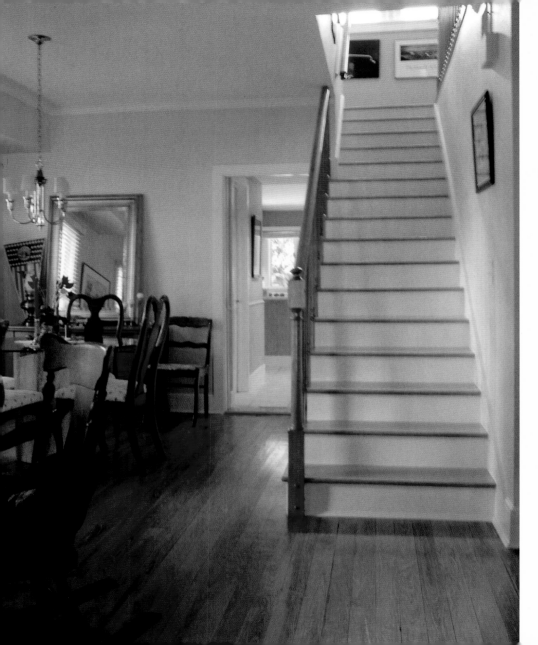

Captain Parker House

James Elson, the owner of the Parker House since 1998, has not only preserved its physical structure, he has archived the history of the cottage, which in most instances is elusive at best. Captain Lee Parker and his wife, Elizabeth, built the vernacular frame cottage on concrete piers between 1929 and 1930 for a cost of $2,500. Parker came to Naples in 1925 at the age of 19 to work as one of Naples' first fishing guides. In 1952 he opened a commercial fishery, Lee Parker and Sons Fisheries. Elizabeth's parents owned a grocery in Naples' Crayton Cove as early as 1908. Lee and Elizabeth were married in 1926.

The Parkers selected their homesite because it was equidistant from the Gulf and Naples Bay—a tactical decision made to minimize the likelihood of flooding. The cottage exterior has tongue-and-groove lap siding or Dutch siding, a gabled roof, and twin shed dormers on the front and back of the house. Dade heart pine, also known as red pine, was used for framing and floors. There are saltwater marks on the floors

*The stairwell with original
Dade pine flooring.*

from flooding during Hurricane Donna. Original windows still utilize a rope pulley mechanism with cast iron weights. The roof is the original galvanized metal, and the original back porch has been enclosed and now serves as the kitchen and breakfast room.

Royal palms in the back courtyard form a picturesque backdrop for a secluded pool designed by Jim Elson. He added a two-story wing that houses a garage and guest suite, joined to the main house by an enclosed breezeway that maintains the authentic footprint of the historic cottage. The original exterior siding serves as one of the breezeway's interior walls. Another piece of the past also has its home in the breezeway; Jim has placed there the circa 1920 postal box from the Old Naples Pier, complete with teller window and 18 closed letter boxes. (Most of the mail at that time was sent to visitors and seasonal residents in care of the Old Naples Hotel.) In short, this inviting cottage is an exemplary synthesis of a historic structure and a comfortable, livable home.

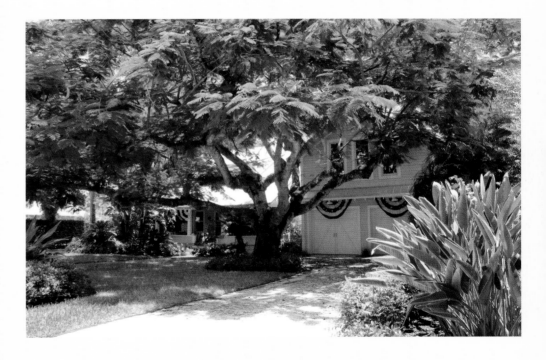

The Captain Parker House,
with Independence Day banners,
facing Cambier Park.

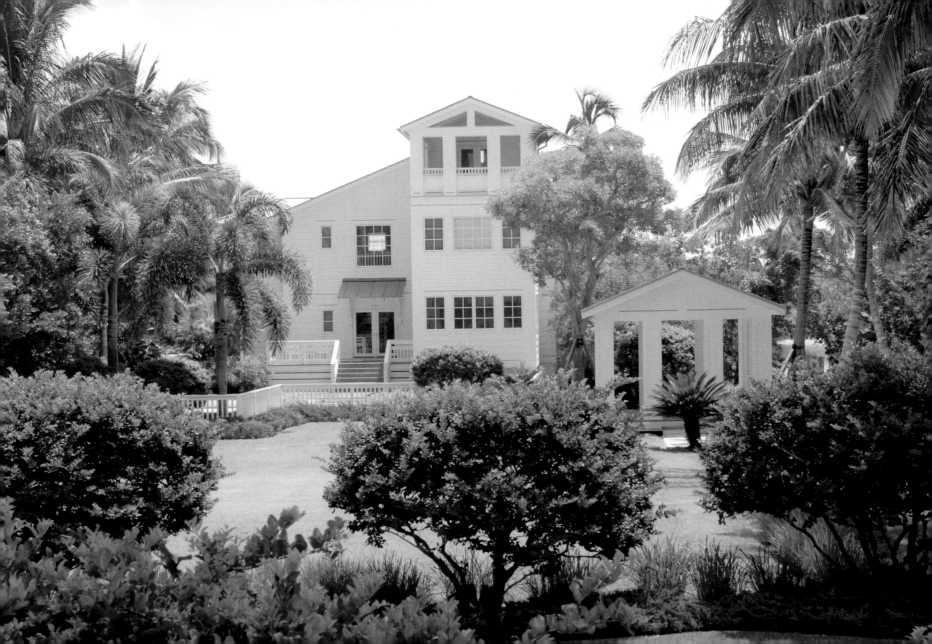

Champney Bay Boat House

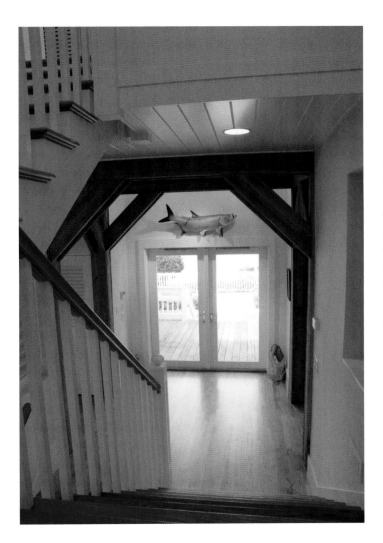

Architect Dwight Oakley was charged with the redesign of this classic Naples boathouse by owners Peter and Elsa Soderberg, who purchased the property in 1997. "We wanted to freeze the design characteristics of this property in the Naples of the early 1930s and proceed with a project that respected those parameters," explained Mr. Oakley.

Although the building's compromised condition required that the original structure be dismantled, considerable effort was made to salvage primary heart pine timbers from the boathouse for reuse as nonstructural columns and beams in the new construction.

At ground level the completed redesign is contained within the original structure's footprint, including the two interior boat slips. The kitchen was created with a cantilevered floor structure. Current building codes were incorporated, and a 2,900-square-foot house was created that honors the original, venerable boathouse.

According to Naples historian Lodge McKee, when it was

facing *Champney Bay Boat House, facing Gordon Drive, is one of only four boathouses in Naples.*

Foyer of the Boat House with fishing trophy. Sport fishing was one of Naples' principal attractions in its early days. In his book Early Naples and Collier County, Earl Baum mentions a New York visitor who came to Naples in 1921 for a two-week fishing trip and caught 32 varieties of fish.

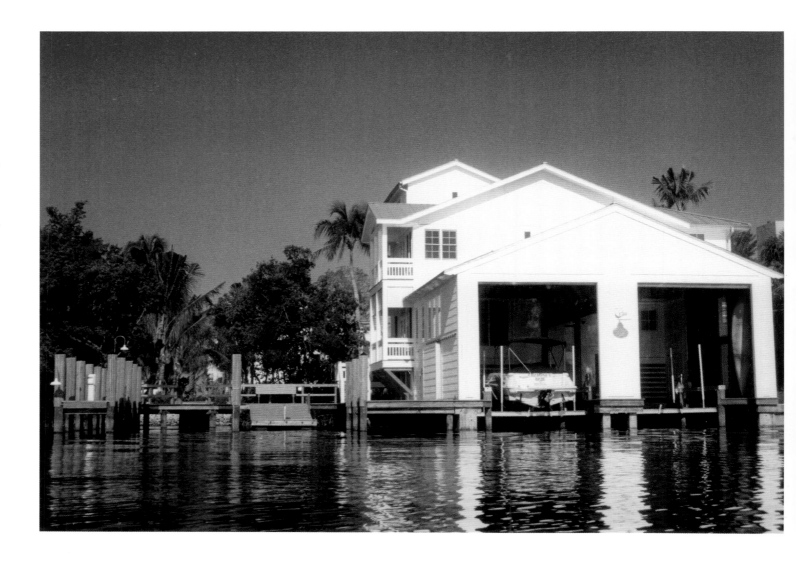

Boat House, Champney Bay view. (Photograph courtesy of Dwight Oakley, project architect.)

first constructed in the 1930s the building was known as the Perley Dairy boathouse. Perley Dairy was the largest family-owned dairy in the United States at that time. Today, the Champney Bay Boat House is one of only two Naples boat-houses with attached living space, and there are only four other boathouses in Naples. New zoning laws prohibit the building of boathouses in Naples today.

When redesigning the boathouse and its attached living space, Dwight added skylights and warehouse-style retractable overhead doors to illuminate the boat slips and water below; a large steel-frame sliding door in the south elevation allows access between the interior boat slips and exterior fishing deck. Dwight designed the wall between the living space and the boat slips to be almost transparent; windows open onto the barn-like interior of the slips and to Champney Bay beyond. The entire structure provides an ideal design for living on the water.

New construction provided the three-story front tower room and deck that offer views of the Gulf. A deep front lot is anchored with a pool and classic pavilion. Of the labor-intensive renovation, owner Peter Soderberg observed, "You take the longer view. This was done as an investment in the future happiness of an extended family."

Naples is known for imaginative dwellings. This home is unique, and it shows how wonderfully a historic structure can be adapted for modern use.

The Boat House at low tide.

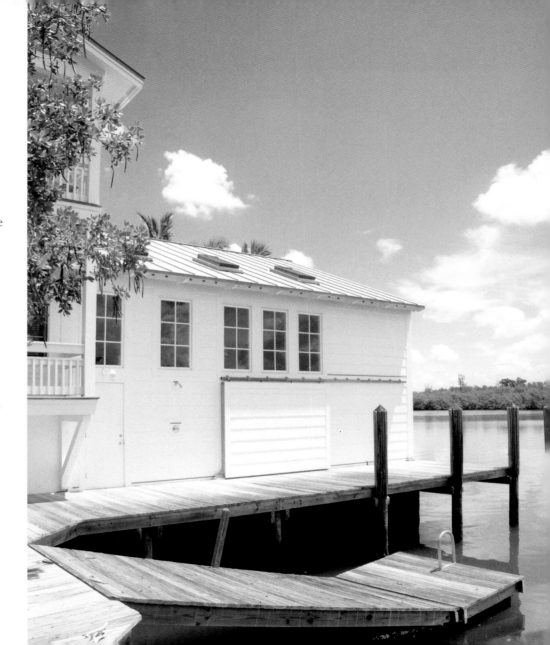

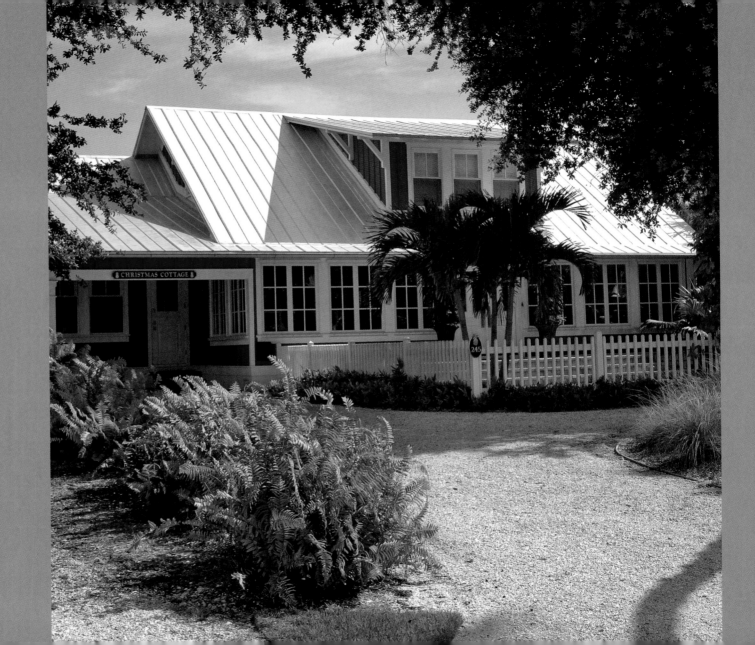

Christmas Cottage

Festive Christmas decorations remained up all year long at this cottage when Mrs. Dorothy McLenon lived here, and this is how Christmas Cottage got its holiday name.

The house was built in 1910 by the Agners. Mr. Agner was the builder of the Old Naples Hotel. In the 1920s, the cottage was sold to the Duncan and Mary Hill Kenner family, who owned the house for close to thirty years. Jackie Sloan, their granddaughter, owns Fisherman's Lodge, the cottage next door to the west. Jackie and her family lived in Christmas Cottage for a time when she was a child; they were year-round residents of Naples. Her maternal grandparents, the Kenners, visited Naples seasonally.

The McLenons owned the home from the 1950s until 2006. In 2006, Tricia and Larry Paolini purchased the home and retained Porter VanArsdale Construction to renovate the cottage,

facing Christmas Cottage, Broad Avenue, is the only cottage featured in this book that is located immediately adjacent to and across the street from retail shops. Its name comes from the year-round front porch Christmas decorations left up by former resident, Mrs. McLenon.

Living room view of Christmas Cottage stairwell; the ceiling beams and board-and-batten walls are original.

The inviting outdoor fireplace was opened from the interior fireplace to create a wonderful outdoor living space. While fireplaces used to be the main heat sources for most homes built in Naples through the 1940s, today they are used to take the edge off the winter chill when temperatures occasionally sink into the '30s.

a project that encompassed almost two years. The entrance of this gabled cottage with its prominent shed dormer was widened for a double front door, and the front porch was enclosed. Crafted from Dade County pine, the frame was stabilized and reinforced. The original ceiling beams and board-and-batten walls remain in excellent condition. The metal roof, floors, ceilings, and interior stairwell and balustrade were replaced with building materials that closely matched the originals.

The original fireplace was rebuilt and opened to both the interior and the outside terrace. Brick terraces frame the front entrance and the outdoor kitchen as well. A carport, kitchen, dining room, and master suite were added to the cottage while maintaining its historic integrity. A surprising detail in the new master bath is a fixture called a ceiling-mount bath filler, which releases a nine-foot smooth and solid stream of water to fill the footed tub below. Some of the cottage's Depression glass windows were salvaged and are still in place. The guesthouse was also restored with its original footprint.

Outdoor living spaces are as integral to Naples' historic cottages as their interiors. An open porch behind Christmas Cottage has been enhanced with columns, decorative moldings, and a fireplace. A pergola wraps the west side of the pool, creating a magical passage to the guesthouse. Like Christmas Cottage, many of Naples' historic cottages feature pools in their enclosed courtyards, creating oases even when the properties are adjacent to busy streets and commercial areas.

The pergola softens the sunlight and frames the pool, creating a visual path to the guesthouse.

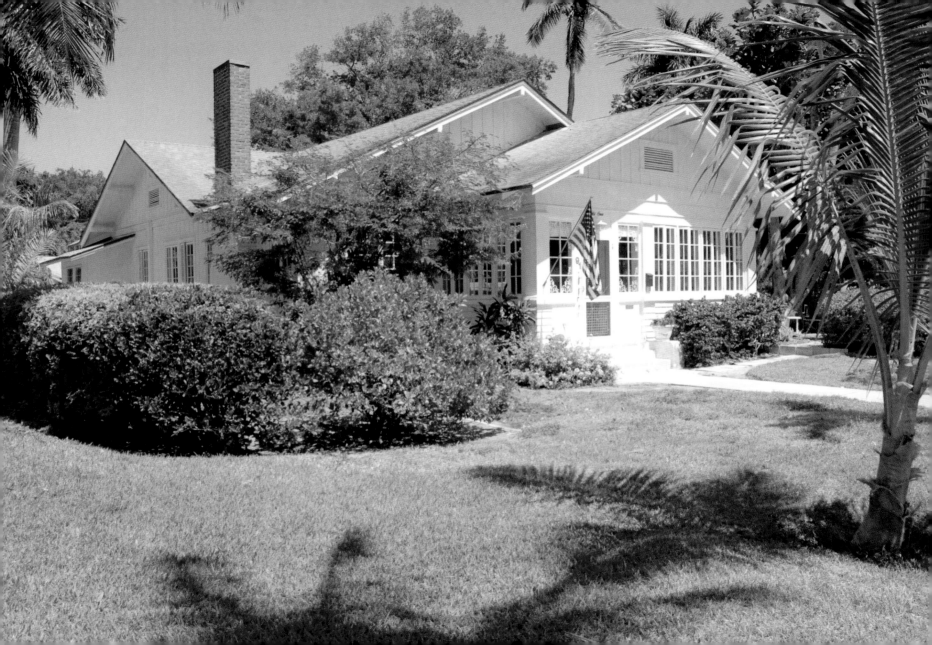

Coconut Cottage

Emily Gutchess, a prolific artist, purchased this home with her husband, Neil, in 1982. The walls of her quaint Coconut Cottage were adorned with her colorful paintings of Naples homes, parties, beach scenes, and tropical flowers.

Emily shared a little-known fact about Naples' historic cottages with me: "The older the house, the higher the land. . . . Early residents picked high spots to minimize the risk of flooding. Built on piers, Coconut Cottage has never been flooded—even when adjacent houses were." Light and airy, the large Florida room serves as both entrance and front porch, as the house has two fronts—one facing Broad Street and the other facing Gulfshore Boulevard. Pronounced roof overhangs allow the windows to be open even during rain showers.

Coconut Cottage was built in 1923 by a Philadelphia jeweler, "Jack" G. Morris, according to Jackie Sloan, great niece of Jack Morris. J. G. Morris left the cottage to his sister, Jeanie Morris Sloan. Maidie Sloan, Jeannie's daughter, bought the

facing Coconut Cottage, Broad Avenue side.

house from the estate in the early 1950s. Maidie Sloan sold the front part of the property with Coconut Cottage to the Wren family from Long Island and kept the guesthouse for her winter home. Emily Gutchess purchased the guesthouse in 2001 from Jane Wynn, Maidie's daughter.

Emily said that the Wren family had owned what she called a "garden store" in Naples, which accounts for the diversity of

Emily Gutchess's painting of her porch.

Coconut Cottage hallway art gallery, featuring the paintings of owner Emily Gutchess. Several paintings, above right, were removed to be digitally copied for use in this book when this photograph was taken. Emily was delighted to share her paintings for this glimpse of beautiful Naples

old plantings, including a fig tree and a powder puff tree. The Wrens sold the cottage to the Ameses.

The family names associated with many of Naples' historic cottages are often intertwined. Neil Gutchess, Emily's husband, was from the same hometown, Cortland, New York, as Don Ames, from whom they purchased Coconut Cottage. Neil's and Don's fathers were good friends in Cortland. Don Ames had purchased the cottage in the early 1960s, after Hurricane Donna.

Neil's father, Claire Gutchess, owned a house on 11th Avenue: the Gutchess House, now known as Westhaven. Claire and Irene had six children, including Neil. Seasonal residents of Florida, they would take their children out of school in New York and travel down to winter in Naples from Christmas to Easter. At that time, it took five days to drive from New York to Florida. Although Emily never visited Naples as a child, her uncle Jerry O'Keefe was manager of the Old Naples Hotel in the 1940s.

In 1982 Neil and Emily visited Key West to look for a second home. They came to Naples to visit their family friends, Scotty and Don Ames, who had just purchased the house next door at 75 Broad Avenue South. The Ameses had just put the Coconut Cottage on the market the day before. Back in their hotel after dinner, Neil asked Emily, "Do you like the Ames house?" Emily said yes, and Neil called his friend to say, "Don, we'll buy your house." So, this classic beach cottage was on the market for only two days.

Scotty Ames said the house was built in 1923. This proto-typical Naples cottage maintains its original knotty pine and cypress walls, pine floors, beaded ceilings with sturdy beams, board-and-batten exterior, windows, and fireplace. There are two interior windows that enhance the circulation of the Gulf breezes. For many years the cypress and pine interior walls and ceilings were not painted, and as the natural wood darkened, the interior seemed shaded all of the time. The use of this natural darkening may have been a method for making Florida interiors seem to feel cooler in the hot summer months. The Ameses painted the interiors in light, airy colors.

The Gutchesses enhanced Coconut Cottage with a new metal roof, the addition of sliding doors to the Florida room, which has never been air-conditioned or heated, and the conversion of two closets to baths. One wall of the pantry was removed so the kitchen could be accessed from the center hall. The guesthouse, created from the garage and staff quarters, has a separate street address—1120 Gulfshore Boulevard—though it shares the same phone number as the main house.

Emily Gutchess, who passed in 2009, was a charming member of the Naples cottage community; she cherished this truly characteristic home and made every endeavor to preserve it for the future.

Shaded interior of Coconut Cottage.

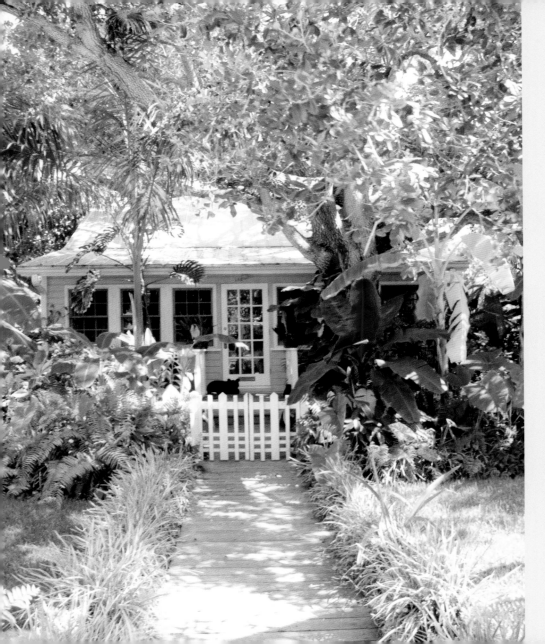

Conch Chowder

Conch Chowder was built between 1915 and 1920 and was purchased by the current owners in 1995. This little cottage, used only for a few months each year, has the feeling of an old Key West cottage.

Built of heart pine, the cottage features diagonal beadboard walls, beadboard ceilings, living room fireplace, and clapboard exterior. The six-foot windows are original and open the rooms to the lush tropical landscaping.

Because the cottage is only two rooms wide, the owner likes to refer to it as a railcar cottage, "just wide enough for the conductor to see out both sides and see everything." Although diminutive, the cottage has an inviting living room, a small den, an efficient kitchen, and several bedrooms. At some point in its history, the front porch was enclosed. As guests enter the porch, a half-moon-shaped console is surrounded by rainbow-hued dancing shoes, a tribute to a dear friend of the owner. According to the owner, part of the lore of the cottage is that it arrived in Naples on a barge from the Florida panhandle.

Conch Chowder, 10th Avenue South.

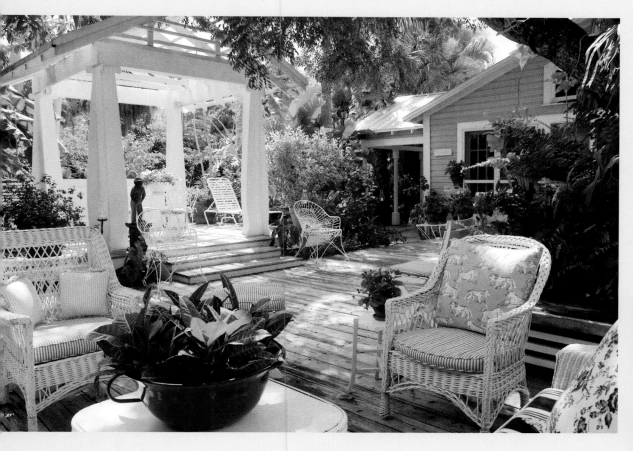

Lush gardens surround the back porch and classical garden pavilion.

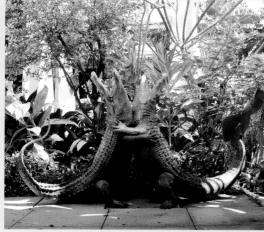

Dancing alligators in the Conch Chowder garden.

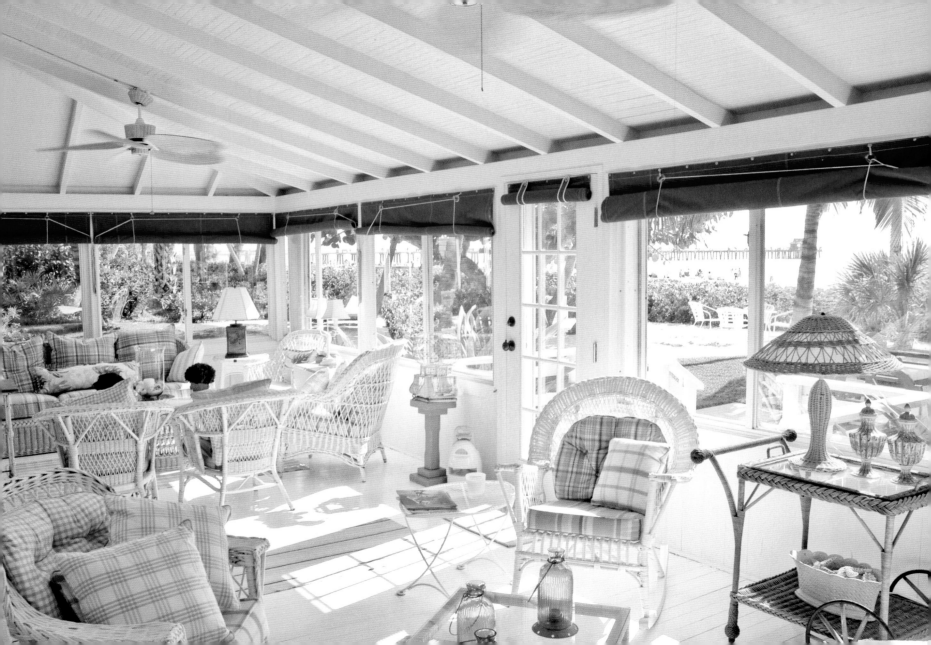

Coquina Cottage

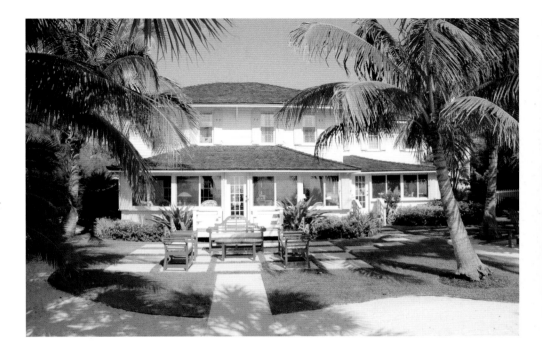

Beach view of Coquina Cottage.

In a March 28, 1985, article, the *Naples Daily News* recounted the history of Coquina Cottage: "Believed to have originally been built by Haldeman in 1895, the home's former residents include Capt. Large, a man who piloted the steamer *Fearless* for Haldeman, and Capt. Stewart and family from about 1902–8. In 1910 Mary Scott Moxley Armstrong and Josephine Smith purchased the property. Coquina was the fourth house built in Naples."

When first built, the cottage had two stories with four rooms on each floor. In 1920 a wing was added, which housed a bedroom with fireplace and a bath on each floor.

Walter N. Haldeman, publisher of the *Louisville Courier-Journal*, built the house as a hunting and fishing camp, and it had the desirable distinction of being in walking distance of the Naples Pier, the point of arrival for visitors (Jamro and Lanterman 21).

A photograph from 1915 shows the beach side of the house with a clipped gable. The Gulf-side porch was added later, and

palm fronds were nailed on the porch fascia board to keep out the sun. At some point the porch was screened, and in the 1980s sliding glass windows were installed. The house has its original three fireplaces. The original pine floors on the first story were in disrepair and have been covered with antique river-salvaged heart pine.

Surviving wear and tear and time, the original Dade County pine floors add character and history to the second floor. The floor plan has remained virtually unchanged throughout

facing *The original front porch of Coquina Cottage with a view of the Naples Pier.*

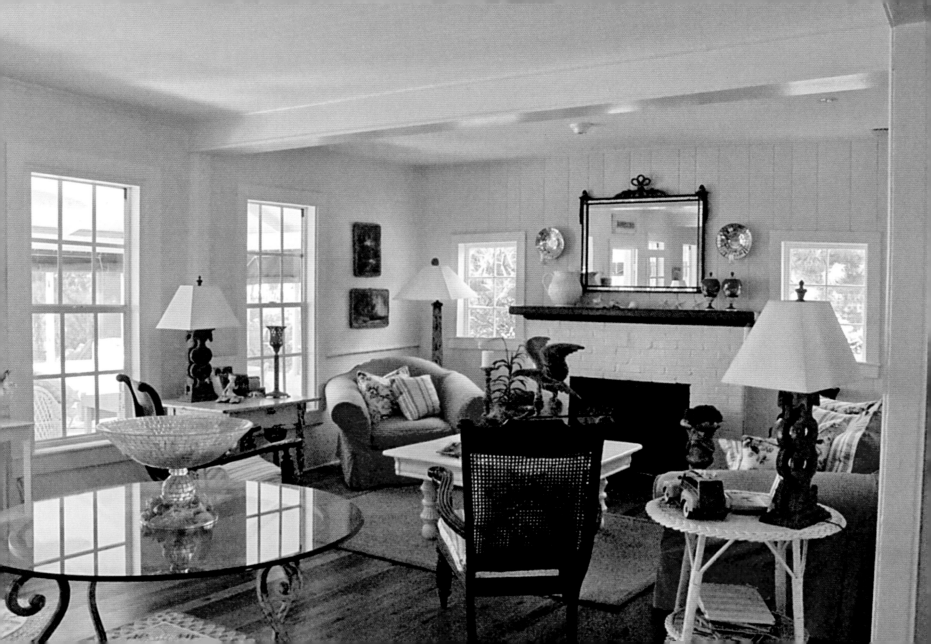

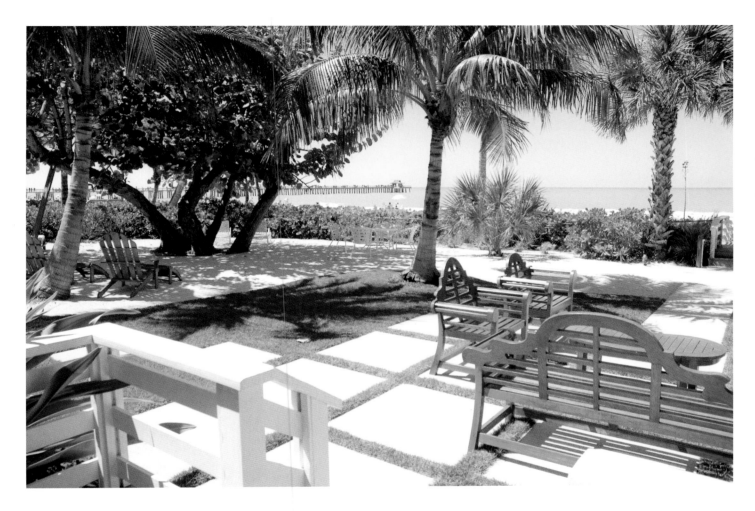

A 100-year-old seagrape tree frames the original sand front lawn.

facing The living room, showing one of the cottage's three original fireplaces.

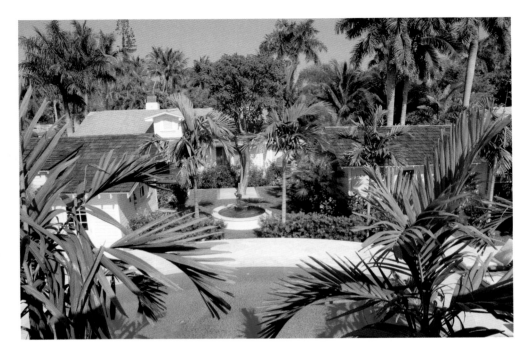

Pool area, with a view of Periwinkle Cottage to the left of the fountain.

Coquina's history. A second-floor bedroom was converted to a master bath and dressing area during the most recent renovation.

According to a winter 2006 article in *La Vie Claire*, Coquina Cottage had a familiar Naples real estate story. The property had "languished as a real estate listing for over a year before the current owners bought it. Others had looked, but many bypassed the cottage altogether and saw only a lot on which

they would build a much larger house. Zoning discouraged these potential buyers; if they tore the original cottage down, the structure replacing it would have to be set further back from the shore" (32, 35).

In 2003, the current owners purchased the home from Gale R. Guild, who inherited the house from the descendants of Mary Scott Moxley Armstrong. Like so many chance encounters that impact history, an impulse visit by the owners led to a three-year renovation and restoration of this hallmark Naples beach cottage. Prior to this time, Coquina Cottage had remained in the same family for 93 years.

Designed to catch the Gulf breezes, the house was not air-conditioned until 2003. The current owner recalled that, during renovations in 2005, just hours before Hurricane Wilma hit Naples, the Weather Channel was broadcasting from the steps in front of Coquina Cottage and warning of a potential 16-foot storm surge. At that time the cedar shake roof had been removed and the new one not yet installed, so the only protection from the rain and wind was tar paper. Virtually every room felt the effects of the hurricane: all the freshly painted interior walls had to be repainted and the south chimney rebuilt.

An oval infinity pool, added in the most recent renovation, enhances the center courtyard of the compound, and the original servants' quarter has been converted into a pool house. The front yard on the beach side was always sand, and Mrs. Guild had it raked twice a week to keep it smooth. Her stepping stones have been repositioned to create a terrace.

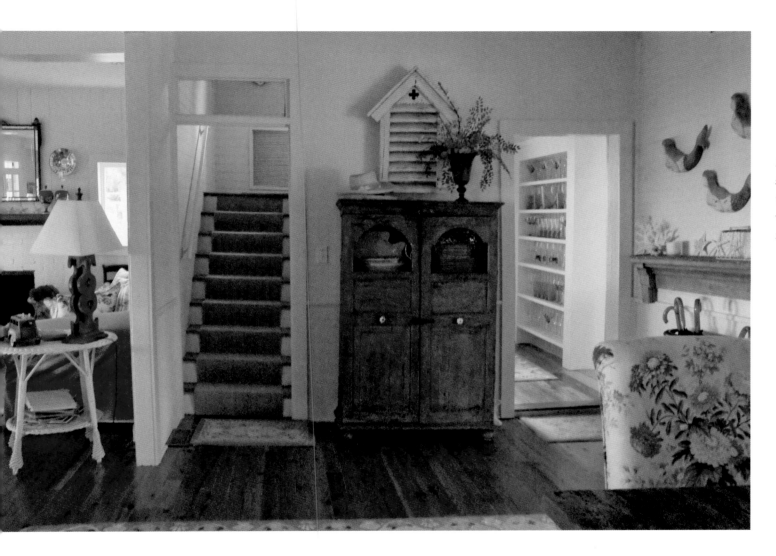

Foyer, c. 1895. The distinctive
slant of the floors caused by
the house settling over time
was preserved when the owner
restored the house.

Kitchen view, Coquina Cottage.
The open shelves speak to the
simplicity of beach cottage
living.

An original seagrape tree, now over 100 years old, and four original coconut palms survived Hurricane Wilma. Early photographs show 19 original coconut palms on the front sand lawn. In the early days tarpon were buried at the base of the coconut trees for fertilizer. The early garage had to be demolished due to termite damage, and has been reconstructed on the original footprint.

Periwinkle Cottage, a Key West–style bungalow located on the east side of the property, was purchased by Mrs. Guild in the 1990s to preserve the property. For years it was known as Tilly's Cottage. It was renovated by the current owners in 2004.

Light-filled, airy, happy, and colorful, Coquina Cottage is one of Naples' most pristine historic homes, and it is cherished by the owners.

Morning porch, with vibrantly painted furniture and floor.

Cottage Row, 8th Avenue South

The four cottages included in this chapter were renovated by Richard and Nancy Foht and their family. A combination of historic and new cottages, this section of 8th Avenue is an exemplary neighborhood that speaks to the best of old and new Florida vernacular architecture. Each cottage has a story to tell.

660 8TH AVENUE SOUTH

The Foht Cottage

Screened by the magnificent branches of three Royal Poinciana trees, this cottage looks as if it grew up from the earth in its verdant corner.

Actually the cottage has been moved twice in its history. Built in 1947 by Richard Jones, it was originally located on the 700 block of 10th Avenue South. North Naples fire chief Jim Jones told the *Naples Daily News* (September 12, 1993) that he grew up in the cottage with his parents and brothers. He recalled nights when the entire family slept on the front porch, because they had rented the two bedrooms to tourists.

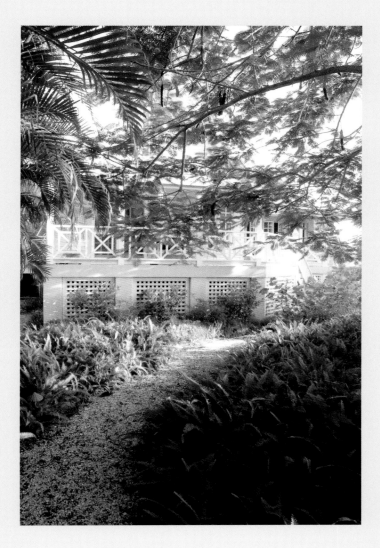

Foht Cottage, adjacent to Saint Anne's School, facing 8th Avenue South.

facing *The newly designed Foht Cottage kitchen.*

left Foyer off the front porch. There is no enclosed living space on the ground level of Foht Cottage, so the front porch and entry are reached by exterior stairs to the second level—a bit like living in a tree house.

center This second-floor bedroom at Foht Cottage shows how every inch has been turned into interesting living space.

right The tropically colored guest wing of Foht Cottage presents vacation living at its best! The high ceiling creates volume in what is a small space.

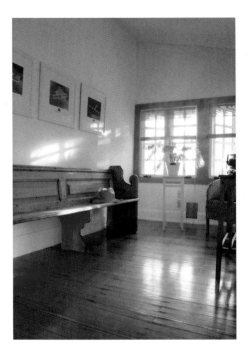
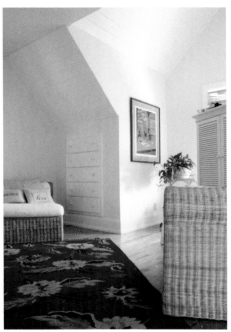
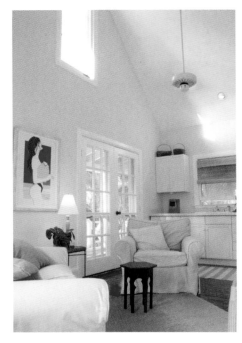

The cottage was acquired by St. Anne's Parish and moved to the 600 Block of 9th Avenue South and used as a retreat.

In the early 1980s the American Red Cross received the cottage as a gift from St. Anne's. As headquarters for the Collier County chapter of the American Red Cross, hundreds of Naples residents learned CPR there.

In 1991 the Red Cross offered to sell the house for one dollar, as they needed the property for parking. Serendipity came to the rescue: Richard Foht, artist and general con-

tractor, was looking for a new home. Richard and his wife, Nancy, acquired the cottage and moved it to its present location on 8th Avenue South. At that time the Fohts turned the 900-square-foot two-bedroom bungalow into a 2,550-square-foot gracious home with studio, playroom, four bedrooms, and an attached guesthouse. The Fohts did everything but the electrical, plumbing, roofing, and framing work on the home.

The footprint of the core living areas remains intact, with the only change being the removal of the wall between the

living room and dining area. Original Dade County pine floors and pulley weight windows are aging beautifully and still hold up to the demands of a busy family's everyday life. The floors bear saltwater stains from the floodwaters of Hurricane Donna. The metal 12/12 pitch roof is new.

The petite but cleverly designed guest wing and third-floor artist studio enhance the diversity of the living space and give great adaptability to the home.

Irresistible porches wrap the house and in the front bring one's eye level to the captivating seasonal coral blossoms of the Royal Poinciana trees, creating the feeling of being in a tree house. "We wanted a meld of an island house and an Old Florida home," said Richard Foht.

This single-story cracker house was artistically transformed by the Foht family, and it serves as a stellar example of how the charming historic cottages of Naples can be adapted for diverse lifestyles and housing needs. The restoration was honored as the winner of the Better Homes and Gardens 1992 home improvement contest, selected from almost 2000 entries.

756 8TH AVENUE SOUTH

HaBayit

This raised Florida cottage was designed and built by Richard Foht in 1998. Jack Molloy and Joanie Bernstein's journey to find their dream home in Naples was a bit convoluted, with

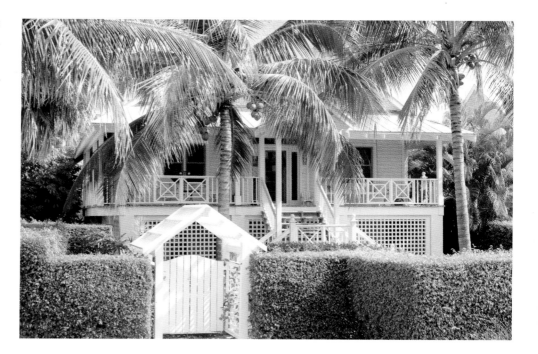

HaBayit front view.

several deals on other properties falling through after numerous trips to look at sites and meet with agents. The process took almost two years. While looking at one historic structure, Jack walked in and fell through rotten floorboards. The Bernsteins knew Richard Foht and were aware of this house, then under construction, though it had been pre-sold to another party. Joanie was reluctant to move as the couple had just built their dream home in Minneapolis; she specified that they would have to live on 8th Avenue if she were ever to move to Naples.

Florida vernacular style gets a fresh look in the new construction of the Hamilton home.

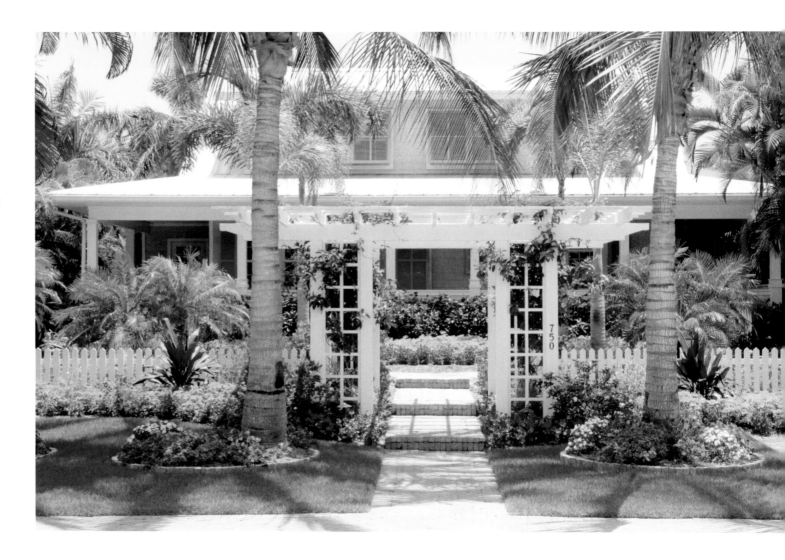

The cottage became available and, after a quick trip back to Naples from Minneapolis and an even quicker decision, they purchased the home. Jack remembers that day: "I took one step onto the porch and knew this would be my home." Jack named the cottage HaBayit, Hebrew for "the house." A charming detail of the story: Jack and Joanie moved into the cottage with their son Zach on Valentine's Day 1999.

An ideal example of new construction that incorporates the vernacular, HaBayit has a porch that circles the entire main floor, high ceilings, novelty siding or shiplap siding, gabled roof lines, and casement windows. Deep roof overhangs allow windows to be open even in rain and provide shade so no direct sunlight reaches the interior spaces during the day. One of HaBayit's intriguing architectural elements is the pair of gabled balconies on both sides of the second floor, which mimic the widow's walks of early seaside dwellings. This cottage is a noteworthy example of new construction that continues the visual legacy of Old Naples.

750 8TH AVENUE SOUTH

Hamilton Home (constructed 2003)

This new, shake shingle cottage, designed and built by Richard Foht, is a wonderful example of new construction in Naples that meets FEMA guidelines while incorporating that marriage of simple Victorian architecture with Florida vernacular style that characterizes authentic Old Naples beach

This colorful breakfast nook offers guests a place to light while owner Linda Hamilton works her magic in the kitchen. She is an amazing cook and will gladly share her recipe for carrot cake cookies!

cottages. The interior offers open spaces that allow for ease of transition throughout the house and for multipurpose rooms that are not defined by traditional floor plan room labels.

Linda Hamilton moved into the cottage in January 2005 and four weeks later entertained over 100 guests there.

Quintessential Cottage, c. 1930.

"Once I saw this home during construction, I couldn't get the house out of my head. I fell in love with it right away. Everything I visualized about it came to be true. I feel as if it has been here forever; the house seems to breathe and move with great energy."

732 8TH AVENUE SOUTH

Quintessential Cottage

Rusty Edwards purchased this circa 1930 cottage in April 2006. The west side of the home is the original cottage, renovated by the previous owner, Rick Olson, who lived in it from 1979 to 2004. Rick said that the original cottage consisted of four rooms with a front and back porch. He removed the asbestos siding that had been applied over the yellow pine shiplap siding, and he also built a separate artist's studio on the site in the early 1990s.

The cottage's front windows were salvaged from the first school building in Naples. Rick restored the frames and reglazed the windows; on one of the sills the initials carved by a student are still visible in the wood: A W. The cottage had one of the few early windmills in Naples, which was used to pump water. When Rick bought the cottage, the windmill had been cut down and the base converted into a storage shed. He also recalls that the cottage had been moved to its present site from the lot immediately to the west.

At one point, Rick researched his homesite (site 8CR691)

and learned from a 1989 standing structure inventory that the building "is associated with Herbert Storter and also Robert Combs of Combs Seafood, both prominent men in the local fishing business in the 1930s and 1940s. This house is a good example of the homes built by fishermen of that era." (Standing structure inventories are excellent sources of information on Florida's historic buildings. They can be found in the Florida Master Site File, an archive located in Tallahassee and maintained by the Florida Bureau of Historic Preservation.)

When Richard Foht purchased the property in 2005, he updated it and joined the two structures, adding a wing onto the east side of the cottage. He created an inviting terrace and plunge pool, which are tucked away behind the old studio.

Beautiful woodwork distinguishes the decorative siding, Bahama shutters, and amazing original porch. Gable roofs with deep overhangs earmark this dwelling as a classic Naples beach cottage. The durable Dade County pine floors have survived.

Rusty Edwards, the current owner, often visited Florida's west coast to see friends. On a whim, she took a look at the cottage, which she calls "the quintessential cottage." As she explained for a *Naples Daily News* article of September 12, 1993, "I took one step on the porch and knew I wanted it!"

Quintessential Cottage, front view, as seen in 2009 from the shuffleboard court at Cambier Park.

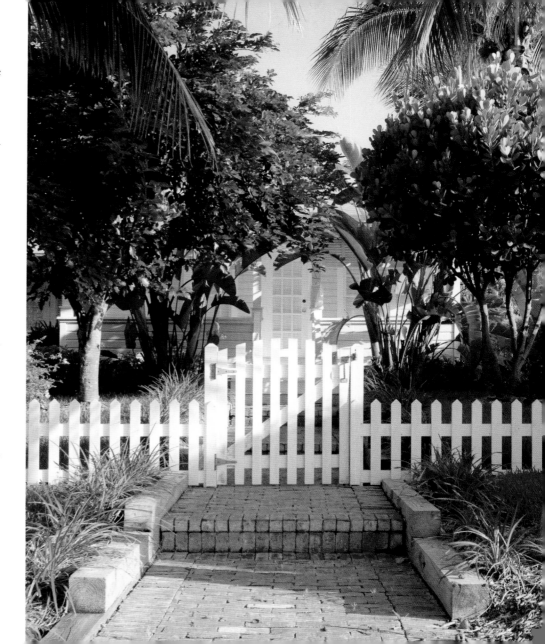

Dolphin Weathervane Cottage

This 1935 Old Naples cottage had been renovated to resemble a 1950s ranch style house when Mary and Bruce McCarthy purchased it in 1999. Having moved to Naples from Cape Cod, the couple fell in love with the Old Florida cottage-style architecture common to the area. "We had restored an old waterside cottage on Cape Cod and hoped to do the same with the 11th Avenue property," said Mary.

After spending time studying many of the hallmark cottages in the Old Naples area, Bruce, an experienced real estate developer, drew up plans for their new home that they hoped would reflect the area's historic setting. In keeping with the property's status as a "historic home," the McCarthys were required to go through a special permitting process. "We had to demonstrate that the changes we proposed would not make the house any less historic," Bruce explained. "It was an easy sell given all the updating that had been done to the house over the years. Our goal was to recapture the beach cottage ambience of the original 1935 structure."

The McCarthys reconfigured the interior of the house, taking the walls down to the old Dade County pine studs. They reduced the number of rooms and vaulted the ceilings to create an open, airy feeling from what had been a rabbit warren of small rooms. The original kitchen "was no bigger than a minute," Mary said. "We opened it up with French doors that now lead to a covered porch and pool where we spend a good deal of time. It's our favorite part of the house."

The end result is a livable home, featuring three bedrooms and two baths, wide pine floors, tongue-and-groove wall and ceiling accents, and an original fireplace with a surround fashioned from antique tin ceiling material. The original front porch was enclosed and now serves as shared office space for the busy couple. The McCarthys have furnished their home with mahogany and teak furniture, wall hangings, and Oriental rugs—all of which combine to create a feeling of airy, tropical comfort.

The exterior has been restored to its original, beach cottage style and its tin roof topped by a dolphin weathervane—a gift from friends who lived in the cottage while their own home was being renovated. The siding is periwinkle blue clapboard, with white trim and grass-green detailing outlining the divided light windows. The landscaping provides a natural setting for the cottage. An arbor festooned with yellow flowers

facing *Dolphin Weathervane Cottage, back porch and view of five gables.*

marks the beginning of a red brick path to the main entrance, which features a Victorian screen door in bright raspberry.

Stately royal palms stand guard at the front of the house, and several more mark the boundary along the alley at the rear of the property. Bruce discovered several palms on a nearby homesite scheduled for demolition and had them saved and transported by flatbed truck to their new home. "I was searching for Cape Cod with palm trees," Mary said. "So this worked out perfectly."

The rear yard features a free-form pool and hot tub built to resemble a natural pond with dark bottom. A waterfall tumbles gently over artfully arranged stones, providing the soothing sound of moving water when Mary and Bruce entertain on the covered deck attached to the rear of the house. A pair of white, automatic gates provides access from the alley through a tall ficus hedge onto a white shell drive that leads to a small, single-car garage on the lot's west side. One of the most intriguing views of the house is from the shell drive near the alley. From this vantage point, the five gables formed by the many additions to the cottage and the cupola that provides the structure's high point and support for the dolphin weathervane come together in an almost puzzle-like configuration.

The front entrance, perpendicular to 11th Street South, welcomes guests with a Victorian screen door and trim.

The home sits on the original coquina footings, and the original southern yellow pine roof rafters were reinforced with scissor joists to compensate for the fact that the cottage had been built without a ridge board. Bruce said, "We were stunned to learn that the cottage had survived hurricanes and high winds over the years without the benefit of a ridge board. The rafters were simply butted together and nailed." "Scissor joists," he explained, "are an old house framer's trick that reinforce such an arrangement. I learned the method from a Cape Cod builder who had restored some old cottages that dated as far back as the late 1700s."

While Bruce is interested in the architectural intricacies of the cottage, Mary is struck by the many inviting local features that create Old Naples' charm. "We were drawn to the human scale of these old cottages," she explained, "and now that we live here, we feel that Old Naples offers a true neighborhood experience that is difficult to find anywhere else in the city. We can walk or ride our bikes almost anywhere we want to go. It's definitely home."

11th Street view of Dolphin Weathervane Cottage.

Dressmaker Cottages

In the 1920s, Mrs. Harry "Peg" Bradley built a trio of cottages on Gordon Drive as employee housing for the dressmakers at Zita's, her dress shop. She had opened a branch of her successful Milwaukee retail store in Naples for her clients who wintered here.

One of the cottages, located at 1309 Gordon Drive, underwent reconstruction with an addition in the summer of 2008. Dot Wade purchased the cottage from Dennis Claussen in the summer of 2006. The cottage was severely compromised, and the entire structure had to be taken back to the floor. Every effort was employed to remake the cottage with as much authenticity as possible and to extend its life another 100 years. Salvaged from the original structure, pine floors, ceiling beams, and floor joists were used to handcraft kitchen cabinets. In keeping with its original architecture, all interior floors, walls, and ceilings in the rebuilt cottage are wood. Now complete, this re-created Dressmaker Cottage has a charming street presence that mirrors the vintage original. City codes mandated that the new garage with guest apartment be connected to the cottage with an air-conditioned passage. FEMA guidelines required that the new connector be raised to meet current flood standards. The result is an inventive design that speaks to the past, present, and future simultaneously. The other two Dressmaker Cottages are located at 1341 Gordon Drive and 1325 Gordon Drive.

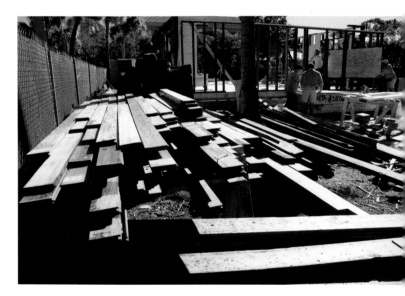

The cottage's original beams and lumber were salvaged for new construction.

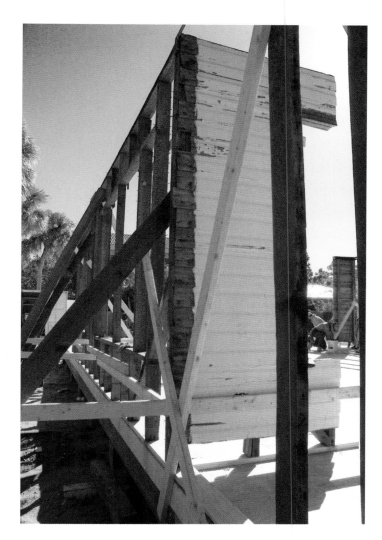

Dressmaker Cottage renovation at 1309 Gordon Drive. Exterior siding was recycled whenever possible.

During the renovation of Dressmaker Cottage, the original pine floors, ceiling beams, and floor joists were salvaged and used to make new handcrafted kitchen cabinets.

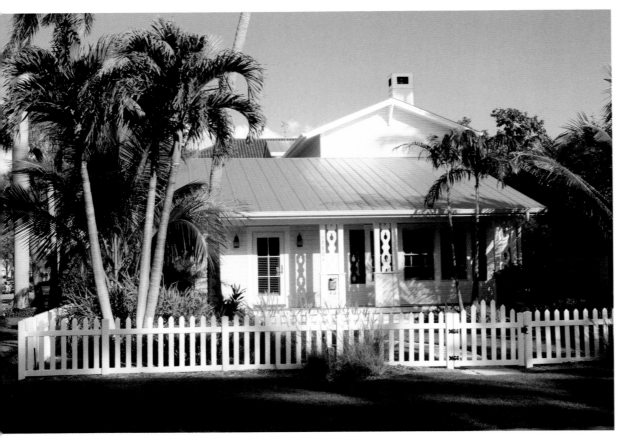

1309 Gordon Drive.

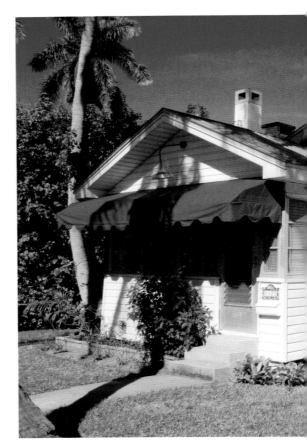

1325 Gordon Drive.

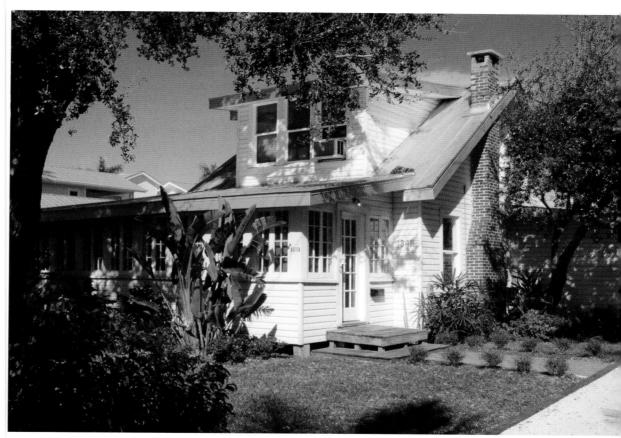

1341 Gordon Drive.

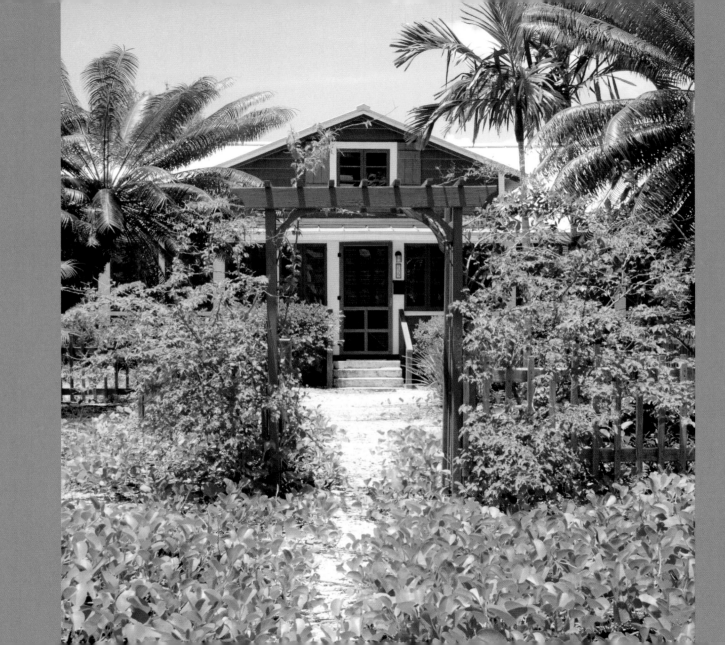

Fisherman's Lodge

If houses were family members, Fisherman's Lodge has a lot of cousins in Naples. Jacqueline "Jackie" Morris Sloan, the owner, is the granddaughter of N. P. and Jeannie Sloan Sr. The Sloans' first property in Naples was Tecopa, circa 1918. Then in 1919, they built Sagamore at 14th Avenue South and Fisherman's Lodge on Broad Avenue.

Both cottages were board-and-batten and crafted with Dade County pine. Family members, friends, and guests flowed between the family's winter homes. N. P. and Jeannie had seven children. Jackie's father was N. P. "June" Sloan Jr.

June Sloan was given the cottage in the early 1940s when Sagamore was sold. Fisherman's Lodge was then moved to its present site at 239 Broad Avenue South. The house was placed on rolling logs and pulled by mules for the three-block journey. At that time, an enclosed porch was added to the front of the house and extended partway down both its sides. The two original bunk rooms remain: one was Jackie's bedroom; the

facing Front view of Fisherman's Cottage with native plant landscaping. This sandy landscape is not only historically accurate but environmentally friendly, with not one blade of grass.

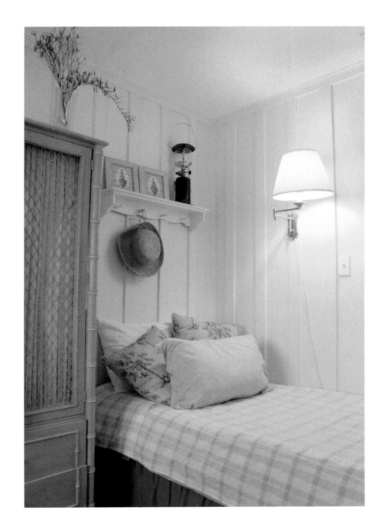

Jackie Sloan's childhood bedroom in Fisherman's Lodge.

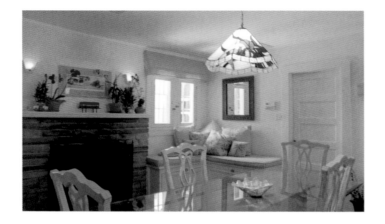

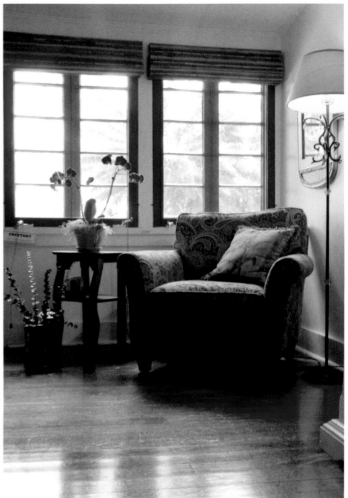

left *Original fireplace in Fisherman's Lodge. The dining area and living room are one large gathering space.*

right *Living room nook, Fisherman's Lodge.*

other was the bedroom of Jackie's older half sister, "Witsy," Mary Hill Burton.

The kitchen was converted to a second bath and the back porch converted to a kitchen. The brick fireplace was the principal source of heat when Fisherman's Lodge was built; it is still functional and the focal point of the large living room. The original Dade County pine floors have a beautiful patina. The wide-paneled interior walls have been resurfaced and painted. Jackie remembers their original honey-colored wood finish, white trim, and decorative nautical theme.

Jackie Sloan was born at the Ft. Myers hospital in 1936 and grew up in this house. She first lived in the neighboring cottage to the east (now known as Christmas Cottage), the winter home of her grandparents, Mary Hill and Duncan F. Kenner. Their daughter Mary Hill Jr. married N. P. Sloan Jr. in

1934. At times the Kenner cottage would be rented, and Jackie and her family would live at the Sagamore or Tecopa properties. "Life was an adventure as a child," Jackie observed. "The old houses were family members; we were welcome in them all . . . we absorbed the graceful character of each distinctive home."

Jackie's youngest sister, Norma, was a favorite of the Palm Cottage neighbors, the Browns. Mr. Brown set up the front-yard rooster pen, left from his game cock–keeping days, as Norma's play area, complete with rocking chair and dolls so she could sit outside and watch the hotel traffic come and go. The Browns would deliver ice cream cones to her in there. Jackie reminisced, "The hotel was the social hub and anchor of the community: everyone was there all of the time; we played bingo there. . . . When it was torn down it was like losing an old friend. The heart of Naples was gone. . . . If you knew it as we did, you can't help but mention it. Naples still remains a magical place. Naples keeps its original essence: sky, sea, air." Jackie still swims in the Gulf several times a week.

The fifth generation of the Sloan family now lives in Fisherman's Lodge. Sean Wilson, Jackie's grandson, and his mother, Cathy Muench Wilson, have lived in the cottage since 1997. Sean, at 14, brings his own appreciation to the experience of living in a historic family home: "I enjoy the location of the cottage, being near the beach and in the middle of all the commotion on 3rd Street. I like the uniqueness of my home and how it is unlike any of my friends' houses. It is very cozy, and the history fascinates me."

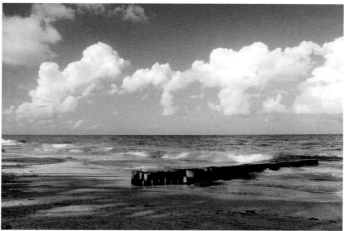

Sean Wilson is the fifth generation of the Sloan family to live in Fisherman's Lodge.

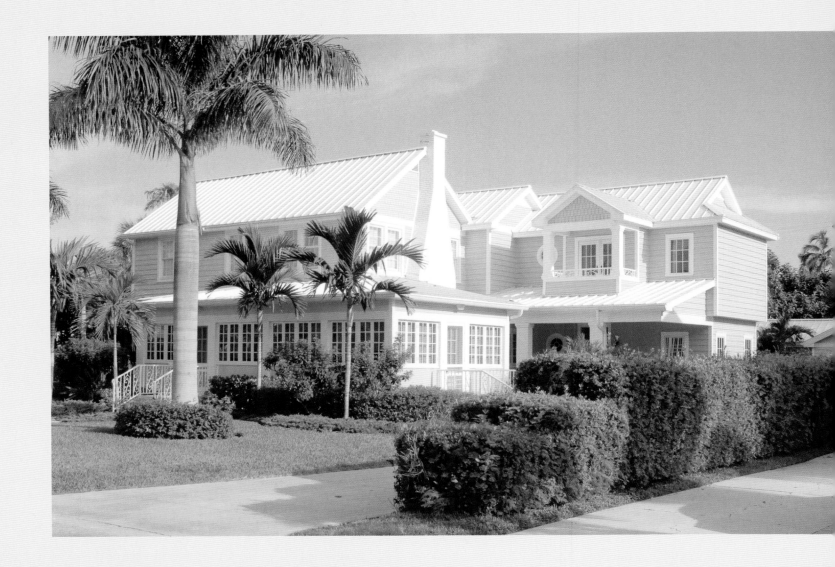

Guest House #53

Mary Parent received the gift of time travel in 2004 on her 40th birthday. Her husband, Dr. Thomas Parent, gave her one of Naples' historic cottages as a present. Her plans were to restore the cottage and place it on the market. The cottage cast its spell, and the Parents decided to make the cottage their family home. Dedicated to keeping the cottage in pristine condition, they have invested countless hours in its renovation. This venerable cottage has withstood Hurricanes Donna, Charley, and Wilma and is still holding strong.

Today, the house is the picture of colorful tranquility. Over 300 panes of original glass frame the sunporch, now a light-filled entry where daughter Katrina plays the piano daily.

Original oak floors glisten, historic ceiling beams are polished to a satin sheen, arched doorways and an enclosed stairway are handcrafted. Paneled walls are installed with hand-fitted pegs. The vintage 1930s fireplace has airflow vents at mantel height to facilitate heat conduction.

facing *Guest House #53. The original cottage is defined by the front porch and chimney wall; additions to the left and rear are recent and were designed to blend gracefully with the historic cottage.*

Early morning light streams in the windows of the sunporch.

Enclosed front porch, with
Katrina's piano. Original
windows have more than 300
panes.

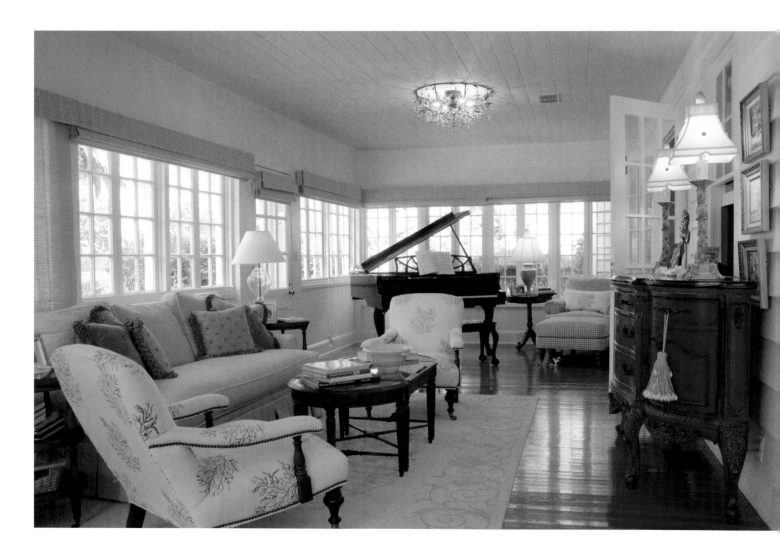

Artist Jeff Arnold spent months personalizing the home. In the downstairs powder room he painted a historic map of Naples. Throughout the house he accented the floors and walls with trompe l'oeil shells, coral, and crabs, some of which—in the pantry—are holding M&Ms in their claws. Daughters Katrina, Juliet, and Dylan helped with the selection and placement of painted motifs. The family cats are a bit afraid of the crabs painted on the floors.

This home has one of the best documented title histories in Naples. Built in the 1930s by Harry Guest, the first sale of the home is recorded with a hand-signed bill of sale for $25,000 from Harry Guest to Ida McKee on March 7, 1947. The document was given to the Parents by Lodge McKee, nephew of Ida McKee. The Parents purchased the home 57 years later on March 7, 2004.

Mary Parent grew up in Naples. She was present as a student when Barron Collier High School opened in 1978. Mary aptly expresses her appreciation for life in this colorful coral cottage. "When guests come to visit, even just for a meal, they seem immediately happy here. It's as if they can't bring their worries or cares into this home. We always feel safe here." In an effort to minimize the visual interruption caused by needed technological equipment, in 2008 the Parents added an office to keep computers out of sight. At the same time, they added a pool bath and another bedroom and bath on the second floor. Mary couldn't have received a better birthday present: this cottage blends a storybook past, an energetic present, and the promise of a happy future for this dynamic family.

Powder room map of Florida, painted by Jeff Arnold.

The Parents' living room,
with original oak floors and
handcrafted ceiling beams.

left Whimsical Florida motifs are sprinkled throughout the house.

right Back stairwell at Guest House #53.

MEMORIES OF LIFE AT GUEST HOUSE #53, WRITTEN RECOLLECTIONS OF LODGE MCKEE, JULY 20, 2008

A Naples historian shares his memories of life in this classic Naples cottage.

While wintering in Miami in 1930, Ida McKee, her husband, Caleb, and children Henry and Indiana toured the west coast of Florida in a 1924 Packard Phaeton. The newly opened Tamiami Trail enabled them to cross the Everglades with relative ease and emerge in Naples where friends from Columbus, Ohio, urged them to stay over for some shelling and fishing. The memory lingered in Ida's mind and 17 years later in 1947, after weathering widowhood, the Great Depression, and World War II, she returned to Naples and rented a cottage on the beach at 38 Broad Avenue South; that cottage is still standing. She began to savor the magic of Naples. In March of that year, the residence of Harry Guest at 53 Broad Avenue South was offered for sale complete with china, silverware, crystal and linens, and all of its furnishings for $25,000. Ida called her trustees in Columbus to send the needed funds and thus began a happy sojourn that would endure between house and family for 57 years. Ida loved to paint, collect shells, fish, and marvel at the beautiful Naples sunsets from her dining room picture window. Her grandson Lodge continued her hospitality from 1970 to 2004, sharing the magic found in the cottage with family and friends.

Mr. Guest built his winter home in 1935 with its wide front porch and entry facing Broad Avenue. The living room, dining room, kitchen, and two of the three bedrooms offered a tranquil unobstructed view of the Gulf across the neighboring beachfront property at the northeast corner of the original property, which Ida acquired in 1948 from Larry and Alexander Brown. The Browns at that point moved to Palm Cottage. The dwelling on the beach lot was the former caddy shack from Naples' first golf course; it had been moved to the beachfront lot as a little beach house. The Browns had eloped and spent their honeymoon and the war years in the former caddy shack.

"53," as the cottage was referred to by the McKee family, features architectural gems including clear cypress paneling, red oak floors, and highly detailed hand craftsmanship. Like most of its neighbors, the cottage was constructed of heart pine and cypress on a concrete slab footer of beach sand and shell. More Cape Cod than Cracker, the cottage was a full two stories with lap siding and a metal shingle roof that resembled barrel tile; those shingles lasted for 60 years! The cherished home was furnished with antiques acquired with the original purchase, American antiques, and art collected by the McKees.

After 67 years the McKee family sold "53" to Tom and Mary Parent in 2004. The home is now in the hands of a family that loves both the home and setting in Naples, and the Parents continue to take very good care of this wonderful home.

facing *Original dining room picture window with Gulf view.*

Haldeman House

The Haldeman House was built in 1886 by General John S. Williams. Walter Newman Haldeman, owner and publisher of the *Courier-Journal* newspaper in Louisville, Kentucky, purchased the home in 1890. Haldeman had significant impact on the early growth of Naples; he built the Naples Pier and several homes, including Palm Cottage. Six generations of his family spent time in the Haldeman House.

The house was originally situated on two and a half acres on the Gulf, just to the south of the pier. The center bay window section of the house was built first, with a small wing to the south. Additions were made throughout the years the Haldemans owned the house. A 25-foot-long breezeway connected the living and bedrooms to the second wing, which housed the kitchen, dining room, and staff quarters with exterior staircase. Several porches wrapped both sides of the house.

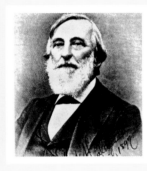

Walter N. Haldeman.
(Photograph from the collection
of Naples Historical Society.)

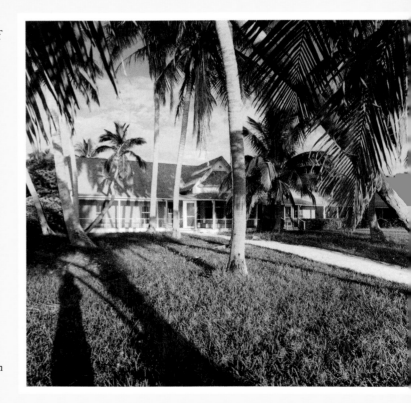

Haldeman House before it was
moved from Naples Beach.
(Photograph from the collection
of Penny Taylor.)

left Gulf view porch, prior to relocation of Haldeman House. (Photograph from the collection of Penny Taylor.)

right Haldeman House renovation in progress. Note the floor seam evident in foreground.

Christian Busk, historic preservationist and landscaper/contractor with the American Society of Landscape Architects (ASLA) rescued the home in 2006 and relocated it to Oak Creek in Bonita Springs. The Friends of the Collier County Museum had called Chris and asked him if he could salvage the home. The house was cut into four sections, moved, and carefully reconstructed. Chris redesigned the interior floor plan to enhance the kitchen, storage, baths, and bedrooms. The original dining room and gabled kitchen wing were large enough to create a second separate dwelling in Oak Creek.

Intricate craftsmanship characterizes the pecky cypress ceiling in the original bay wing of Haldeman House.

The cottages have been sited with several other homes from the same era that Chris has preserved. Chris elaborated on his preservation work: "I came to Naples in the 1970s after living in Palm Beach and surviving its rapid growth. I was hired to do a project here and realized that Naples had for me a sense of community with its compelling Florida vernacular architecture. There is tremendous creative energy in bringing these wonderful homes back to life."

The woodwork of the Haldeman House, completely hand-crafted in the late 1800s, is impressive. Pecky cypress was used to create an amazing puzzle-like ceiling in the original bay wing. The battens used to seam the boards are triangular cuts, and the interior walls are reinforced with horizontal waists accented with clover motif caps. The baseboards and moldings are all hand chamfered. Artist-craftsman Terry Schmidt, master carpenter for the painstaking renovations, said that 27 cases of caulking were used to seal the house once it was placed on site. Chris Busk explained that the original wood-shingled roof was cleverly designed to admit light on sunny days, while in rain, the wood swells to make the roof impervious to water.

The hours of handwork invested in the reconstruction of Haldeman House cannot be counted. The result is a perfect blend of past and present in a unique home that has always been inviting and breathtaking.

Honeymoon Cottage

The Honeymoon Cottage was built in 1935 by Lester LeFebre as a wedding present for his bride. This cedar shake storybook cottage maintains its original windows, back porch with balustrade, and garage. The steep gable metal roof is accented with a front right gabled second-floor peak and a north-facing small extension. This charming home is a vibrant example of Naples' cottage architecture. Unfortunately, little of its history is documented or available.

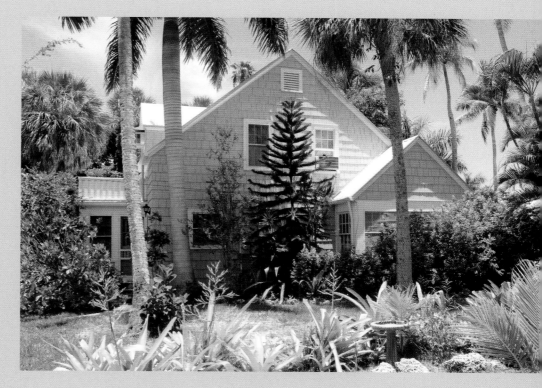

Honeymoon Cottage, accented by a colorful bromeliad garden.

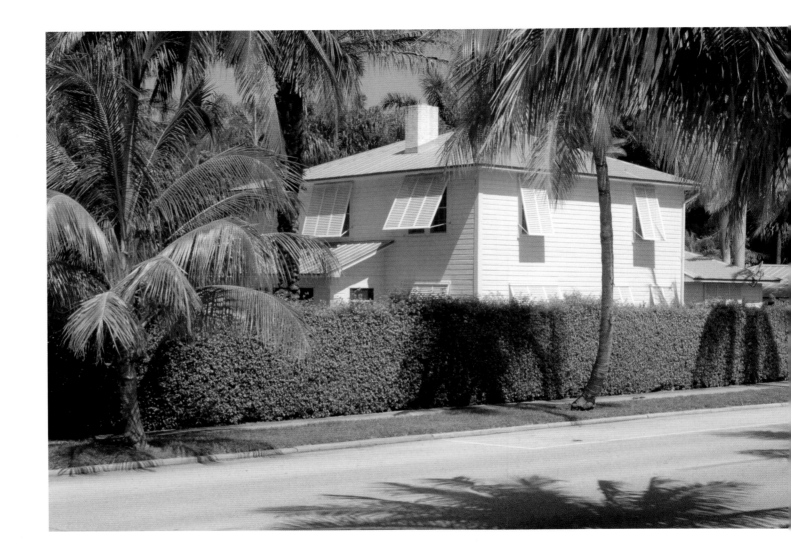

Inn by the Sea from 3rd
Street South.

Inn by the Sea

Tucked away behind a ficus hedge, this cottage was well known in its recent past as the Inn by the Sea bed-and-breakfast. With eight bedrooms and five baths, the cottage features exterior Dutch siding, lathe and plaster walls, original heart pine floors, and a metal roof. Recent owners Diane and George Gratz updated the kitchen, plumbing, electrical systems, and baths, insuring its viability for the future.

Unique to cottages in Naples, the living room of Inn by the Sea has an L-shaped wooden staircase that wraps two of the living room walls. The stucco fireplace is anchored by pecky cypress bookcases. Even empty of furniture and treasured possessions, the room is full of character and charm.

The Bowling family owned the home in the 1930s when it was built. The second floor was not finished at time of construction, possibly as a cost-saving effort. The presence of one of the earliest types of drywall on the second floor indicates its later completion date.

Just prior to the publication of this book, Inn by the Sea was sold and is undergoing significant renovations, including the removal of the pictured original staircase. A new chapter is in the making for this lucky cottage!

The Inn by the Sea living room features an original L-shaped staircase seen in just a few of Naples' historic cottages.

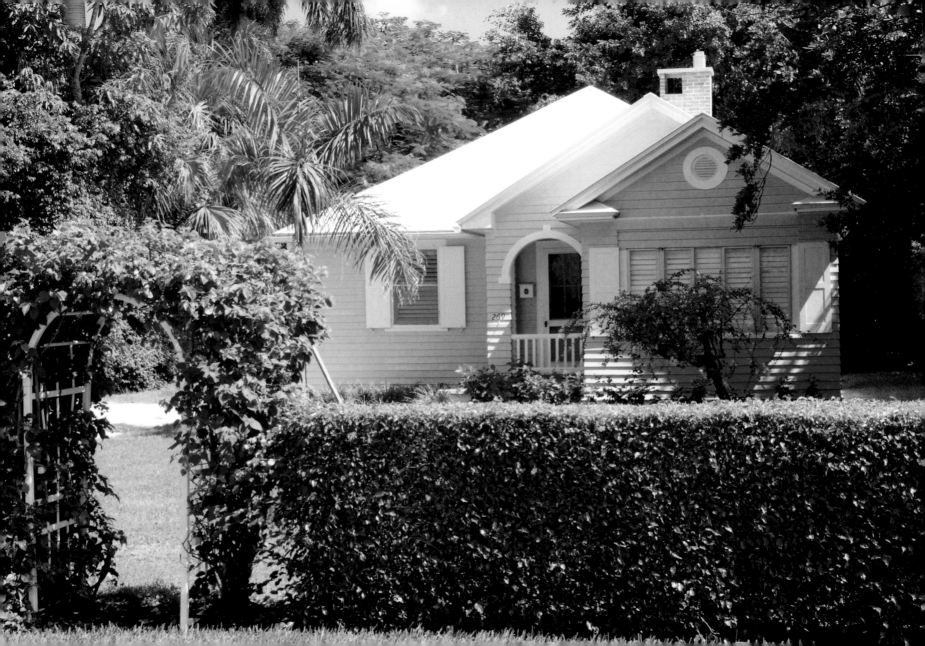

Jasmine Cottage

Jasmine Cottage is a delightful circa 1925 cottage with lap siding, metal hip roof, and a one-of-a-kind arched entrance. The interiors feature the original wood floors and beadboard and decorative wood ceilings throughout. Two front gable extensions add dimension to the facade, and the original windows are still in place. The guest cottage is known as Clementine Cottage and faces the alley between 10th Avenue South and 11th Avenue South.

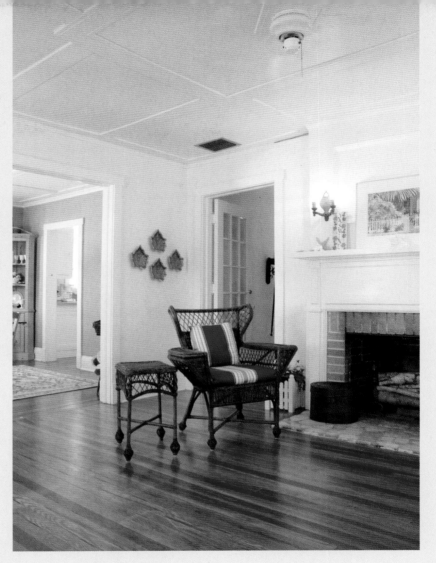

facing *Jasmine Cottage.*

Living room at Jasmine Cottage, with original ceilings.

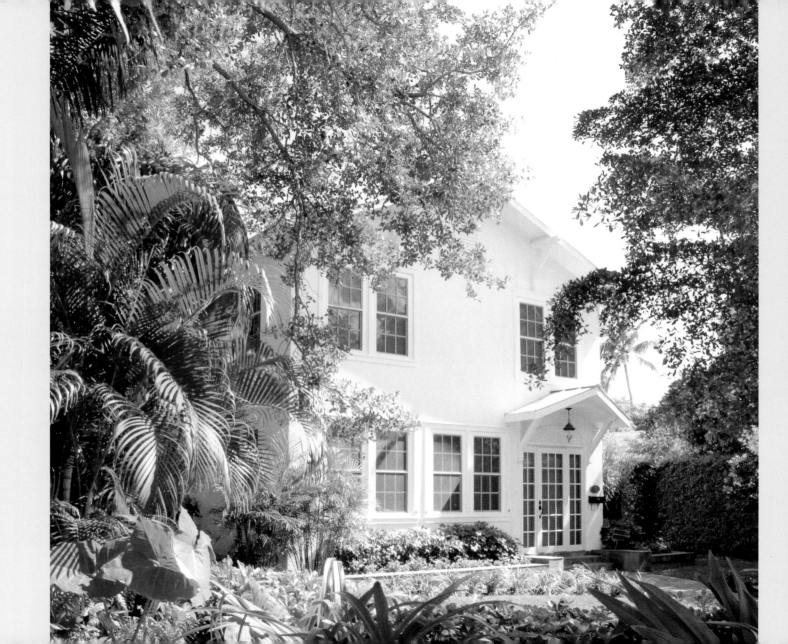

Leila Canant's Cottage

Renovations have changed the details of this light-filled airy cottage, but it retains the characteristics of a true Naples beach cottage: deep roof overhangs with exaggerated brackets, shallow gable roofline, pine flooring, and double-hung divided windows. At some point, the front door was shifted from the center to the left side of the facade. A beautifully tiled pool and spa enhance the lanai, with doors opening onto it from almost every room to catch the Gulf breezes.

In the spring of 2008, owners David and Jean Pittaway lived through the inconvenience of replacing the doors and windows with hurricane-proof ones, further insuring that this venerable cottage will stand the test of time.

One of the oldest cottages in Naples, this 1927 cottage is on the National Register of Historic Places. The original owner was Mr. E. W. "Ed" Crayton, one of Naples' early developers. Crayton and a group of investors from Ohio purchased the Naples Town Improvement Company from Walter Haldeman, the businessman who recognized the vacation market potential of the area and built the Naples Hotel in 1890.

The next owner was one of Naples' best-loved historic figures. Leila Bryant Canant came to Naples in 1928, the same year the Tamiami Trail opened, to teach school. In 1928, Naples had one K–12 school and one school bus. She taught in the Naples school system for 77 years and celebrated her 100th birthday in October 2005. A matriarch of Collier County public education, she died in 2006.

The Canants rented the cottage from Mr. Crayton until he suggested they buy it. In a 2005 interview with Virginia and Randy Wilson published in the "At Home in Naples" newsletter, Leila Canant explained: "We made very little money in those days and we couldn't afford to purchase the house. But Mr. Crayton said he would use the rental payments as our down payment so we could buy the property—so that's what we did." Just as Leila Canant nurtured the minds of many children who grew up in Collier County, she also carefully tended her home. Her legacy of giving lives on in this charming cottage.

facing *Leila Canant's Cottage.*

The Lighthouse Cottage
compound has three dwellings:
the oldest cottage with its
lighthouse tower (c. 1948)
on the west side of the main
house; a guesthouse located at
the rear of the property behind
the pool; and the main house,
visible on the right side of this
photograph.

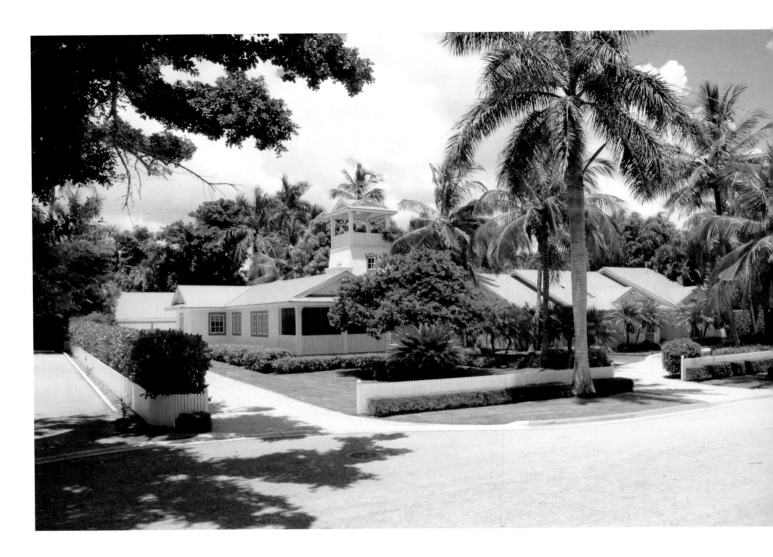

Lighthouse Cottages

In 1993, Jane Parker purchased the large, circa 1950 cottage with small guesthouse at 67 8th Avenue. Captivated by the location, in 1998 she purchased another smaller cottage (circa 1948) just west at 47 8th Avenue and added to it a unique lighthouse-style tower. A lap pool was built in 1997 and the garage in 2001. The oldest cottage is the one closest to the beach, which dates from 1948; the larger house was built in 1950.

Jane added metal diamond-pattern roof tiles and fish-scale shingles to the gables, as both materials are authentic to the construction era. Interiors still feature original pine floors. Jane also renovated the guesthouse tucked at the back of the yard.

The landscape design is punctuated with a boardwalk-style walkway between the structures. The cottages create a story-book atmosphere with decorative paintings of shore birds, beach gear, and other nautical motifs on the exterior walls. Even an alligator is painted on the garage porch.

Jane Parker extols the spirit of Naples life in her comments: "Naples is a wonderful community. It would be hard not to be happy here. These cottages have always been charming."

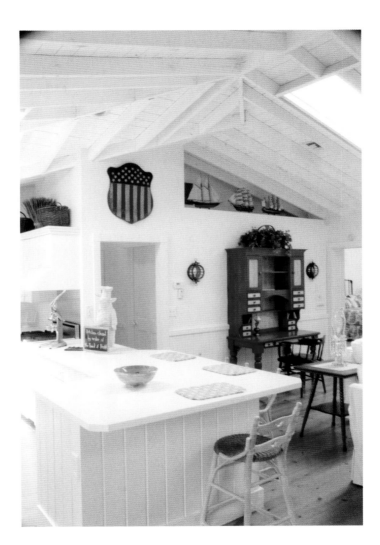

The light-filled kitchen of Lighthouse Cottage (c. 1950) combines whimsy with function, a design mantra for beach houses!

left *Guesthouse interior at Lighthouse Cottage.*

right *A surprising mix of Florida motifs make the cottage garage unique.*

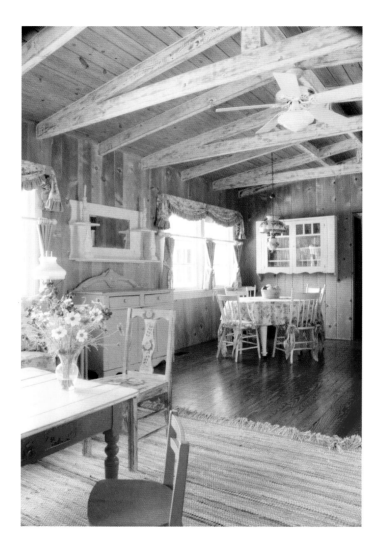

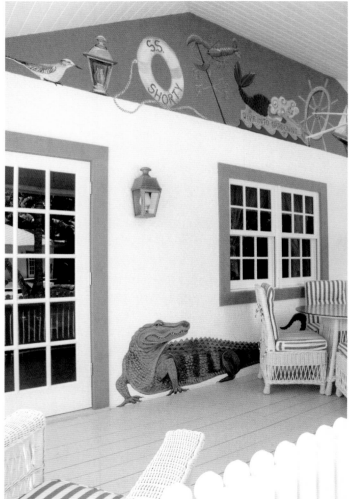

Mandalay

Mandalay was built in 1908. Mrs. William Scott Moxley Armstrong, an early owner of Coquina Cottage just to the south, later acquired Mandalay although records are not clear as to the date. She left the home to her son G. Barret Moxley. The Moxleys owned the home until the late 1940s.

In 2004, this beachfront home was purchased by John and Joan Vatterott. They have created an inviting home that speaks a language of comfortable simplicity.

Upon purchasing Mandalay, the Vatterotts committed to a major renovation, which included a new metal roof, new exterior siding, and new electrical and plumbing systems. The pecky cypress paneling on the ground floor was removed, numbered, and later returned to its original place. The adjoining 1950s guesthouse was also updated.

"This is a working, wonderful home," observed Joan Vatterott. "We protected the great bones of the house and brought it into this century. It continues to welcome family and friends, as it has for over a century."

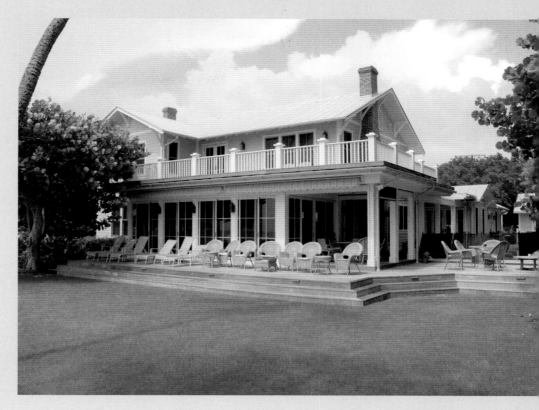

Mandalay, Gulf side.

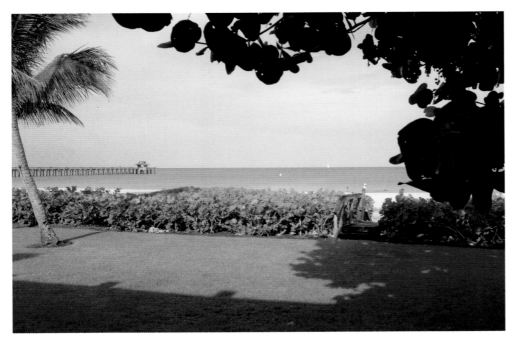

View of Naples Pier from
Mandalay.

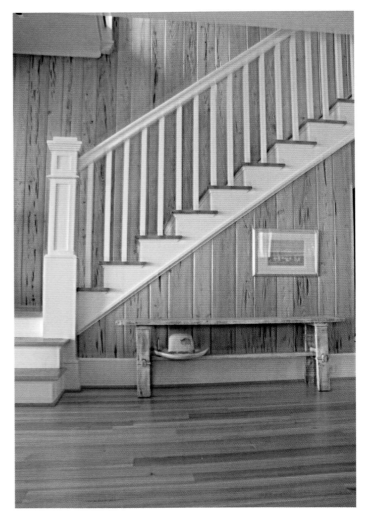

Stairway at Mandalay. The pecky
cypress paneling was removed board
by board, numbered, and put back
in place during the remodeling
phase to allow the installation of
new electrical systems.

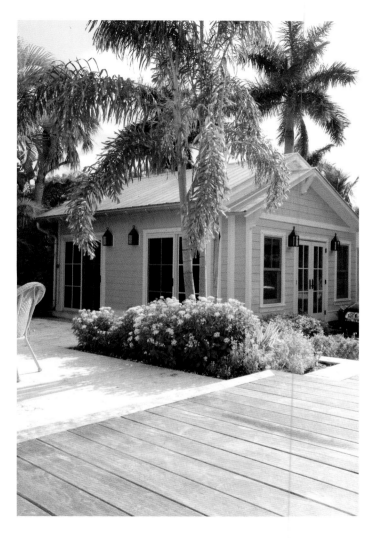

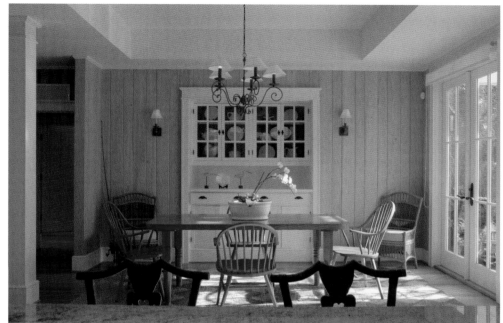

Dining room at Mandalay.

The c. 1950s guesthouse at
Mandalay was given a fresh face
during the Vatterotts' renovation
of the main house.

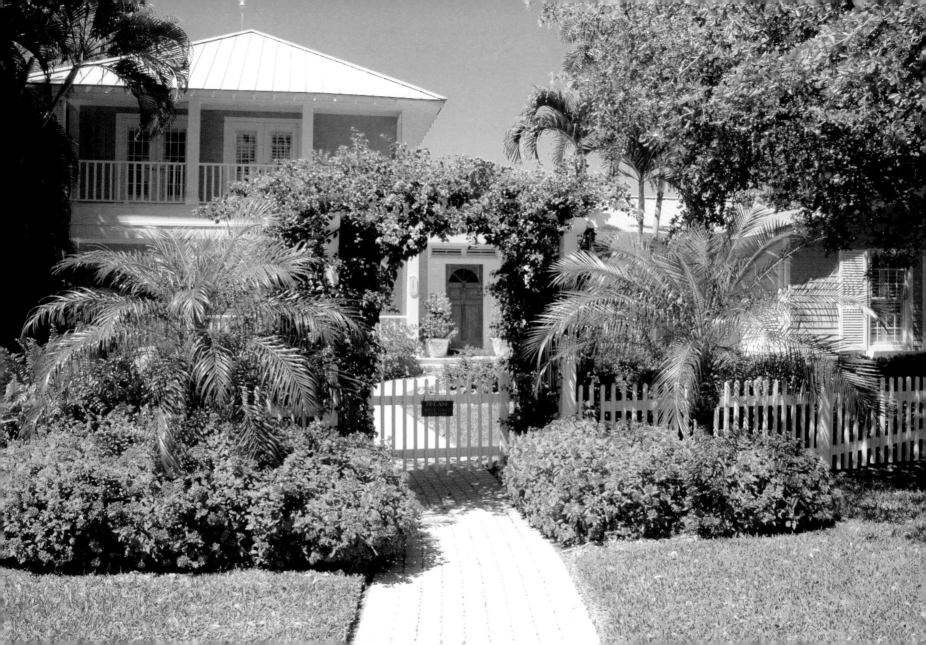

Monkey Blue Cottage

This cottage has a unique tie to Naples' history. When the Tamiami Trail, U.S. 41, was constructed between 1915 and 1928, wooden two-story railcars were used for dormitories and cafeterias for the construction crews. When the project was completed, a number of the railroad cars were used as the construction cores for residences.

Monkey Blue Cottage originated with one such railcar, and the family room of this home still shows the railcar framework.

When the current owners first saw the house, the foundation was literally sinking into the earth. They undertook a total restoration, including salvaging the railcar framework. The original cottage was constructed of Dade County pine on a raised foundation. Larry and Bob Ploski, owners of Gulf Coast Remodeling, lovingly handled the arduous seven-month restoration. The wood floors are recycled from an old tobacco barn discovered in North Carolina.

An early guest cottage has also been updated and a guest quarters and office added over the garage. In 2005, when Hurricane Wilma decimated the plantings, a pool was added at the time of the post-hurricane garden redesign.

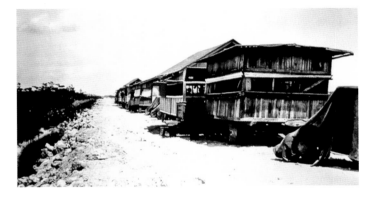

Railcars provided housing for work crews building the Tamiami Trail between 1915 and 1928. These railcars were later used as the shells for houses. The original struture of Monkey Blue Cottage was one of these railcars. (Image courtesy of Naples Historic Society.)

The owners are passionate about living in Old Naples and preserving the authentic beach cottage architecture. "Part of the appeal of Naples is the cottages. . . . I had studied this cottage and thought it was sweet and charming. When I got out of the car to look at the house, I knew this was the home for me," recalled one of the owners. "There are so few communities left intact that offer amazing water and sun. We love it here; within five minutes of walking in the door, I feel like I've been on vacation for a month. It's easy here, relaxed and happy."

facing Monkey Blue Cottage.

The Monkey Blue Cottage family room incorporates the original railcar cottage.

facing Relaxed outdoor dining at Monkey Blue Cottage.

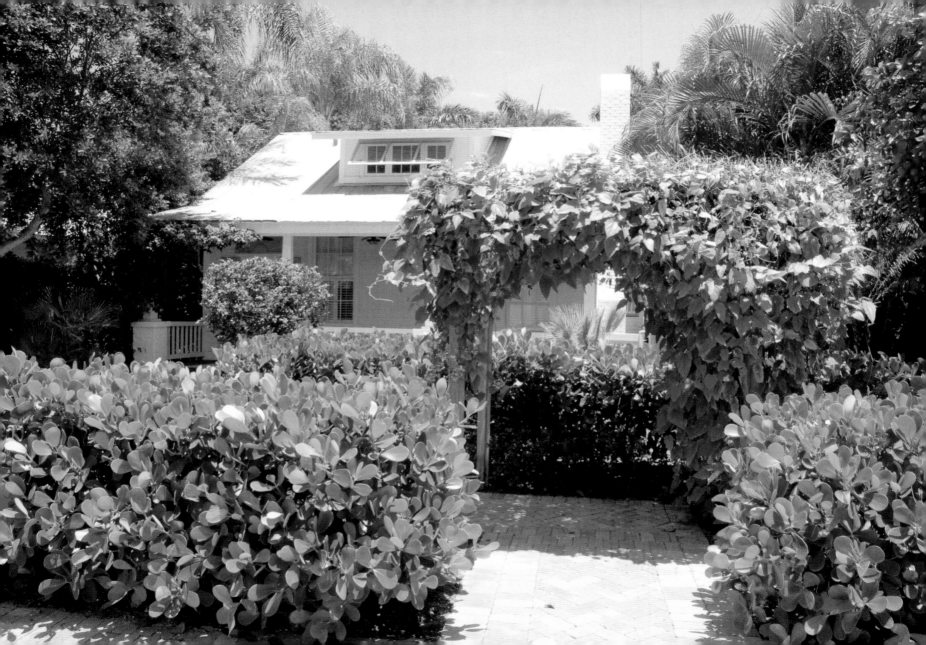

Morning Glory Cottage

In Naples, 11th Avenue South is known as the cottage street. A picturesque and surprisingly spacious cottage at 281 11th is another prime example of beach cottage architecture from the last century.

It has been renovated by several of the recent owners, each capturing the charm of a historic Naples cottage but with a tropical flair. Joyce Fain, the current owner, is enamored of the entry arbor, which is covered with morning glories that start each day in full bloom.

In the early 1980s the home was owned by Sam and Julie Hazard. Sam was the first headmaster of Naples' first private college preparatory school, the Community School. The Hazards eliminated the original center hall to create a master bedroom and library on the ground floor without changing the facade.

For many years this house was simply known as the Pink House, as it had pink kitchen counters, pink bathroom fixtures, a pink exterior, and a pink swimming pool. The last renovation of the 2,250-square-foot cottage with standing seam tin roof was done by Ed Catarsi. In the December 2006 issue of the local N Magazine, Ed dated the cottage to 1927. He was able to keep the original pine hardwood flooring, the solid core five-panel doors, and many of the original sash windows. The exterior was updated with HardiPlank clapboard siding.

John and Joyce Fain purchased the cottage during the 2008 winter season. The cottage has an inviting guesthouse and pool area. Original crown moldings, ceilings, a claw-foot tub, pedestal sink, and the original wood-burning fireplace remain intact. The original beadboard interior walls have been updated with new beadboard wainscoting in sync with the casual beach cottage ambience.

facing *Morning Glory Cottage.*

New Orleans Girl, 3rd Street
South view.

New Orleans Girl Cottage is
a classic example of a Naples
fishing cottage floor plan.

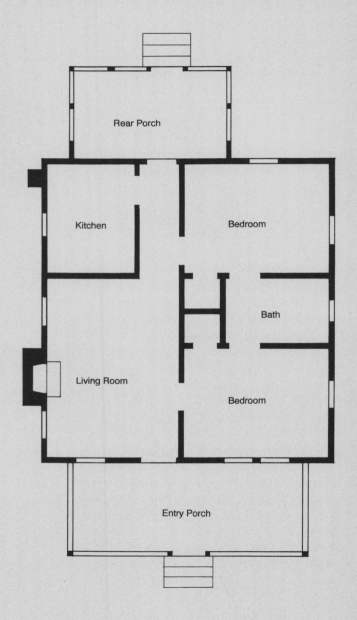

Rear Porch

Kitchen

Bedroom

Bath

Living Room

Bedroom

Entry Porch

New Orleans Girl

This authentic fisherman's cottage has been in the same family for almost 70 years. McCoy "Coy" and Maude Bowling purchased the house about 1940. Coy came to Naples from Kentucky in the 1920s to spend time with his brothers, Lodge and Robert Bowling, who started Bowling's General Store. The store building is still in use in Naples as Campiello's restaurant.

The current owners are Jack and Elinor Jo Williams; Elinor is the daughter of Coy and Maude Bowling. Elinor said her father told her the cottage had been built on the opposite side of Naples Bay and floated across and placed at the present site. The porches were added once the cottage was in place.

The cottage, according to Elinor's recollections, was built by a plumbing contractor from Ft. Myers, a Mr. Walker, as a dorm for his employees. The family refers to the house as "Coy's Cottage." Coy Bowling is a descendant of the McCoys known for the famous Hatfield and McCoy feud in Kentucky in the late 1880s.

Elizabeth Crawford, a New Orleans girl herself, has rented the cottage since 2003. She has lovingly restored the original floors and fireplace, stripped the moldings and hand rubbed

a whitewash finish on them, renovated the kitchen, and spent hours in the garden. Liz recalls that when she first went to view the cottage, she stepped onto the porch and immediately said "I'll take it," even before seeing the inside. "The scale of the house, the welcoming porch, the antique ball-and-claw tub, and the architectural details are reminiscent of the cottages in the Garden District of New Orleans," said Liz. "I felt at home right away."

Living Room of New Orleans Girl Cottage.

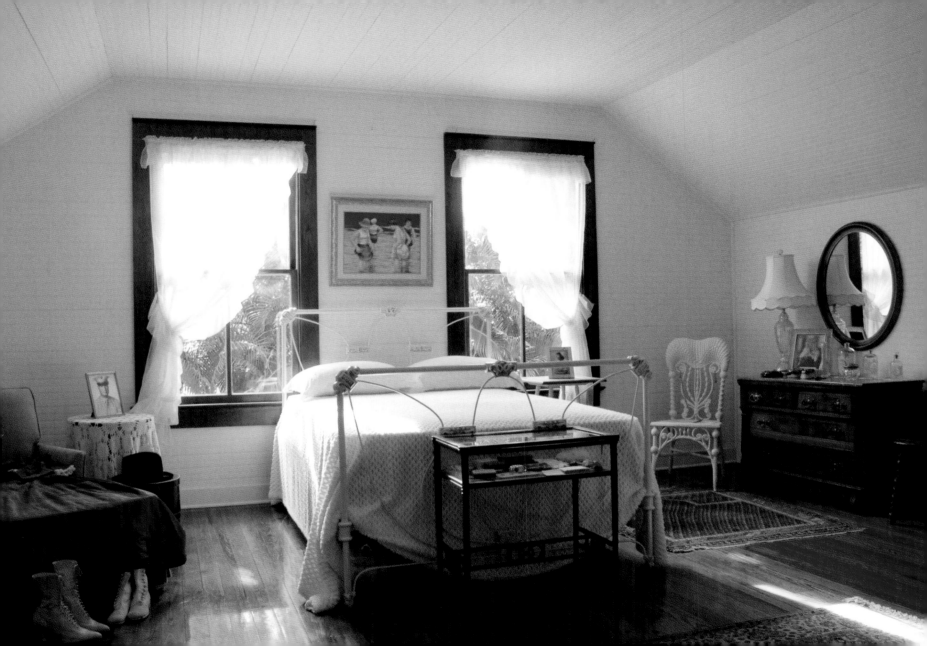

Palm Cottage

Palm Cottage, the oldest remaining house in Naples, is an open door to the past that also serves as headquarters to the Naples Historical Society, formerly the Collier County Historical Society. This cottage is the only one featured in this book that is open to the public throughout the year.

The Naples Historical Society rescued the house in 1978 when the City of Naples wanted to purchase the property for a parking lot for the pier. A generous gift of $68,000 provided by Lester and Dellora Norris, dedicated members of the Historical Society since its inception, facilitated purchase of the property for $100,000; the balance came from other sources. Merle Harris, a board member at the time, recalled the Society's need for a home.

With the immediate need to renovate the property looming and no additional monies in the fund, the Norris's philanthropic tradition was continued by their daughter, Lavern Gaynor. Not only was the complete renovation of Palm Cottage underwritten by Mrs. Gaynor at the time, but she has

facing Turn-of-the-century furnishings grace the Palm Cottage bedrooms, all on the second floor. At Christmas, each bedroom is decorated with its own Christmas tree.

Palm Cottage, 12th Avenue South.

Second-floor hall. Several of the cottages have transom windows over the interior doors to facilitate airflow from the Gulf breezes.

continued her generous and unmatched financial support ever since. In 2008, a magnanimous gift from Lavern Gaynor and her sister, Joie Collins, saved the adjoining property from development. This leading gift made possible the Norris Gardens, truly one of the most beautiful public gardens in Old Naples.

In 1982, this center-gabled cottage with shed-porch roof was listed on the National Register of Historic Places. The carefully restored cottage is filled with period furnishings.

An annual highlight in Naples is the traditional holiday event, Christmas at Palm Cottage. The cottage is artfully decorated for the season and magically comes to life.

The cottage was built in 1895 as an annex for the 16-room Naples Hotel built in 1888. Commissioned by Walter Haldeman, one of the founders of the City of Naples, Palm Cottage™ is a fine example of tabby mortar construction. Tabby is a hand-made concrete consisting of sand, shells, and water. Christened Palm Cottage by past owners, Mr. and Mrs. Walter Parmer of Louisville, Kentucky, the house has had a vibrant history with notable guests, including Gary Cooper and Hedy Lamarr.

Founded in 1962 as a 501c3 nonprofit organization, the Naples Historical Society is dedicated to preserving Naples history and heritage for the community and future generations to enjoy.

The Norris Gardens, generously funded by the Laverne Gaynor family.

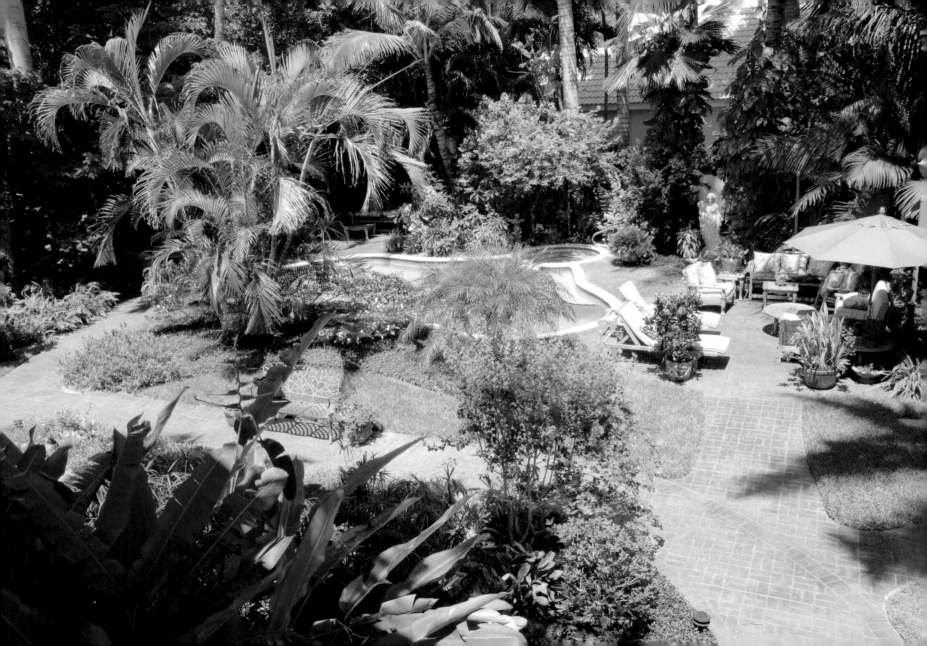

Palm Villa

Palm Villa was built in 1915; owner George Uding has the title abstract documenting the construction date. The Udings purchased the cottage in 1998 and completed extensive renovations over the next two years. They first rented the property, sight unseen, in 1995 and continued to rent it for several years. George recalls that when he retired, "my wife Rose talked me into buying this amazing place."

The cottage is well known in Naples, as it was purchased by Philip Rust and Eleanor DuPont Rust in 1935; the cottage was often referred to as the DuPont Cottage. The Rusts added a second building to the property for overflow of children, staff, and guests. This dormitory-like structure was later connected to the main cottage. The side profile of the house, facing Gulfshore Boulevard, shows where the two cottages were attached.

Part of Naples' architectural history is the alley wall that was built by the Rusts after the Lindbergh baby kidnapping to create greater security for the property. The wall has been called the Lindbergh Wall in Naples for decades.

facing *The courtyard and gardens at Palm Villa.*

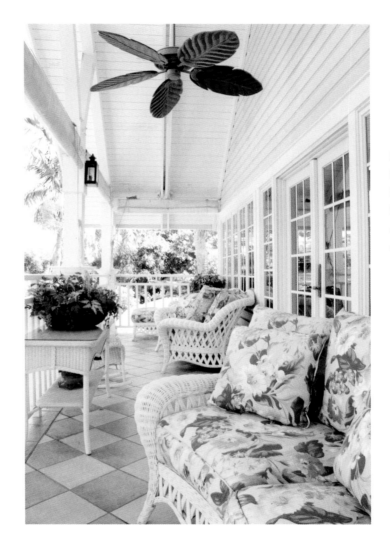

Palm Villa's picturesque second-floor porch. Owned in 1935 by Philip Rust and his wife, Eleanor DuPont Rust, this cottage was at that time known as the DuPont Cottage.

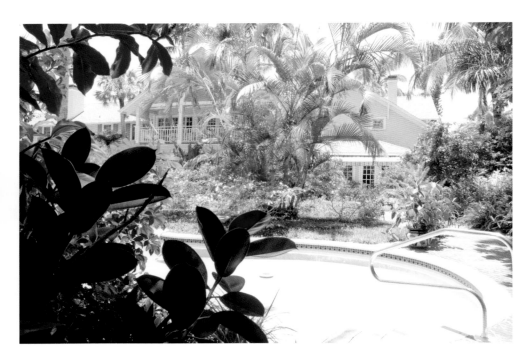

East elevation of Palm Villa,
showing the pool and lush
gardens created by owner George
Uding. Palm Villa stands at a
busy corner in Old Naples; the
thick plantings and pool make
a tropical oasis that keeps the
world at bay.

Lindbergh Wall along the alley.

Today the Broad Avenue facade is dominated by the tall-pitched gable roof which forms the second floor. A wide-gabled dormer accents the row of ground-floor windows. As with many Naples vernacular cottages, deep eaves allow for the windows to be open even when it rains. The eaves are supported by thick brackets. The side profile of the house from 2nd Street South shows where the two cottages were attached. Roof gables on the dormitory wing run perpendicular to the original front cottage.

George Uding pieced together the architectural history of the second structure through evidence he discovered during renovations. The structure seemed to be comprised of bedrooms, a sleeping porch, and a summer kitchen. At some point, the dormitory building was connected to the original cottage.

The original cottage is now used as the guest cottage. It maintains many original construction details, including Dutch lap siding, interior doors, beadboard ceilings on the enclosed porches, and Dade County pine floors. One notable element in this cottage is its lack of a subfloor. The Dade County pine used for floors in many of the early cottages is dense, durable, a natural insulator, and impervious to termites. At the time of construction, all building materials arrived in Naples by barge, which necessitated efficiency in materials selection and construction methods.

Today, Palm Villa is an ideal example of how a stately home can be created from two simple cottages. The ample scale is perfect for the frequent visitors who arrive on the doorstep

Dutch lap siding on an exterior wall that has been incorporated into an interior space.

to the home, with its gathering rooms, two kitchens, seven bedrooms, and seven baths.

The main house, created from the dormitory building, encompasses 4,500 square feet and the guest cottage, 2,000 square feet. George Uding closed the passageways between the two to create privacy for guests. He built an aviary for Rose between the garages. At one time Rose Uding had over 50 birds as residents, including love birds, pigeons, doves, ducks, a cockatoo, a parakeet, and a canary.

George was committed to maintaining the historic flavor of the house. When an original door was discovered in the main house, George commissioned reproductions for all of the interior doors. He purchased salvaged pine logs from the Suwannee River to be milled for floors.

George has also created a spectacular garden and courtyard area. Hurricane Wilma destroyed almost all of the plantings, but in a two-year period George re-created this picture perfect setting.

Palm Villa's dining room overlooks the beautiful garden, ideal for the family's frequent entertaining.

facing *West elevation, showing the later wing.*

Pappy Turner's Houseboat Cottage

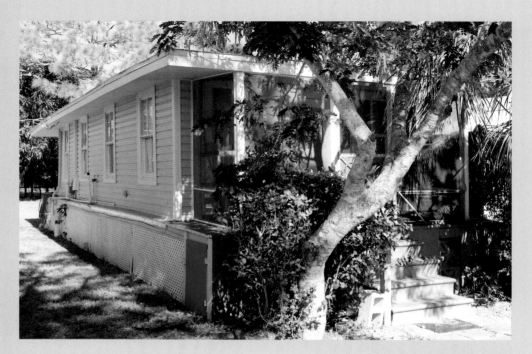

The houseboat is still in good condition and serves as a residence in the City of Naples.

"Pappy" Elisha Turner and his wife, Marion Grace, came to Naples in 1941.

They lived on a houseboat between the two Gordon River bridges, near present-day Beau Mer, and raised their nine children there. In 1944, a hurricane pushed their houseboat onto shore, and this became their landlocked home. Pappy built a cottage attached to the houseboat at 10th Street South and 9th Avenue South. Pappy Turner is part of Naples history: he was the founder of Turner Marina, started in the 1940s. The cottage was later moved to Ridge Street.

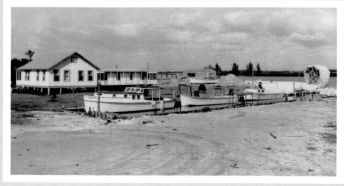

Pappy Turner's homestead on Naples Bay, c. 1950. (Image courtesy of the Nick Turner family.)

Party House

Donald Ames and Elizabeth Scott "Scotty" Ames purchased this home in 1983; they had previously lived in the cottage next door at 91 Broad Avenue. They sold that cottage to their friends, Emily and Neil Gutchess. Scotty Ames, when interviewed for this book, liked the Party House as the chapter title because of the first well-known story about the cottage.

The cottage was originally built in 1921 for the Diak family from Michigan. The Diaks had wintered in Naples and purchased this sand lot with two palm trees on it. They retained Red Carroll to build the house when they returned to Michigan for the summer. Red took pictures of the progress with his Brownie camera and sent them to the Diaks. Mrs. Diak shipped all of the furnishings to Naples from Detroit, so the house would be ready upon their arrival for the season. Red Carroll was proud of the house and wanted everyone to see his creation; he threw a party in the house without the owners' knowledge just before their arrival back in Naples. Even though the house was spotless when they arrived, Red confessed. The Diaks were so pleased with their new home, they forgave Red for his party. This story was repeated in the annual Christmas letter Mrs. Diak sent to friends.

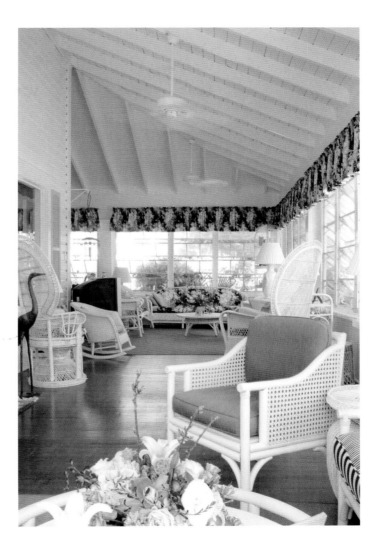

The front porch with exposed rafters.

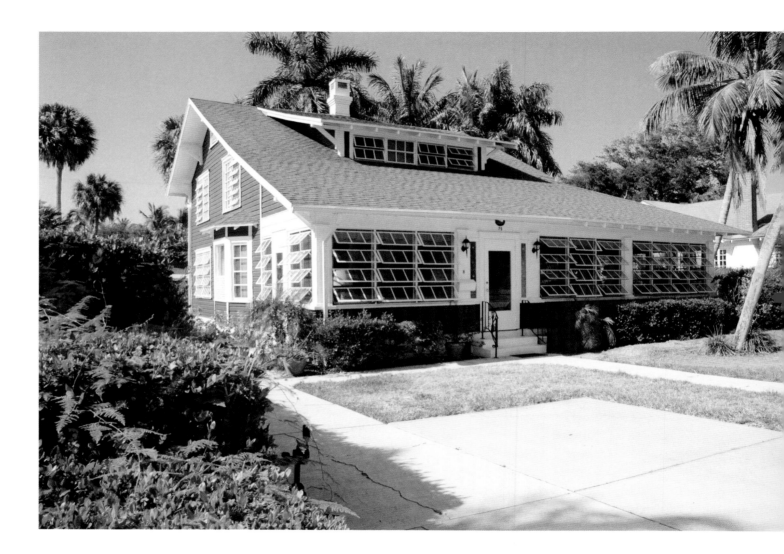

Broad Avenue view of the Party House.

Crafted in the Florida bungalow style with pecky cypress and southern heart pine, the house has decorative Dutch-style siding. Completely unexpected from the exterior view of the house, the interior of the fabulous front porch is open to the roofline with exposed rafters and beams. The porch wraps the left side of the house and is used as the dining room.

The living room entrance from the porch has woodwork not often seen in Florida vernacular cottages, including double French doors, a decorative cornice, dental molding, and pilasters.

Another distinction in the cottage floor plan is that each of the three bedrooms has its own bath. On the second floor, the master bedroom runs the entire front width of the house. The bedrooms and the living room have the original board-and-batten paneled walls, and the living room is embellished with a paneled ceiling and original fireplace.

When first built, there were louvers on the roof of the Florida room that heated water for interior use. On cloudy days, there was no hot water available for baths, washing dishes, and laundry.

A few noteworthy accents in the cottage include the vintage glass door knobs on every door and a Chinese ancestor painting on silk that Scotty Ames found in a chest in the home they owned next door at 91 Broad Avenue. Scotty Ames was a published author: in 1995 her book, *The Deaconess of the Everglades*, was published by Courtland Press. The book is an account of the life of Harriet Bedell, who lived and worked with the Seminole Indians in South Florida for more than 30 years.

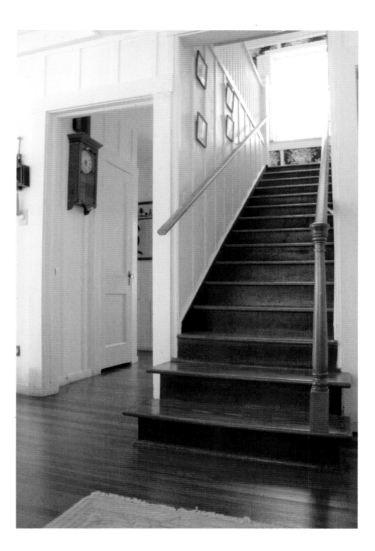

This unusual enclosed ship-style staircase starts in the Party House living room and features many woodwork details seldom seen in Naples' old cottages, including dental molding and classical pilasters.

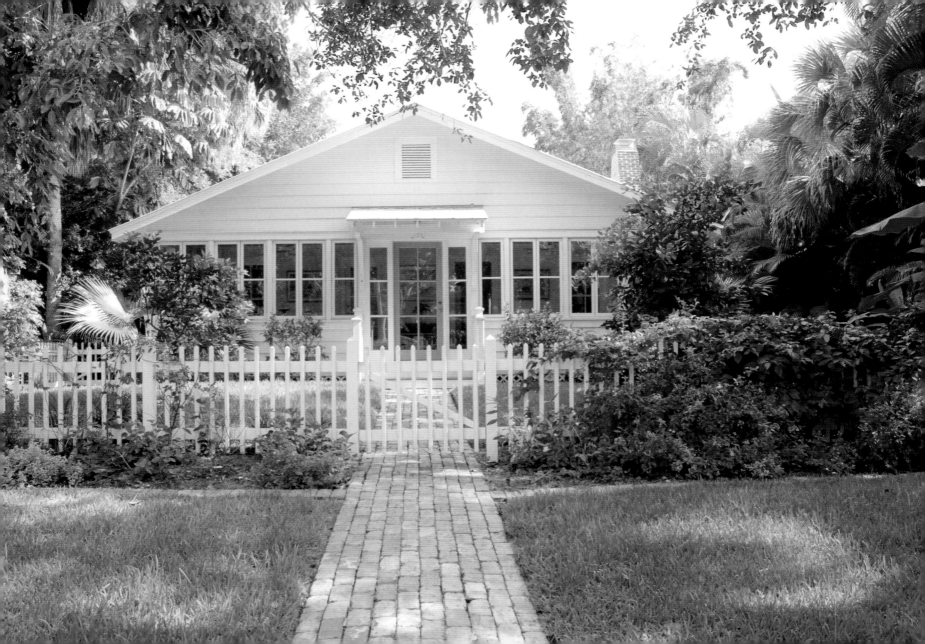

Periwinkle Cottage

Periwinkle Cottage at 123 11th Avenue South is a circa 1930 cottage. The cottage has had four owners: Julian and Lily Walden, James and Win Lukens, Chico Pipes, and Betty Van Arsdale. Betty, the current owner, fell in love with the cottage after having lunch there one day with Mrs. Pipes. When Betty sold her home in Port Royal she tried to purchase Periwinkle Cottage, but Mrs. Pipes wasn't ready to sell. Betty purchased another house on 2nd Avenue. The day she placed a deposit on that cottage, Periwinkle Cottage came up for sale, so she put a deposit on it, too. On March 31, 2000, she flipped the one house and bought Periwinkle Cottage.

Many of the homes built in Naples in the 1930s have large porches across the front. On Periwinkle Cottage, the porch faces south; Betty enclosed it in 2002, and it now serves as a sunroom. She also enhanced the facade with a decorative fence and small covered entrance.

The cottage's interior plan is unique in that there are no hallways. Two front doors open off the porch to a series of

facing Periwinkle Cottage has a delightful entrance, accented with a brick walk, trim picket fence, and butterfly garden.

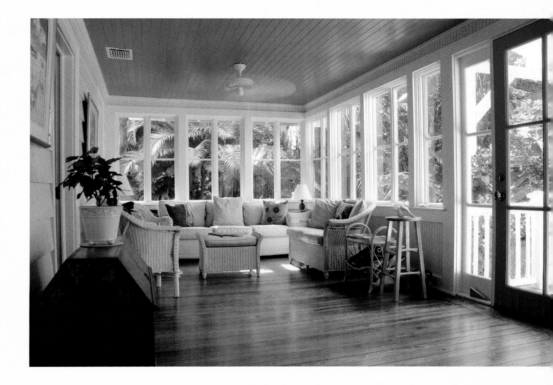

three rooms that open to each other and run down each side of the cottage. The right side front door opens to a beamed living room with a fireplace flanked by two high windows with bookcases below.

Opposite the living room is a den with large double doors that open to make a large room across the entire front width of the cottage. The view from the right front door is a straight

South-facing enclosed front porch, Periwinkle Cottage.

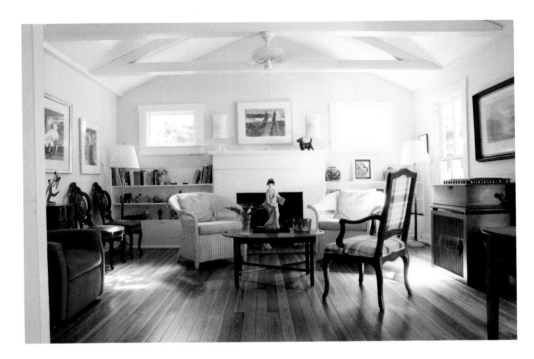

All original, the fireplace, ceiling beams, beadboard walls, and Dade County floors have been restored to perfection.

shot from front to back to a long covered porch that opens to a small patio and plunge pool. Bedrooms and a bath run down the left side of the house.

On the alley at the back of the property there was once a carport and an apartment used by Mrs. Pipe's staff. These have been replaced by a guesthouse and two-car garage. On the garage's second floor, another bedroom is reached by outside stairs. Outside stairs were often built onto Old Naples cottages to allow guests and seasonal renters privacy to come and go without passing through the principal home.

Original interior building elements include Dade County pine floors and ceilings, beadboard walls, beams, and a fireplace. Some of the pine floors are stained where standing water rusted floor nails. The Southern pine used to build these cottages is very hard and resistant to termites and carpenter ants; the durability of Southern pine, often called Dade County pine, is one reason so many of the cottages have survived the many Gulf Coast hurricanes.

In 1957, Betty and her husband, John, started the first airline in Naples to operate on a schedule. They brought planes and staff down from Provincetown-Boston Airline, their airline operation based in Provincetown, Massachusetts. In 1959, they received a lease from the City of Naples to operate Naples Airport and continued to manage it until the 1980s. John C. Van Arsdale tells the story of his airline and airport in his unpublished autobiography, *It Wasn't My Time*, recounting there the many times he flew Jack Kennedy around the Northeast when he was running for office.

A couple of days after Hurricane Donna struck Naples in 1960, Betty flew down from Boston to check on the damage at the airport. Many planes had been blown about and were piled on top of each other. Betty recalled, "I could ride my bike in the neighborhoods even with the downed trees. Streets and yards looked like sand dunes. Amazingly, once the sand was cleared away, the grass looked better than ever."

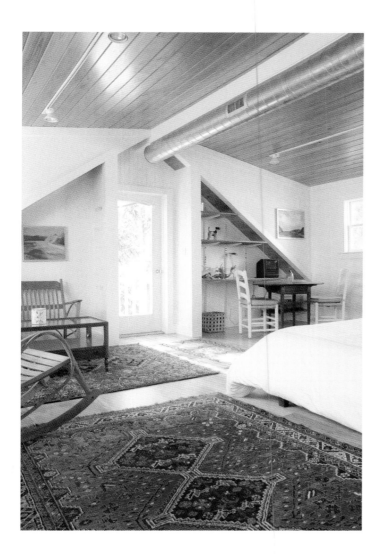

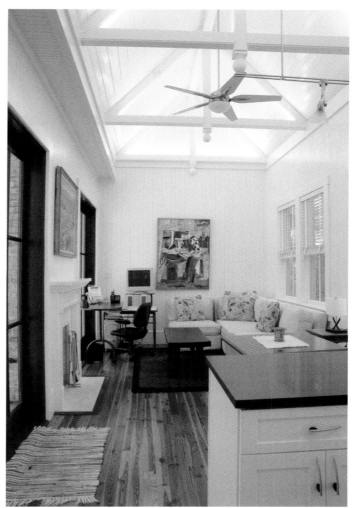

left *Added over the garage, this cleverly designed guest space is reached by stairs that run along the outside of the building. Featured frequently among Naples' older cottages, exterior stairways allowed seasonal renters to come and go at their leisure.*

right *The guesthouse's long, narrow living room exemplifies how less-than-ideal structural proportions can evolve into appealing living spaces. The kitchen counter shows in the foreground.*

Pier Pleasure

Front entry of Pier Pleasure, with its enveloping tropical landscape and koi pond.

This circa 1914 cottage is named for its presence on the pier block in Naples. The accompanying guesthouse is nicknamed Pier Pressure, as it seems anyone with a guesthouse at the beach has lots of company!

Owners Bruce and Lois Selfon rented the cottage first. Bruce is an avid fisherman and found the proximity to the Gulf irresistible. The cottage cast its spell, and the couple purchased the property in 1994, undertaking a major salvage of the main house.

This raised clapboard cottage with metal roof still features the original fireplace. The renovation of Pier Pleasure called for the complete gutting of the structure and the removal of asbestos siding to restore the home's historic character.

Lois Selfon has lots of engaging information about Pier Pleasure's history: "The cottage was originally built for the railroad conductor who oversaw the transfer of luggage for tourists arriving at the pier, where the baggage traveled by rail up 12th Avenue to the Old Naples Hotel. The house was on the waterfront until 1960, when Hurricane Donna deposited enough sand to extend the beach, allowing for two more homesites between Pier Pleasure and the beach." The Selfons'

transition from renters to owners came about as Lois "judged other properties by their distance from the pier, and Bruce and I decided this cottage was where we wanted to be."

The property boasts one of the most spectacular hidden gardens in town. Under the guidance of the late Robert Read, Smithsonian Institute botanist and South Florida horticultural consultant, Lois created not simply a garden but an artistic composition. Combining lush, tropical perimeter landscaping with Mediterranean-style container plantings on the open terrace and deck areas, Lois has built a private botanical garden on a busy block.

Local writer Caryn Stevens describes the cottage itself as both "fishing pier and art gallery." Serious fishing gear and contemporary art share quarters here. A sense of fun is pervasive, visibly expressed in the sienna brown facade that contrasts the lilac and terracotta paint colors on the back of the house. The cottage interior maintains the element of surprise—in the Selfons' eclectic art collection, ceiling murals, and blending of modern fixtures and furnishings with the cottage's original features.

Hidden pathway to the guesthouse, Pier Pressure.

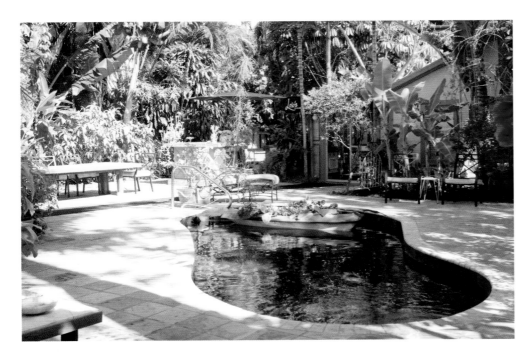

With its colorful pool and garden terrace, Pier Pleasure is true to its name.

In an effort to balance privacy and community presence, the house is surrounded by a tall fence with a gate. Lois shared her thoughts on living on such a highly trafficked block: "To live this close to the pier, one must have an attitude that the visitors are a wonderful addition to the fabric of daily life. Thousands of people go by my house. If someone is peeking through the gate, I invite them in to see the garden. I feel this gives them a whole different view of Naples, a setting where the beautiful botanicals rule!"

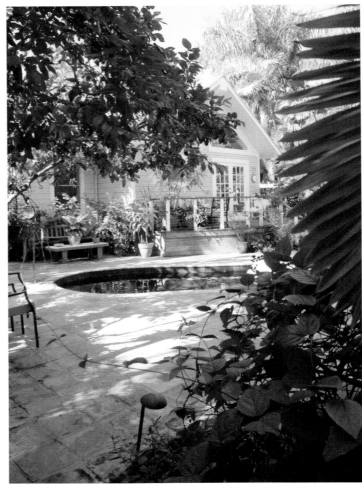

The garden terrace, where container plantings stand out from the jungle-like surroundings.

left *A living room art gallery.*

right Chili dog, docent for Pier Pleasure.

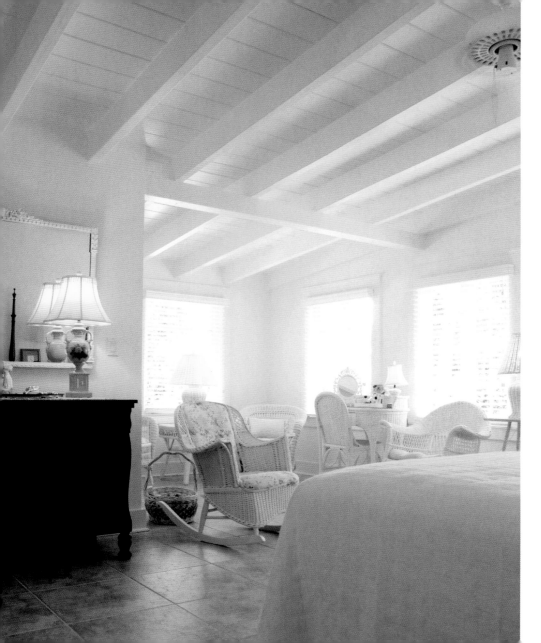

Pineapple Plantation

Don and Diana Wingard have given Naples an enduring gift with their restoration of Pineapple Plantation. This storybook cottage is unique in its architectural style, painstaking restoration, and colorful history.

Three dominant gabled wings face 11th Avenue South, accented by a central chimney with terracotta and iron details and lozenges of exposed brick that show from beneath its smooth stucco surface. European in style, this is the only historic cottage in Naples that features a front chimney.

The Gulfshore Boulevard facade showcases a second-floor balcony and garden-gate entrance. The principal entry is accessed from the walled garden at the rear of the house.

During the 1950s, local painters gathered in the back garden for informal art classes and Pineapple Plantation became a center for Naples' art culture. During that period, a professor from the University of South Florida introduced the concept of paint throwing at one of the events. Soon paint throws were a weekly occurrence at Pineapple Plantation, where

Serenely beautiful ground-floor bedroom at Pineapple Plantation.

Pineapple Plantation viewed from 10th Avenue South.

Hand-applied turquoise glaze enhances the pecky cypress paneling.

guests would imbibe and throw paint on large canvases, creating alfresco works of impromptu art.

George Upton created this idyllic home around 1930, when he purchased lots 7–12 of "Naples Tier 2 Block 9" from the Naples Town Improvement Company. He built his home, a guest cottage, and a servants' cottage. An avid gardener, Upton was well known for his extensive edible garden. The moniker "Pineapple Plantation" is attributed to Mr. Upton's attempt to cultivate pineapples. He supplied exotic fruit to the Naples Hotel.

During the 1960s the land was parceled off. Thanks to the efforts of the Wingards, the property was restored to its original lot size in 2001, when the couple began a painstaking

restoration. The principal house, also christened Spanish Villa and the Pink House, has been designated a "Contributing Historic Structure" in Old Naples and is part of the Historic District. The servant quarters were salvaged; sadly the original guesthouse could not be saved.

The house was essentially rebuilt from the inside out in 2001. Constructed of stucco over southern pine framing—installed on a diagonal bias for strength—the house features arched windows, a metal tile roof, multipane casement windows, heart pine floors, and pecky cypress paneling.

Exquisite pecky cypress walls and cathedral ceiling beams add rich texture to the perfectly proportioned living room. Turquoise stain was hand-rubbed into the variously shaped pits and creases in the pecky cypress.

When the walls were dismantled during the restoration, each length of cypress paneling was numbered and later put back in its exact location. Fern green ceramic floor tiles in the living room were imported from Cuba. The original working stucco fireplace and antique iron chandelier add to the character of the room.

Handcrafted kitchen cabinetry with glass doors and custom hinges survive from Upton's original house. The kitchen door leads to an exterior beach bath and one of two outside staircases. On the second level there are four bedrooms with baths, which originally could only be reached by an outside staircase. Guests could come and go as they pleased, reaching their guest suites without having to enter the principal living quarters.

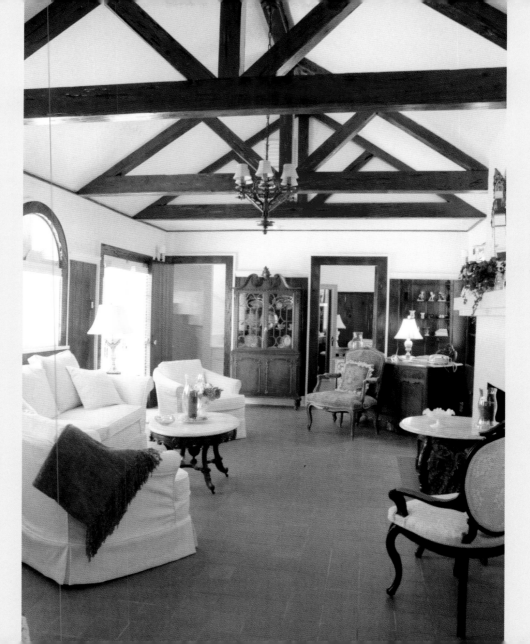

The living room at Pineapple Plantation features original vivid green floor tiles from Cuba. The paneling, beams, and walls are also original.

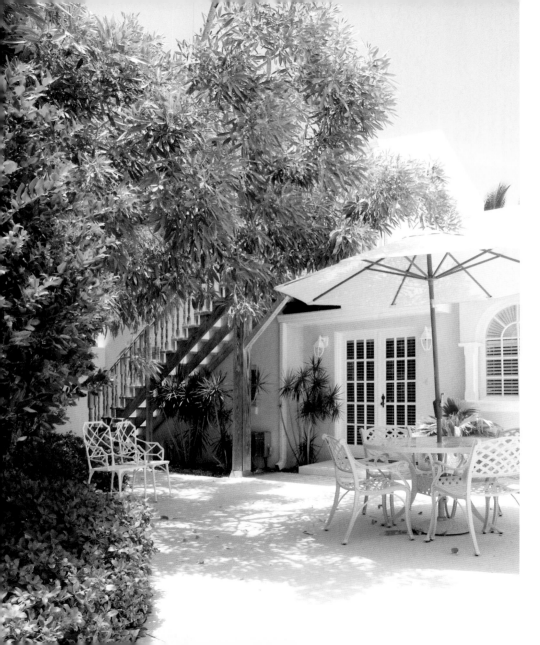

As inviting as it is historic, the guesthouse is stucco over block with the original pressed concrete floor and a beamed ceiling of Florida southern pine. Original windows and stucco fireplace enhance the intrinsic charm of this adjacency.

Renovations of this scale on homes of this age always bring up questions about where a door was placed or a wall ended. Don Wingard became an expert at deducing most of these mysteries, and still he looks at ridges in the foundation and wonders . . .

It would be a challenge to find such a well-cared-for home anywhere. The Wingards live next door to Pineapple Plantation, in close proximity to maintain it, preserve it, and share it with friends and family.

Pineapple Plantation's walled rear courtyard, showing the principal entry and the exterior staircase to the second-floor bedrooms.

Pink Pearl Cottage

Mary Jo and Peter Sharkey had to call Africa to buy this cottage in 2001: the owner, Mike Laverdiere, was on safari at the time, and they had to wait for him to reach various base camps for telecommunication opportunities to complete the deal. The bungalow was a birthday present from Peter to Mary Jo. The Sharkeys had only been to Naples once before; they saw this house only briefly before purchasing it long distance.

Immediately, they began to restore the cottage, salvaging the original Dade County pine floors, tongue-and-groove ceilings, plaster walls, and metal roof. Plumbing and electrical systems were also updated.

Next on their project list was the renewal of the guest cottage, Seaside Cottage. The guesthouse also required major renovation. Because some of the original building materials were beyond repair, the Sharkeys carefully matched new materials and techniques to old.

Time-honored construction methods had protected the cottages to make renovation even possible. Both buildings survived, without damage or flooding, the major hurricanes that hit Naples.

Welcome to the front entry of Pink Pearl Cottage, truly a fairy tale cottage!

Pretty-in-pink dining room.

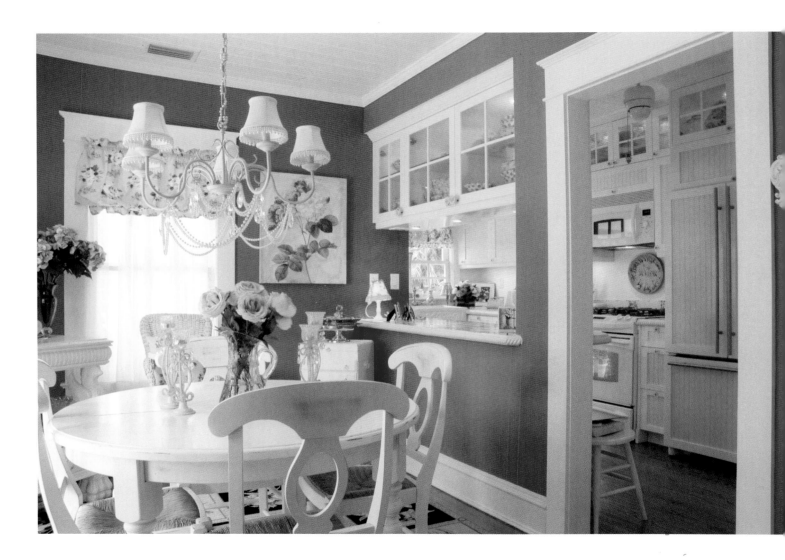

Pink pavilion, the poolside cabana.

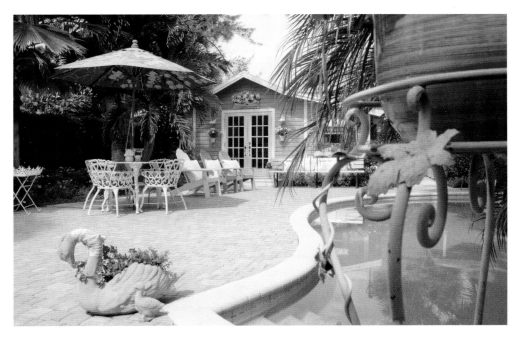

Pool-area view of Pink Pearl's guesthouse, Seaside Cottage.

A love of entertaining inspired the courtyard design, where the Sharkeys added a tented cabana to the pool area. They share their home frequently with friends and family.

Much of the interior color scheme reflects the cottage name, Pink Pearl. Mary Jo is a breast cancer survivor; when she received her "cancer free" report from her doctor, Peter gave her a strand of pink pearls as a present. Peter says the cottage is a visual reminder never to abandon hope.

Plantation House

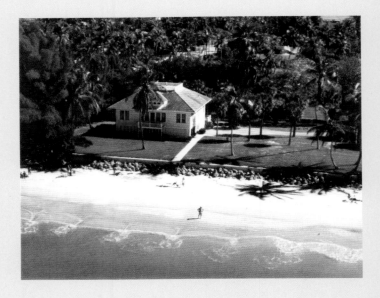

Plantation House, circa 1910, was built by Edwards G. Wilkinson; he lived in the home until his death in 1944. Wilkinson was the second mayor of Naples, from 1925 to 1927, before Naples was incorporated as a city. This stately beachfront plantation house features more elaborate construction details than many of the Naples homes built during the same era.

It is lathe and stucco inside and out, with cypress timbers, French doors, and elaborate hardware. All of the construction materials arrived at the building site by raft, floated down from Ft. Myers in the summer when the water is calmest. Originally, the house was built on stilts and crowned with a widow's walk. Over time, the under-house area was enclosed as a ground floor to house a dining room, kitchen, and staff quarters. Raft lumber was used for ceiling beams on the ground floor. Beach sand and shells were used for footers.

The exterior staircase on the east side of the house has always been its principal access. A 1930s photograph shows a balcony on the north side of the house that matched the one on the west side. The interior still features handsome pine floors and woodwork.

This classic four-square house was owned by the Buchanan-Keller families from 1947 to 1997, and although the home is also referred to as the Wilkinson House, Alan Keller said the family called the home "Plantation House." He remembers that in the winter months both fireplaces were lit every morning. Alan and his brother Scott were charged with bringing in the firewood. Gloves were mandatory because on a couple of occasions coral snakes were spotted in the wood pile.

To preserve the anonymity of the current owner, little can be added about the house as it stands today, so we must be content with memoir.

Sagamore

Suzanne and John W. Saltsman Jr. purchased Sagamore in 1993. This charming cottage on 14th Avenue South was built by N. P. Sloan, a Philadelphia cotton broker, around 1919. Sloan built the house as a fisherman's quarters with two or three bunk rooms. The original structure did not have a bathroom or kitchen. A second cottage, or bunkhouse, was added later and at some point moved to 239 Broad Avenue South. Bill and Barbara Creason purchased the home in the 1950s. According to Suzanne Saltsman, the Creasons added two bedrooms and two baths. John and Virginia "Jidge" Browning from Chicago were the next owners. In the 1970s they added the three-story guesthouse, which has been kept in its original form since that time.

Jidge Browning was known as a formidable hostess with an open-door policy at cocktail hour. When John and Suzanne bought the cottage, most of the blank space on the interior walls was covered with newspaper articles and literary pieces collected by Jidge.

When the Saltsmans purchased the house, only one original window was left. The rest had been replaced by jalousies. This lone original window, with hook and eye latch, remains

This glimpse of the garden at Sagamore shows the three-story guesthouse in profile and the koi pond.

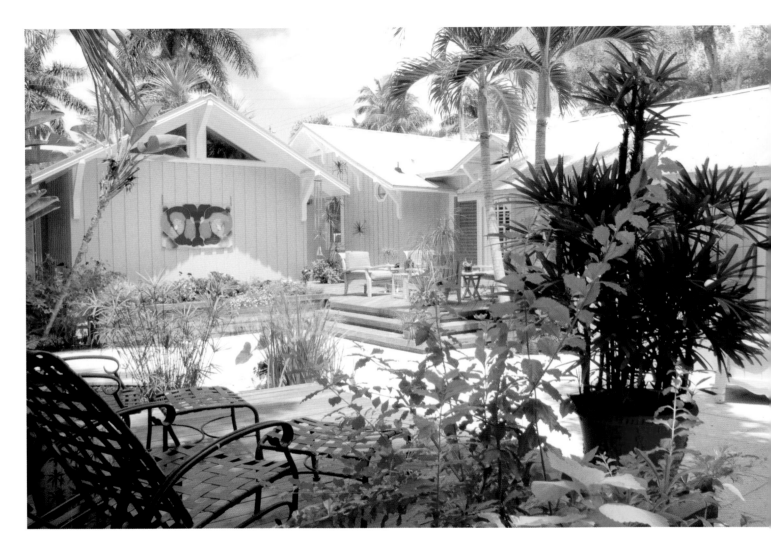

Vibrant artistic touches enliven the garden at Sagamore.

intact in one of the former bunk rooms and opens onto the enclosed porch. The Saltsmans replaced the jalousies with casement windows in keeping with the original house design.

Two memorable details of Sagamore are the watermarks on the dining room walls from flooding during Hurricane Donna and a tethering ring that was once used to tether horses on the property. Suzanne Saltsman discovered the ring—now attached to an exterior deck post—nailed to a large pine tree right outside the front door. During a phone conversation, Barbara Creason related the story behind the ring. The Creasons' daughter Ruthie owned a chestnut quarter horse named Belinda Ann that she rode about town and on the beach every weekend. She would hose the saltwater off Belinda Ann in the front yard of Sagamore and then ride it back to the stables at Goodlette Road and 7th Avenue, the current site of the Naples Athletic Club. Belinda Ann was the last horse to be in the homecoming parade for Naples High School, just prior to the City Council passing an ordinance against horses in the city limits.

With its front porch and board-and-batten exterior walls, Sagamore is constructed in the Cracker style and built of Dade County pine: floors, walls, and ceilings. In its simplest form, the Cracker house of Florida's past is a square, cabin-like structure with a steep symmetrical roof and a deep, wide front porch. More complex forms, created by adding rooms, are called by different names—double-pens, saddle-bags, dog-trots, and so on. But all are examples of Florida's vernacular architecture: wood-frame homes tailored to the

Sagamore's three-story guesthouse comes with a second-level deck.

Sagamore living room, with the
original fireplace and heart pine
walls and ceiling.

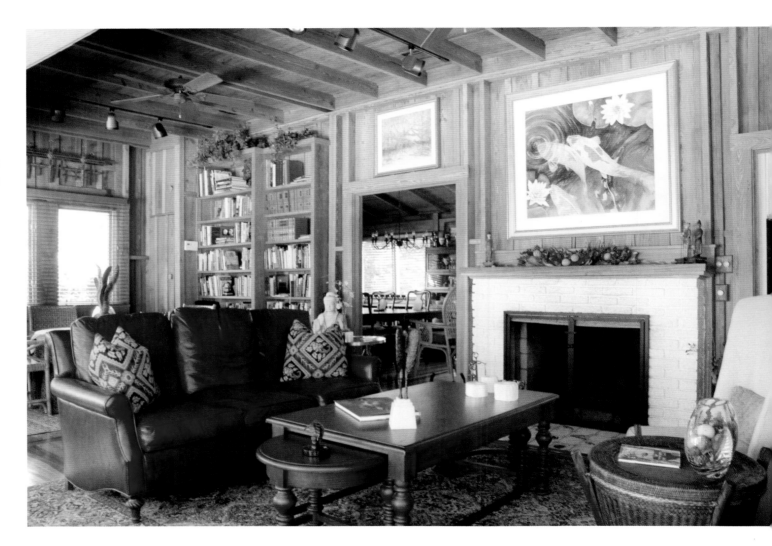

environment. They were oriented for shade, featured one or more wide porches, used windows to catch cross breezes, and were raised above the ground on blocks or stones to promote under-house airflow.

In restoring the original part of the cottage, the Saltsmans contracted with divers to bring heart pine logs up from river bottoms in Central Florida. Long ago, these logs fell from the river barges transporting them and are the only remaining sources of original Dade County pine other than boards recycled from old houses. The Saltsmans used this heart pine to replace bookshelves, window casings, and some of the interior flooring.

The gardens at Sagamore were designed by Suzanne Saltsman and organized around the large trees already on the property when she and John purchased it. Suzanne added native plantings and a koi pond. Bright, contemporary art brings color to the outdoor spaces year round.

Sagamore was the name of a silver mine owned by N. P. Sloan in the East Mojave Desert. Originally christened the New York Mine, it was organized in April of 1870. Sloan purchased and revitalized the mine in 1907 and in 1908 erected a mill with the capacity to process 50 tons of earth per day. The mill operated for only six weeks. Possibly Sloan's real treasure was this charming little getaway at one of the world's most beautiful beaches. Suzanne Saltsman would probably agree: "Every time I walk in the front door I feel embraced by the essence of this cottage near the sea. I love the neighborhood feeling that one experiences living in Old Naples."

Bird's-eye view of a hidden picnic table on the grounds at Sagamore. In the summer of 2010, Sagamore hosted a bald eagle.

Sand Dollar Cottage

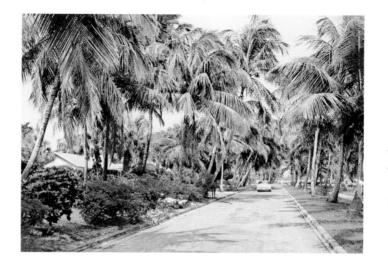

Azaleas and palms line Broad Avenue in this photo from the 1950s. (Photograph courtesy of the Wimer family.)

One of Naples' most picturesque streets is Broad Avenue.

In 2002, Linda and David Schusler purchased this sunny yellow cottage at 187 Broad Avenue South. Decades earlier, from 1928 to 1932, there was a boom on Broad Street. Lots of new houses were built then, including the Schusler cottage. The Tamiami Trail and the railroad, both opened in 1928, made this growth possible by offering easier transport of building materials and vacationers to Naples. Today, Sand Dollar Cottage is listed on the National Register of Historic Places district map as a "contributing structure"—one that adds to the overall historic character for which an area is valued.

This bungalow-style cottage features a double shed roof and classic awnings, barely visible behind the lush ficus hedge. Original clapboard, windows, heart pine floors, and plaster walls evince the attention to quality paid during the original construction. Amazingly the wood floors have never been refinished, gaining the rich patina that only comes from the passage of time.

Broad Avenue in 2009.

facing *Sand Dollar Cottage guesthouse and pool.*

left Light and air bring casual elegance to the living room at Sand Dollar Cottage.

right The original heart pine floors of the Sand Dollar Cottage front porch retain their original finish.

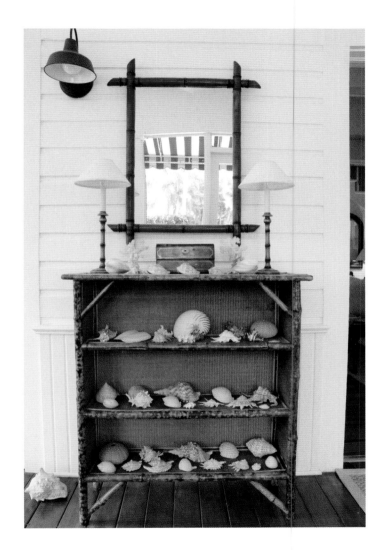

Linda, an interior designer, has crafted a bright, white, light and airy interior. Natural fabrics, bamboo furnishings, and bare floors are a visual embodiment of a casual Florida rhythm of comings and goings from the beach.

The Schuslers have enhanced the home's charm with the addition of a pool, side porch, and large gabled great room. They rebuilt the guesthouse on its original footprint, raising the floor level to protect the structure from high water.

During the remodeling process, handwritten 1936 receipts from the Naples General Store were discovered in a crawl space. The prices listed there are definitely from another era: bread 24¢, eggs 37¢, soap 6¢, cigars 8¢.

The Schusler's granddaughter Devon is a very young and very avid shell collector. Her lucky find of a tiny perfect sand dollar on Naples Beach, just off the Broad Avenue beach access, inspired the name Sand Dollar Cottage. The sand dollar is a perfect representation of all the treasures to be found in Naples' irresistible cottages.

Old grocery receipts discovered in one of the cottage's crawl spaces.

The Sand Dollar Cottage shell collection.

Sandcastle Cottage, view from
the Tile House.

Sandcastle living room with
stucco fireplace.

Sandcastle Cottage

This stately storybook cottage is part of the beachfront Tile House estate. Unique in the all-white stucco exterior that seems to glitter in full sun, its resemblance to a sandcastle is perhaps the source of its moniker.

Built in 1925, Sandcastle Cottage retains its original tile floors and interior and exterior stucco walls. A beautiful stucco fireplace anchors the living room.

Sadly, very little documented or oral history of this cottage is available to date; it is nonetheless important to have a visual record in the event it is someday torn down. We hope this charming home will always be a part of the vista and that someone will capture more of its history, facts, and lore before they are forgotten.

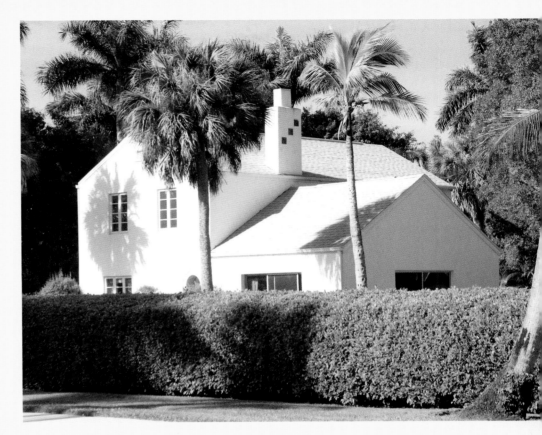

Sandcastle Cottage, on the grounds of the Tile Estate, is one of the few historic stucco cottages remaining in Naples.

Sunset View

Dorcas Watson, renowned proprietor of the Mariner Motel, was the previous owner of Sunset View. Dorcas and her husband, Edwin, started the Mariner Motel in 1966.

The Watsons purchased Sunset View from the Espenheim family in 1963. For many years the cottage was known as "Pop's Place" for an earlier owner, Pops Miller.

The cottage at 180 Broad was built of board-and-batten siding with a shed dormer roof and interiors crafted of Dade County pine. The main house has the original fireplace.

Two circa 1940 Naples Hotel staff cottages are clustered near the main house to create a charming enclave of holiday rentals known as the Coquina Cottages. Guests to the property are promised a beautiful view of the brilliant Gulf sunset. Lush vegetation re-creates a feeling of tropical Old Naples, and the property is distinguished by the largest gumbo limbo tree in town. It was planted by Mr. Watson, an avid gardener, who often brought specimen plants to the property from exotic nurseries in Miami.

facing Sunset View Cottage. *The large overhanging eaves, typical of many of Naples' historic cottages, allow windows to remain open when it rains.*

Vintage promotional material for the Mariner Hotel.

During the 1940s, the Naples Town Improvement Company acquired the Naples Hotel and guest cottages, which covered the double block between Broad Avenue South and 13th Avenue South. During the late 1940s, Dorcas Watson worked for the company. Directly across the street from the Watson cottage were three well-known Naples Hotel guest cottages: Coquina Cottage, Scotch Bonnet, and the Nautilus. All three were destroyed over time, lost to progress.

David Teeter, a year-round Naples resident, lived in the main house at Sunset View as a young child. His family, from Hagerstown, Maryland, rented it every winter from 1935 to 1938. David has interesting memories of Naples from an earlier time. His father, Herman Teeter, used to land a plane where St. Anne's Catholic Church stands today—at the corner of 3rd Street South and 10th Avenue South. He remembers going to kindergarten and first grade on Key Waden Island, between Naples and Marco Island.

Captain Sam, the teacher, picked up students from their driveways in a Ford "woody" station wagon every morning. He didn't wait for anyone, David recalled. They would take the boat *Kokomus* over the Gordon River twice a day and were required to wear life vests. The school consisted of two rooms built on stilts. The rooms, simple screened porches, each had one wall filled by a blackboard. The school structures survived until 1996. David said that the young children were served milk and cookies at a tiki hut on the beach every day. Captain Sam's wife, who helped with the students, was Caroline Shaw, but the children simply called her Shaw. David Teeter recalls Sunset View being constructed around 1930.

Gordie Watson, both the current owner of Sunset View and Mrs. Watson's son, is a Naples native. He told his wife, Pam, when they were dating that she had better love Naples as he was never going to leave.

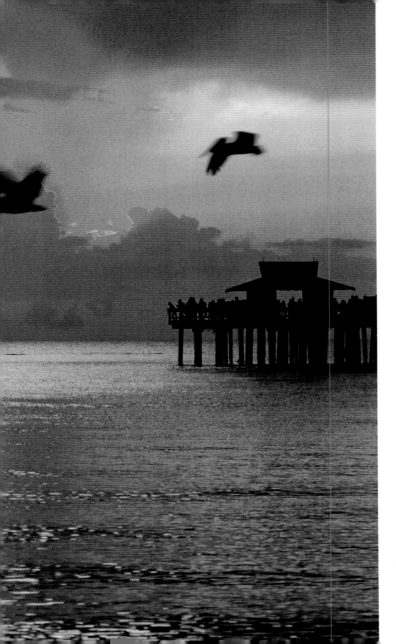

Sunset Cottage is a wonderful example of how a cherished family home can be shared with visitors, now as a bed and breakfast. In Naples, it was not unusual for even rooms in the main house to be rented out to vacationers. Sometimes this was an important economic boost for a family; in other situations it was simply a generous gesture that helped the community. For those of us who love these structures that have an allure, both in their proximity to the beach and in their quaint style, any adaptive use has merit.

Sunset over Naples Pier.

Tackle Box Cottage orchard at a
distance, with a lychee tree in the
foreground.

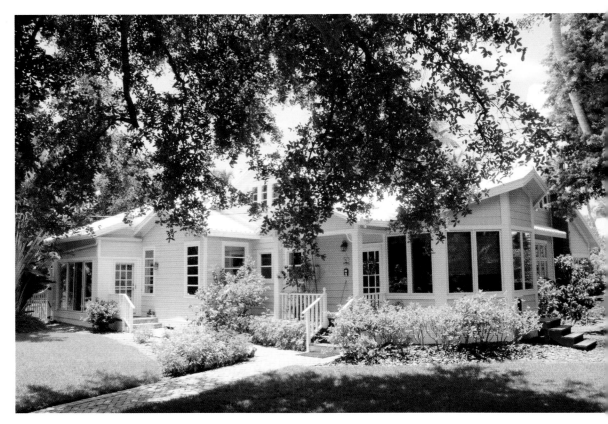

With its specimen orchard, including mangos, lemons, lychees, a
macadamia nut tree, and other tropical fruits, Tackle Box Cottage is unique
in Naples' downtown historic area.

Tackle Box Cottage

Tackle Box Cottage was built in the 1930s by David Jones, a judge from Harlan, Kentucky, as a winter home. In 1938 the cottage was purchased by Roy and Bessie Whayne of Louisville, Kentucky, parents of the current owner, Mrs. William Whaley Jr. Roy was an avid Everglades fisherman, so Bessie named the cottage Tackle Box Cottage.

Sue Whaley recalls, "I spent many idyllic hours fishing with my father. The fish were endless; the boat would be full by lunchtime of red fish, snook, and trout. At the time my parents came to Naples, it was a quaint fishing village with about 1000 residents in the season."

David Jones shipped Kentucky chestnut wood down to Naples for paneling for the living room and dining room; that paneling is still in place. The front porch of the clapboard cottage was later enclosed, and the Whaleys had custom roof tiles crafted to replace the original metal barrel roof tiles.

In the 1980s, Mr. and Mrs. William Whaley were able to acquire the adjacent property to the west and planted there a specimen orchard with mangos, lemons, lychees, a macadamia nut tree, and other tropical fruit trees. This amazing little orchard is just down the block from the Gulf in the middle of Old Naples.

Many of the palms in the yard date from the 1930s and 1940s. The Whaynes had a caretaker, William, who planted and then named some of the palms for family children. Whayne family lore has it that one of the grandchildren became deathly ill, and the palm tree started to die. The child miraculously recovered, as did the palm tree.

Tackle Box Cottage is a much-loved family home. Mrs. Whaley wants to stay here: "I hope my family can enjoy this special place for many years in the future."

Shady backyard hideaway, brightened by orange ixora hedges.

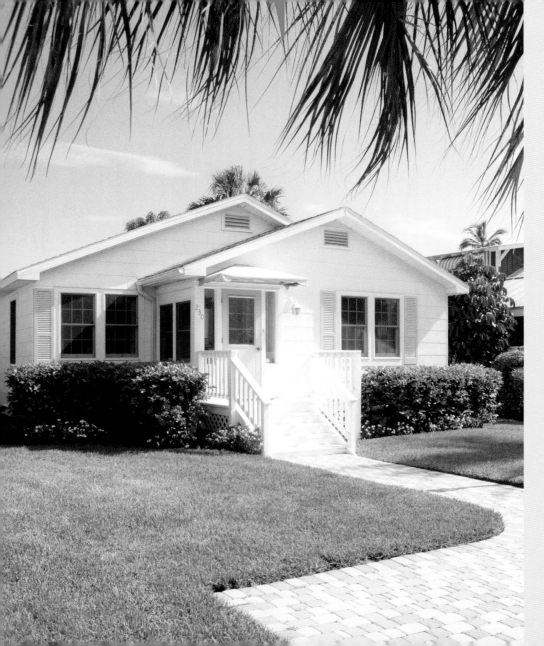

Teapot Cottage

Doreen Davis is from Birmingham, England, and serves Marks and Spencer tea in her cottage at 3:00 every afternoon—hence, the cottage's name. Doreen has dozens of teapots on display inside. She and her husband, Clarence, purchased Teapot Cottage in 1957; she was told at the time that it had been built in the early 1930s.

The facade of the cottage has remained virtually unchanged since it was built, with its double gable rooflines and large shingles. Along with shutters, Doreen added the small deck entry with steps, balustrade, new front door, and awning. The raised cottage is high enough that the floodwaters of Hurricane Donna flowed underneath the house.

Interior changes have been limited to finishing touches, and the original floor plan remains intact. The historic guesthouse is accessed from the alley.

Teapot Cottage, named for the owner's collection of tea pots!

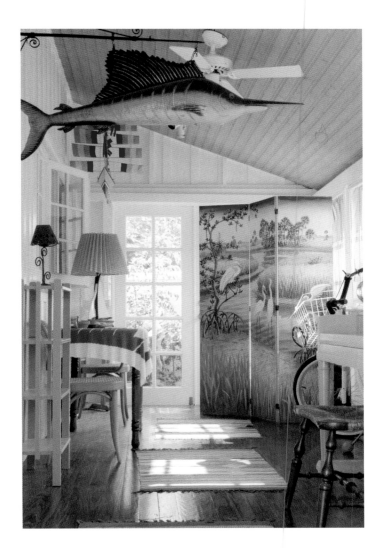

Tecopa

A chance meeting, a party invitation to a newcomer, a love of art . . . the history of this house is, in part, an engaging love story.

Eileen Burden Arsenault moved from Baton Rouge in 1982 and onto the Tecopa property as a tenant in the main house. An admirer of local artist Paul Arsenault, she was invited to a reception in his honor in May of 1982. "I didn't know anyone here, so when invited to a reception for a local artist, I was delighted. . . . I was the first guest to arrive," said Eileen. Eileen and Paul met at the event and married in May 1985. After an earlier attempt to purchase the home, the Arsenaults formed an owner consortium and acquired the home and its guesthouses in 1987.

Paul Arsenault, a resident of Naples since 1974, is one of Florida's most renowned artists. He has captured the magic of many of the signature homes and vistas of Naples. His studio is the second-floor porch of Tecopa. Paul refers to this charming hideaway as "my sweet little property."

Eileen says her home "has a wonderful energy; it is a haven,

Coral Cottage guesthouse porch at Tecopa. Paul Arsenault painted the Everglades scene on the screen.

The ground-floor front porch is perfect for lazy cats on a lazy afternoon!

facing The original board-and-batten paneling in Tecopa's living room makes a handsome background for Paul Arsenault's and other artists' paintings.

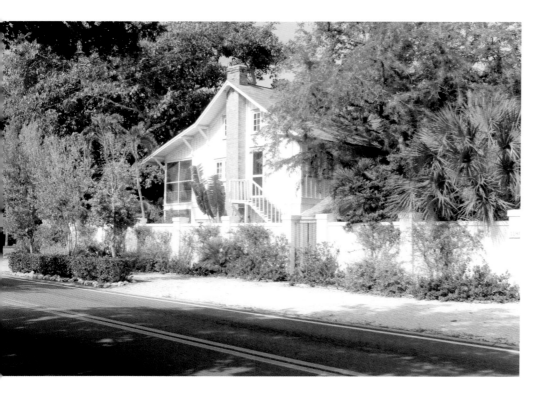

Street view of Tecopa with privacy wall, corner of 12th Avenue South and Gordon Drive.

was moved to an exterior wall to allow for additional rental opportunities. To accommodate family and guests, Mr. Sloan also liked to build small houses around the main house on a property. At Tecopa, he built two guesthouses.

The only source of heat in the main house is the fireplace. The Arsenaults updated the kitchen and baths and remodeled two of the three guest cottages on the property. A new tin roof was applied after the older one was destroyed by the winds of Hurricane Donna in 1960. The house was also flooded in that disastrous storm, with three feet of standing water in the living room.

The second owner of the house, a Mr. Trout, was the founder of *Field and Stream* magazine. Mr. Trout owned Tecopa from the 1940s to the 1980s, and Robert Frost was one of his guests there. Mr. Trout sold the house to Indiana "Indi" Earl, a well-known preservationist and socialite in Naples, confident that it would be preserved during her ownership.

The Arsenaults shared a story about early life at Tecopa told to them by John Pulling when he was a dinner guest of a former owner. Someone at the table pointed to a palm rat scurrying along the top edge of the wall. The hostess pulled out her small gun, shot the rat, and the dinner continued without further disturbance.

In the 1950s Emile Grupee, a well-known artist, and his son lived in the yellow guest cottage known as the Boat House and paid the rent with paintings. The third cottage on the property, converted from the garage, is inhabited by Anita McGilvray, one of the original consortium members.

and it always feels good to be here." The Arsenaults added a privacy wall in 2006, as the Gordon Drive area is heavily trafficked; the wall design was patterned after the wall along the alley of the adjacent former DuPont property.

N. P. Sloan, who also built Sagamore, built Tecopa in 1918. Dade County heart pine was used to construct the two-story, board-and-batten cottage. At one point the interior staircase

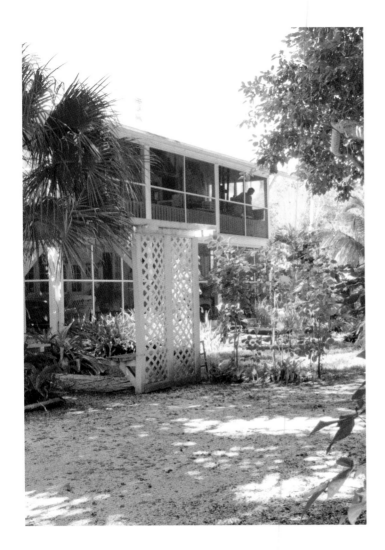

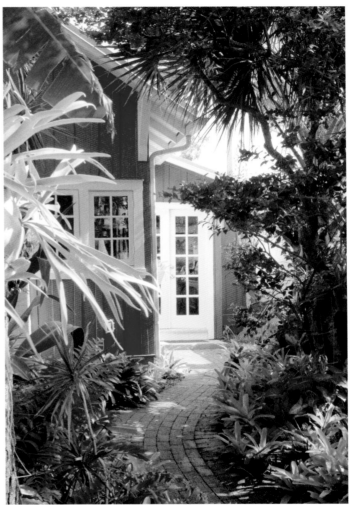

left *Artist Paul Arsenault in his studio, Tecopa's second-floor porch.*

right *Coral Cottage guesthouse glows against the myriad greens of its tropical setting.*

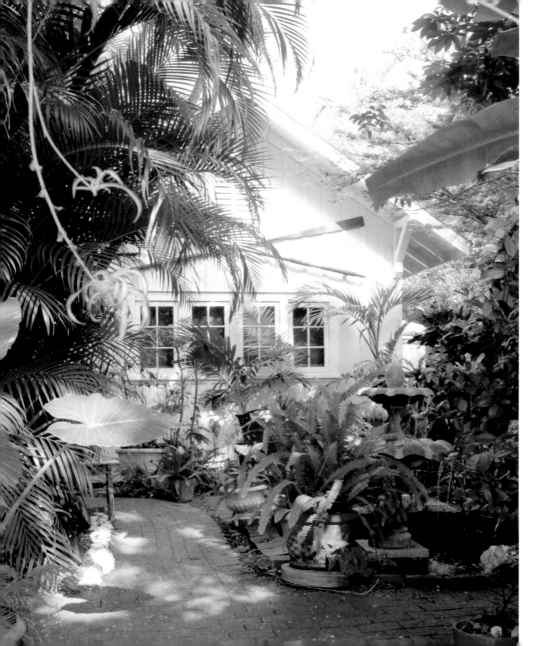

Tecopa has the distinction of the largest and oldest banyan tree in Naples. The magnificent and magical tree was planted by the Sloans sometime between 1915 and 1920.

A feature in the March 28, 1985, *Naples Daily News* describes Tecopa and how it got its name.

> The Tecopa Complex, located at the intersection of Gordon Drive and 12th Avenue South, is owned by Mr. and Mrs. Dean Earl. The complex was built by Norman Prentice Sloan, a Philadelphia cotton broker with an international business, who first came to Naples in 1916 for hunting and fishing. In 1918 Sloan constructed the main house, guesthouse, and cottage, using heart pine and other local materials. He named the complex Tecopa after the chief of the Tecopa Indians of New Mexico.
>
> The batten-board construction was originally stained brown with white trim. The actual structure has changed only slightly since it was first built except for the addition of an upstairs apartment.

The Tecopa compound, once considered the first corner in Naples because of its location across the street from the Naples Hotel, is full of energy—creative, organic, past, and present. Tecopa reflects the vibrancy and charisma of dynamic residents and guests throughout a colorful history.

The Boat House guest cottage.

Tecopa's historic banyan tree.

Anita's Cottage next to Tecopa was originally a 1920 garage. Privately owned, the cottage exterior is playful and almost hidden with orchids and lush foliage.

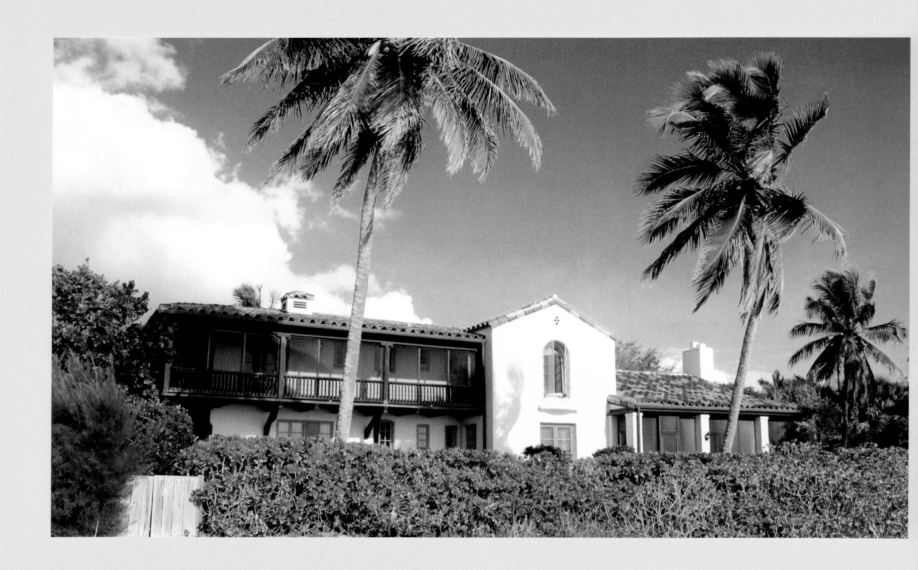

The Tile House

The Tile House is one of the finest examples of Mediterranean architecture in Naples. Built in 1927 for Mr. and Mrs. Henry Timken of Canton, Ohio, family members still retain the property.

When the home was built, it was positioned with the front entrance facing the beach and the street running adjacent to it. Coquina Cottage shares with the Tile House this same beach orientation—ideal for homes with front fenestration. The front of the Tile House is divided by a central projecting wing with a second-floor arched casement window and a first-floor rectangular one.

The right section of the house, comprised of the beach porch and living room, has a sloped roof and ends with the original chimney. The left wing features a projecting second-floor porch with cypress balustrade and thick millwork brackets. The original casement windows, painted turquoise, vary in size and shape around the house. A two-story garage at the left rear of the house once provided staff housing on the second floor.

facing *Tile House, west view, facing the Gulf.*

Passage to the guesthouse, with the kitchen wing on the right.

Tile House, southern exposure. The turquoise paint trim on the windows is original and adds colorful, tropical drama to the old world silhouette. The exterior of the house has changed little through the years.

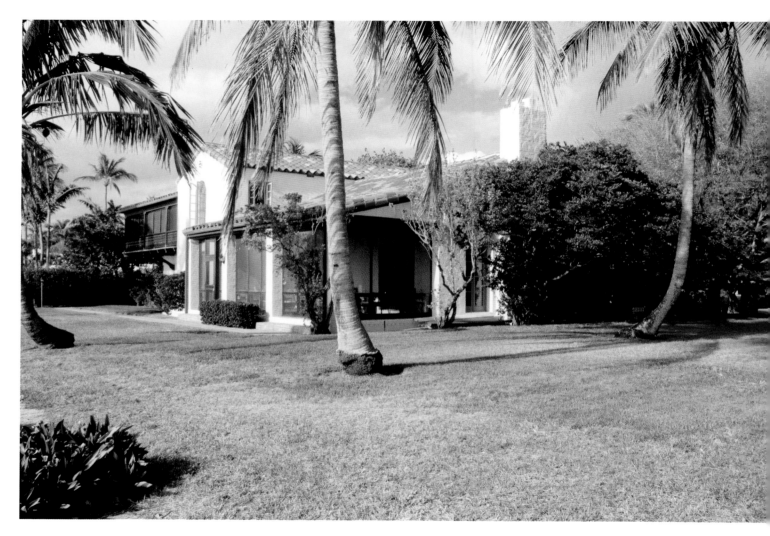

Phineas Paist, one of Florida's most renowned architects, designed the Tile House. Paist designed the Miami Federal Courthouse and was the supervising architect for Coral Gables with its Mediterranean Revival style, including the Venetian Pool. Paist was a well-known colorist and created the color scheme for Coral Gables—pastels ranging to strong sun colors. He also designed the original plan for the University of the Sun, the University of Miami. Illustrated information on Paist and Coral Gables architecture can be found at the John Singer Sargent Virtual Gallery (www.jssgallery.org/Other_Artists/Paist_Phineas/Phineas_Paist.html) and at the Coral Gables Chamber of Commerce Web site (www.coralgables chamber.org).

The home has remained unchanged since construction. The current owner has a passion about not changing the house. The original colors Paist chose for the exterior stucco have been maintained: warm cream accented by vivid turquoise. Inside, one kitchen wall was cut in half to allow for a view of the Gulf of Mexico. The only exterior change over time has been the replacement of some of the Spanish clay tiles on the roof. The house is constructed of stucco and hollow tile, which predates cinder blocks. In Mediterranean climates, exterior wall surfaces are typically textured, because bright sunlight on smooth walls is glaring and uninteresting. Traditional builders textured walls by whatever means possible, and stucco—because it can easily be manipulated or used as a matrix for other materials, such as sand, shell, or gravel—was a familiar choice. The Tile House's interior ceilings and wood trim are cypress.

The Timken family has cherished the Tile House for more than eight decades, and many early photographs and original blueprints documenting its history and architecture can be found in the home. I can only hope this absolutely magnificent house continues to have such loving caretakers in the future.

Historic photograph of the Tile House. (Courtesy of Lodge McKee.)

The Twins

344 11TH AVENUE SOUTH

Dover Cottage

St. Patrick's Day 2000 was an auspicious day for Gary and Sharen Thomas of Naples. They had ridden their bikes downtown to see the parade and happened to ride up 11th Avenue South on their way to a party. They never made it. Seeing an open house sign, they stopped at Dover Cottage, and Sharen fell in love with it on the spot. They immediately returned home to their downtown Naples residence to discuss the "what ifs" and "whys" involved in making Dover Cottage their own.

Sharen had wanted to buy "a little alley house" and soon discovered that one has to purchase a principal house in order to acquire one of Naples' guesthouses. Two days later, the Thomases purchased Dover Cottage, and their dream of preserving an Old Naples cottage became a reality. The Thomases use the home and the guesthouse for friends' and family visits.

Painted sunshine yellow with sea green accents, Dover Cottage is a center-gable structure built of heart pine board-and-

batten. The main house has 1,368 square feet of living space under the original metal roof.

Gary's research indicates that the house was constructed around 1930 by James and Lois Burgay Gaunt in Ochopee, Florida, where James Gaunt operated a commercial tomato farm. In her book on the Ochopee Post Office, the late Maria Stone, longtime Naples resident and Florida history writer, mentioned a Dr. Herb Bryan, who said the J. T. Gaunt Company had mile-long tomato rows, probably the longest in the state.

The cottage was moved to Naples along with its twin around 1940 to serve as housing for the U.S. Army Air Corps base in Naples. Lumber was rationed as part of the war effort, so houses were moved to Naples to meet the needs of a growing population.

The previous owner, Barbara Holley, completed major renovations on Dover Cottage in 1999. The front porch, which originally mirrored the porch on the adjacent twin cottage, was enclosed and divided into two rooms. Barbara incorporated the left porch space into the living room, where the ceiling is supported with two columns. The right porch area now opens onto the front bedroom, where a window was closed in on the right side of the house to allow for a closet addition. The kitchen and bath were also updated during the 1999 remodeling.

The floor plan reflects the original footprint. In Dover Cottage, the bedrooms and bath are on the right side of the house whereas in its twin, the Wittenbergs' home, the

The Twins—Dover and Wittenberg cottages—on 11th Avenue South.

left *A door that opens this Dover Cottage bedroom to the outside has produced speculation that the room was in its past life used for other purposes or rented out to seasonal visitors.*

top right *A 1999 renovation joined the Dover Cottage living room with the left front porch space.*

bottom right *Dover Cottage was moved to Naples around 1940 to serve as housing for the U.S. Army Air Corps, based in Naples during World War II.*

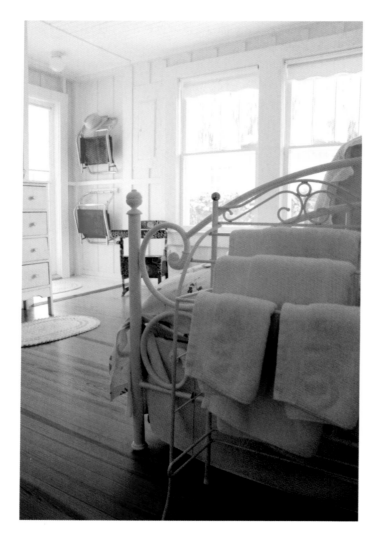

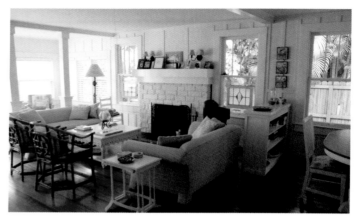

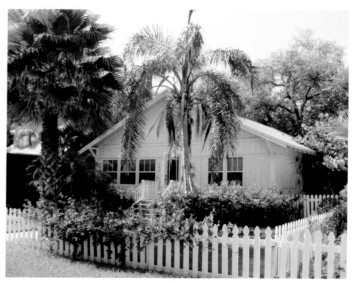

bedrooms are on the left side of the house. The cottage retains its original wood floors, ceiling, walls, windows, and fireplace. Gary has been told by area residents that the claw tub in the bath came from the Old Naples Hotel, which was built in 1888 and torn down in the 1970s. The fully functional, 420-square-foot guesthouse has a minute kitchen, bedroom, bath, and living room.

A favorite phrase of the Thomases' daughter, Tara, captures the couple's intent in relation to their home: "Live simply so others may simply live." Sharen and Gary have preserved the character and charm of this piece of architectural history. Many of the interior furnishings are recycled, discovered in area thrift and resale shops.

The original back porch was screened in by Barbara Holley, and this space, sheltered by an oak tree that is said to be over 100 years old, has become the favorite gathering place for the Thomases, their friends, and family—a cozy nook to rest, relax, restore.

330 11TH AVENUE SOUTH

The Wittenbergs' Cottage

This charming cottage was also moved to Naples from Ochopee, Florida, soon after the air corps base was established. Constructed of board-and-batten like its twin, the Wittenbergs' cottage has the distinction of being next to a small city park, Rogers Park, a green oasis in the midst of the

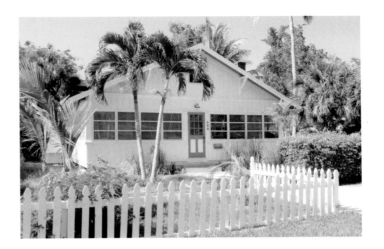

In season, the pristine Wittenberg Cottage houses visitors from all over the world.

3rd Avenue district. The property also has a guesthouse with a second-floor artist's studio.

Marilyn and Gary Wittenberg purchased the cottage in 1993 as rental property. They were intrigued by the Old Naples lifestyle and used the cottage as a family retreat. As Marilyn says, "There is no other place like Naples. It will always be this little town and I love the feel of it."

Few changes have been made to the cottage: the front porch has been enclosed for many years, the original wood floors and ceiling are still in mint condition, and the house has the original windows and fireplace.

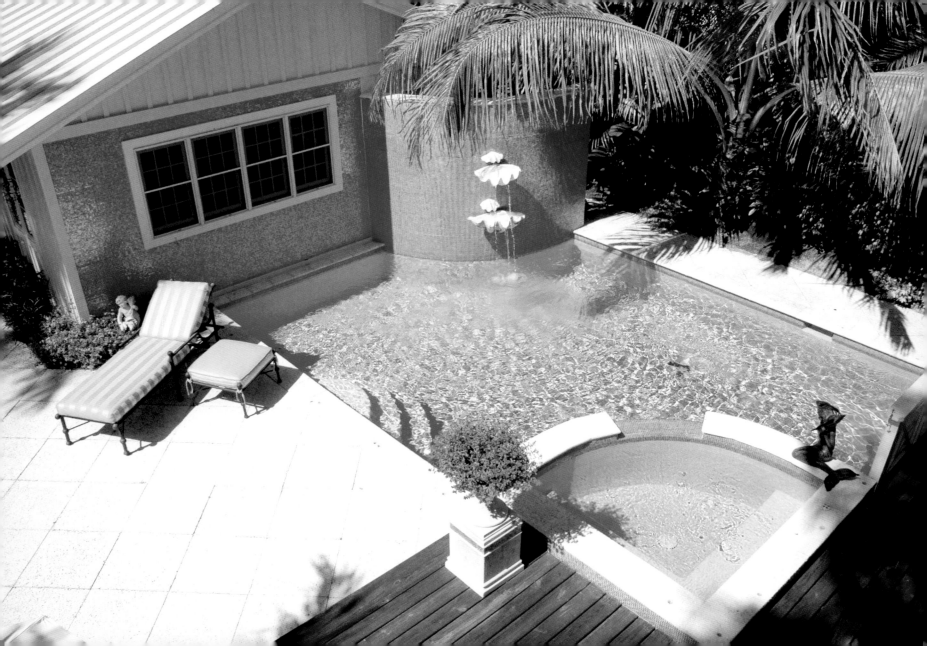

Tiffany's House

Happy Anniversary, Darling!

Jim and Julia Valentine purchased Tiffany's House for their 25th wedding anniversary in September 2007. Jim moved to Naples in 1978 to develop property, and both were drawn to the tropical climate and sunshine.

The couple had lived in Bermuda for five years before moving to Naples, and their Bermuda home was christened Amber for America-Bermuda. Known as Martha's Cottage for many years, the new name, Tiffany's House, was inspired by the Valentines' Yorkshire terrier, Tiffany. The condo they had been living in did not allow dogs, so Jim and Julia were looking for a new, dog-friendly home. The minute they walked into Tiffany's Cottage, they just knew the house should be theirs. Before seeing it, though, they had put an offer on another house. The Valentines spent a tedious hour waiting to see if the other offer had been accepted, which, serendipitously, it was not. Tiffany, the Yorkie, received a Tiffany heart for her first Christmas in her new home.

facing Tiffany's House pool and guesthouse create a stunning private retreat.

Historic photograph of Martha's Cottage, from the owner's collection.

A photograph of the board-and-batten cottage taken in February 1920 shows the front porch and ground floor, with a second floor under the gable.

The home was originally built off the ground, an early solution for the dampness of sea-level building sites. Fill has been added over time, so the foundation is now at ground level. The high ceilings, paddle fans, wide porches, and numerous windows that characterize Tiffany's House and Naples' historic cottage architecture in general were essential in assisting airflow in homes that, for decades, did not have air conditioning in Florida's subtropical climate. After World War II, many homeowners expanded their cottage living spaces with the addition of pop-up dormers. The pop-up on Tiffany's House is crafted of board-and-batten in keeping with the original construction.

Tiffany's House, 11th Avenue South.

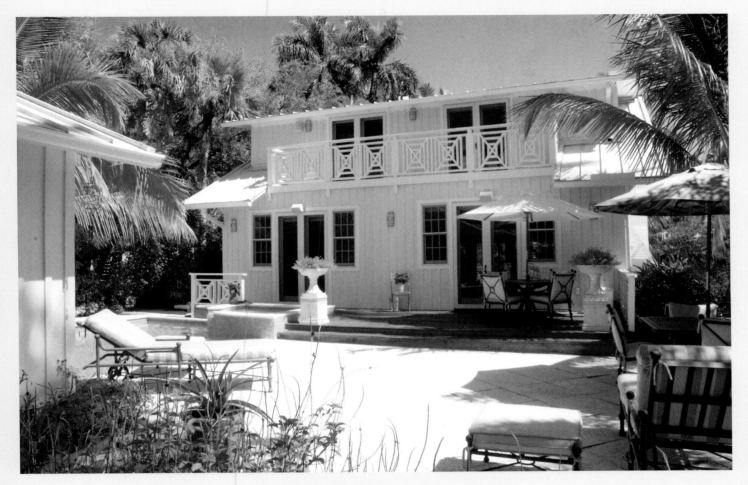

Tiffany's House, rear view. During renovation, larger windows and doors were installed to allow the abundant Florida sunlight to reach every interior space.

The living spaces on the ground floor—kitchen, living room, dining room, and entryway—create one large open area that takes advantage of the tropical breezes and sunlight.

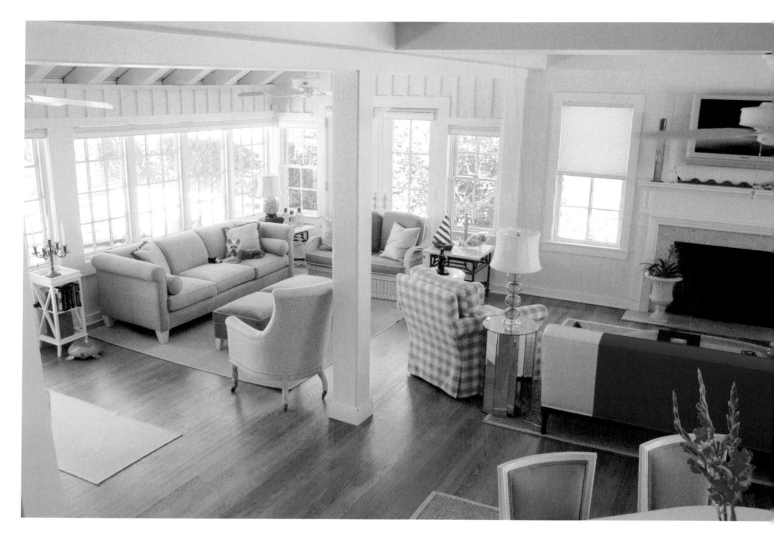

Sometime around 1910, the Moxley family of Kentucky discovered Naples. Mary Scott and George Moxley purchased Coquina Cottage. Their son, Barret Moxley, inherited Mandalay, and another son, Henry Moxley, owned Tiffany's Cottage, known then as Martha's Cottage. Sperry Kane purchased the home in August 1965 for $13,000. Lorraine Ensminger was the next owner, buying the house in August 1967 for $27,000. Five years later, Marjorie Jones acquired the home for $43,000, and in July 2005, Mitchell Wiley bought it from the estate of Marjorie Jones for $2,200,000. The pool, terrace, and fountain areas already graced the property when the Wileys bought it. Mitchell Wiley completed his own extensive renovations in 2006. Devoted homeowners such as Mitchell Wiley are a driving force behind the preservation of the historic homes of Old Naples.

Giant clamshells create a falling-water feature for the pool and terrace. Many of Naples' cottages are located on busy streets, and water features diminish traffic noise.

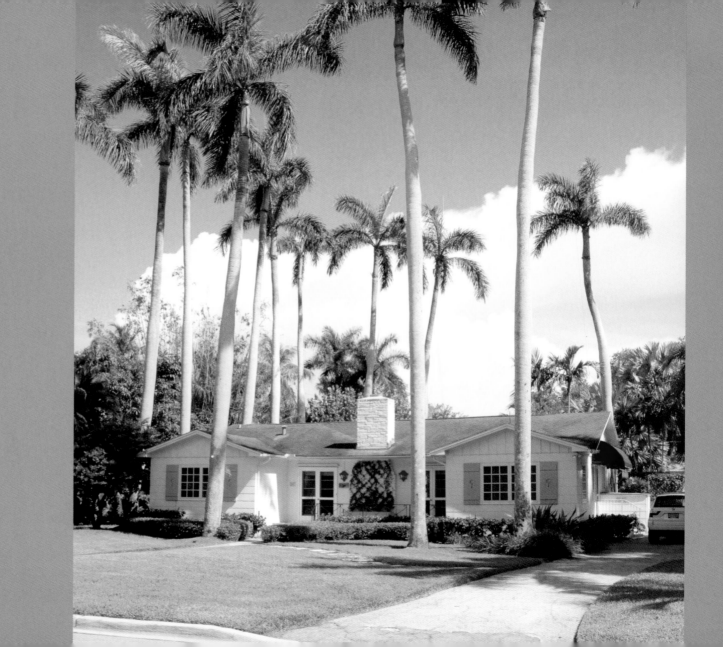

Tree House

Mary Graves sold a tree farm for this cottage. She first saw it in 2002, fell in love with it, and completed the purchase in early 2003. Mary's father, Davis Fair, carved the house name on the door plaque as a housewarming present; he was 91 at the time.

The Tree House is unique in Naples, with its symmetrical wings and pair of front doors. The aqua palm tree–motif shutters and coral porch lamps give a tropical flavor to a classically beautiful house. Built in the 1950s, the exterior walls are covered with overscaled shingles and the eaves with a variety of board-and-batten wood siding. A charming guesthouse, known as the Pool House, also dates from the 1950s.

The sunporch retains its original pecky cypress walls and ceiling, updated by white-painted walls and a tropical turquoise ceiling. Coral-colored walls in the dining room are accented with a decorative hand-painted border similar to designs seen on Mediterranean tiles.

Tree House name plaque carved by Davis Fair in 1991.

An artist, Mary designs and makes custom rugs. Asked about the inspiration for the vibrant color she has used throughout her home, she explains, "It's Naples! All you have to do is walk outside."

facing *Proceeds from the sale of a tree farm paid for this little piece of paradise.*

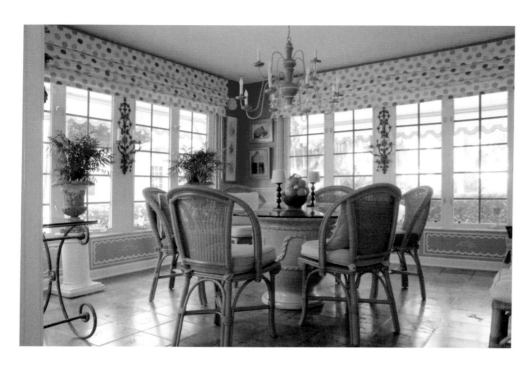

The Tree House dining room
features vibrant color and hand-
painted wall panels.

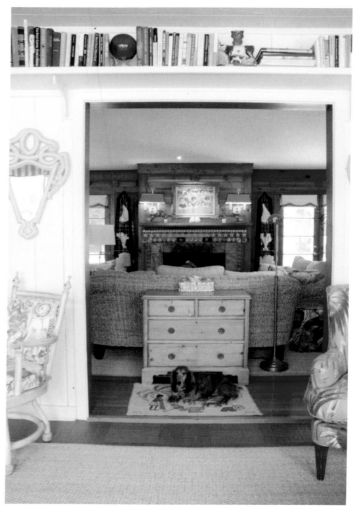

View from the back porch
into the living room, with
its colorful art and accents,
including rugs designed and
hooked by owner Mary Graves.

Garden gate view of the Tree House guesthouse, softened by the ever-blooming bougainvillea.

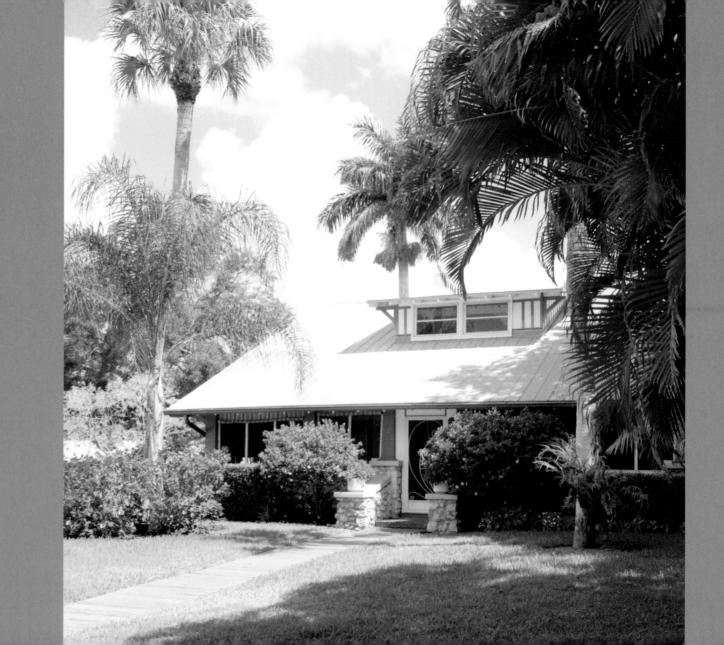

Trophy Room House

Naples' earliest growth was spurred by the abundant hunting and fishing opportunities in the area. Between 1948 and 1949, Dr. Earl Baum, then owner of this home, added a trophy room to the rear of his cottage to display his collection of over 180 wildlife specimens.

At one time, this room was probably the most frequently visited room in Naples' history. The collection today is on display at the Collier County Museum. Specimens include a seven-foot cottonmouth, a 36-inch coral snake, a nine-foot six-inch coach snake, a hammerhead shark, and 100 species of fish. The doctor left an explanation for his collection: "It is my sincere hope that when the display is opened to the public, it will spark interest in wildlife among our young people. With the growing interest in ecology, perhaps some will apply their talents to finding a way for man to live in harmony with one of our greatest resources, our wildlife. If not, in the not too distant future, my display and others like it will possibly be all that is left to remind us of the wonderful wildlife that once abounded here" (Baum 53–54).

facing *The Trophy Room House.*

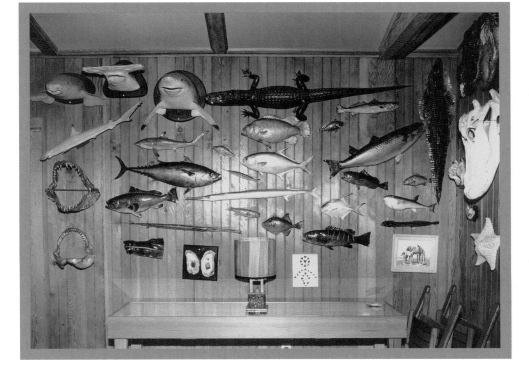

Dr. Baum's original trophy room.

Built in 1928, this charming bungalow-style cottage retains its original stone fireplace, windows, and Dade County pine floors. "Shorts," or short board ends, were used for the floors on the second story to create an interesting grain pattern. The house rests on eighteen sets of cinder blocks; because there is no subfloor, the wood floor is the only barrier to the open-air crawl space beneath. A new metal roof has been applied over the original one, and at some point in the 1940s or '50s, asbestos shingles were installed over the board-and-batten exterior walls.

In correspondence for this book, Steve Briggs, the current owner, wrote me about his purchase of the house and some of his neighborhood experiences.

It was Thanksgiving of 1977 and I was in Naples with my children: Sandy, Shelly, and Stephen. Carol (a business partner) and I were not on very good terms, but she did want me to go look at this house which belonged to Lodge McKee and was on the open house tour. I went over with the kids, but somehow I was not in the mood to absorb the ambience of the house. It was nice, quaint, and old with a great location. Several weeks later I was in Rio on business and the desk clerk told me I had a call from the States. It was Carol, who advised me that Lodge had an offer coming in on his house but he really wanted me to have it. I barely remembered what it was like, but as I was in a hurry I told Carol I would take it at his price, which was $109,000 furnished, and that I would deal with it upon my return. So I basically bought 107 Broad Avenue South over the phone through a third party.

Mr. Boyd, circa 1986

Mr. Boyd was my neighbor just east on Broad Avenue South. He was a real strange duck. In the mid-1980s Sandy and Todd came to visit with their golden retriever puppy. For some reason, Mr. Boyd decided to declare war on us. He dug a trench on the property line in the front and then put on his fatigues and helmet and sat in his chair on the line complete with an MI rifle in his lap. At some point I asked him if he would sell me back a 15-foot strip of land that was originally part of my lot but had been sold many years prior. He didn't answer; however, he did proceed to paint in large red letters on the west side of his garage, "I will sell Steve Briggs 15 feet for 1 million dollars cash." Next he decided my woodpile was a big problem, so every morning around 4:30 a.m. he would take his hose and water my woodpile. This became a real pain as it was just outside my bedroom window and every now and then he would aim the hose at the window.

The best was when he sold the house or actually the bank took it back and it was discovered that every room had a bidet in it that was not hooked up but just sitting in the middle of each room!

Naples is full of both colorful houses and colorful characters. Steve's anecdotes are more evidence to support the claim by the *Oxford American* (a Southern literature magazine) that Florida is the southernmost state and the strangest.

The Briggs family came to Naples in 1934. Steve's mother, Joan Nickels, of Detroit, Michigan, had visited Naples with her family for the first time in 1929. Steve's father and his grandfather were also named Steven F. Briggs. In the 1950s his grandfather was the proprietor of one of the best privately

owned photographic studios in the country. The family lived at 2700 Gordon Drive, and their cutting garden was located where the Port Royal Club tennis courts are located today. Steve attended the Hill School on the beach in the 1950s; the school was conducted in a private home, which is still here at the beach. The Briggs family has always maintained a tradition of philanthropy in the community.

Steve is well known in Naples, as he owns the local Old Naples Pub restaurants, one of which is set in a magical garden in Old Naples. Among other interests, Steve is an avid rider who rides four times a week, even though he had never even been on a horse until six years ago. His creative talents, warm personality, and friendly face are favorites around town.

At home in the Trophy Room House, Steve's dog Serena is the picture of serenity. The original staircase is the only one among all of Naples' cottages that has open space beneath the stairs.

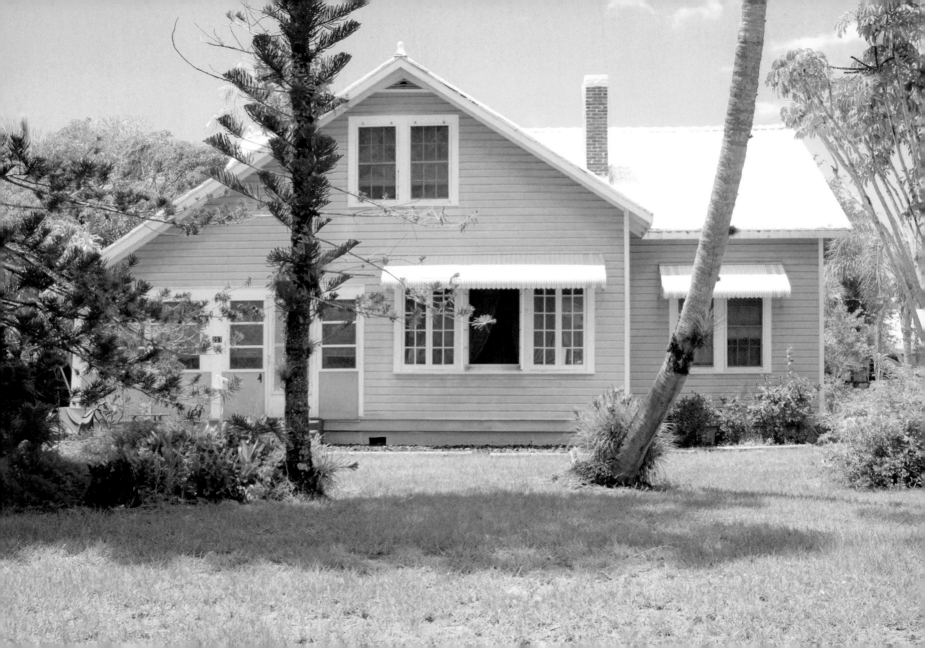

Turquoise House

This circa 1935 cottage has a prominent location at the corner of Broad Avenue and 2nd Street South. Owner Gerald Johnson said the house was built by the Bowling family, who ran Bowling's General Store around the same time.

Johnson's parents, Bertram and Frances Johnson, bought the cottage in 1961 after Bertram retired. They moved to Naples from Sewaren, New Jersey. Bertram was a Florida native and had grown up on Ft. George Island, near Jacksonville. They bequeathed the house to their three sons, Gerald, Barry, and Richard Johnson. A guest cottage from the same period is part of the property and faces the alley.

Turquoise House is adjacent to two other significant cottages of the era, Fisherman's Lodge and Christmas Cottage, both on Broad Avenue. Sand Dollar Cottage is directly across from Turquoise House on the 2nd Avenue South corner.

The distinct gables, lap siding, multipaned casement windows, and barrel tile roof are characteristic of many of the beach cottages constructed in Naples in the early 1930s. The interior has kept its integrity, with original wood floors and

facing The aptly named Turquoise House.

Stairwell with turned balustrades, one of the unusual features of the Turquoise House interior.

both beadboard and board-and-batten ceilings. Two unique features of the cottage interior are arched doorways and turned balustrades on the staircase.

When Gerald was asked how he would describe the brilliant turquoise color of the house, he replied, "Needs paint!"

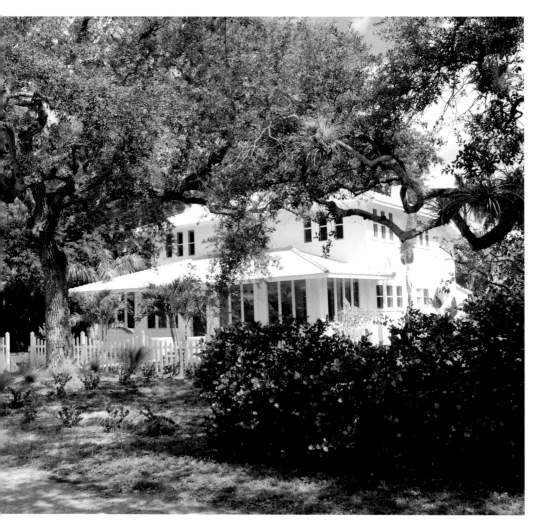

Wedding Cottage

On May 17, 2008, Sarah Teigen married Zachary West at this soft-yellow classic cottage trimmed in white; she had lived in the cottage as a small child.

Owners Ray and Alice Miller are Sarah's grandparents, and they had one year's notice that their granddaughter wanted to get married in the cottage, which meant they had a tight time line for giving the slightly neglected house a face lift. They accomplished the task. The wedding was beautiful, with strands of party lights covering the trees like gossamer webs.

There was music and dancing on the deck, and late in the evening the entire wedding party walked down to the beach for a star-lit beach walk. Sarah's mother, Julie, had had her own wedding reception in the home in 1987.

This circa 1920 cottage was a wedding present for the first owners as well. Bob Wilson, founder of W. R. Wilson & Associates, was the engineer of the Tamiami Trail from Lee County to Dade. Bob moved to Naples and married Elva Day; Elva's mother, Mrs. Elizabeth Day, owned two boarding houses in

The Wedding Cottage, 11th Avenue South.

Naples, and she gave this cottage to Bob and Elva as a wedding present.

Ray Miller, a partner with Bob Wilson, purchased the cottage from him in 1979. Ray has owned the home for 30 years, and although both of his children, Julie and Stuart Miller, and their families have lived on the property, until recently he had never spent a night in the house.

Immokalee Cottage, the original name of this cottage, is inscribed on the original front sidewalk. The property comprises three historic structures: the cottage, a carriage house, and servants' quarters. The latter two are now guesthouses with year-round tenants. The resourcefulness of the builders is admirable, as all of the materials for these houses had to reach Naples by boat. Restoration of the cottage was a family affair according to Ray Miller. His children, grandchildren, a nephew and cousins pitched in.

The light-filled bungalow has 57 windows: 37 of them are the original large-paned casements with catch mechanisms that require using two hands to open a window. Ray installed 20 new tall casement windows when he enclosed the front porch, keeping the silhouette authentic by using windows that fit the screen framing. This home has original panel doors with glass doorknobs, horsehair plaster, and Dade heart pine floors. Even the rafters are Dade heart pine. The exterior is tabby stucco, a combination of beach sand and shells.

Built before Naples had electricity, the house was lit with kerosene fixtures, and the two fireplaces were the only heat source. The living room fireplace is readily operable, but the

The cottage entry lit for wedding guests.

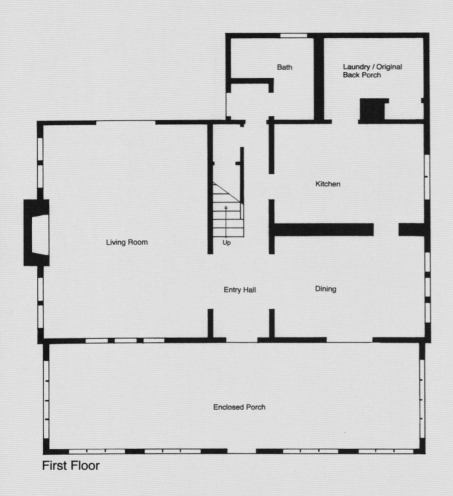

First Floor

Bath

Laundry / Original Back Porch

Kitchen

Living Room

Up

Entry Hall

Dining

Enclosed Porch

First-floor plan of the Wedding Cottage.

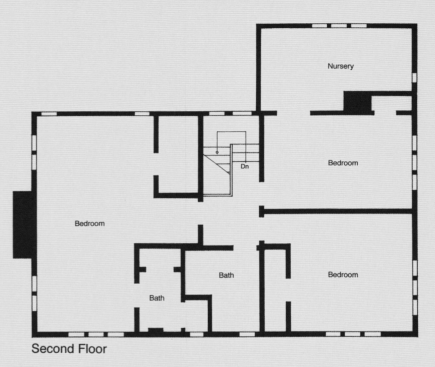

Second Floor

Nursery

Dn

Bedroom

Bedroom

Bath

Bath

Bedroom

Second-floor plan of the Wedding Cottage.

second fireplace was sealed off at some time in the past. Ray calls it the mystery fireplace as no one knows the location of the original hearth. He thinks it opened either to the kitchen or the back porch, which was enclosed to create a laundry room.

A barrel-style tin roof covers the shallow hip roof, and in over 88 years the roof has never leaked. The house weathered Hurricane Donna without harm, even when the storm surge reached the front step. The two-story, center-hall design is unique among cottages in Naples. The upstairs has had only two small changes: a small "crying room," or nursery, was opened to the adjoining bedroom, and the second closet in the master bedroom was retrofitted for a bath. Each door-way on the second floor, including the door to the bath, had a screen door, making the bedrooms similar to sleeping porches. During the renovation prior to Sarah's wedding, the Millers removed interior screened doors and furred out cracked plaster walls, replacing ceilings with drywall to allow for central air and overhead lighting. A new whitewashed pine ceiling in the living room keeps the historic cottage character intact. Three-section, deep baseboards were reproduced, and the white paint used for the trim gives them a crisp finished look. A butler's pantry was opened up to make the kitchen larger.

Most welcoming is the original front door with its large window that provides a glimpse of the center hall and handcrafted stairs and stairwell. A fun surprise is the old-

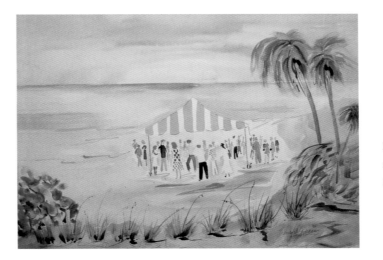

Beach Wedding, by Naples resident and artist, the late Emily Gutchess.

fashioned doorbell that dates to construction and still rings. The Wedding Cottage also has the distinction of 115 feet of street frontage and a lot depth of 150 feet. Recorded in the Public Records of Collier County, Platt Book 1, page 8, Town of Naples, the property contains three of the original thirty-three and a third–foot lots; a fourth lot was divided with the Westhaven property directly to the west, with 175 11th Avenue gaining an additional 15 feet.

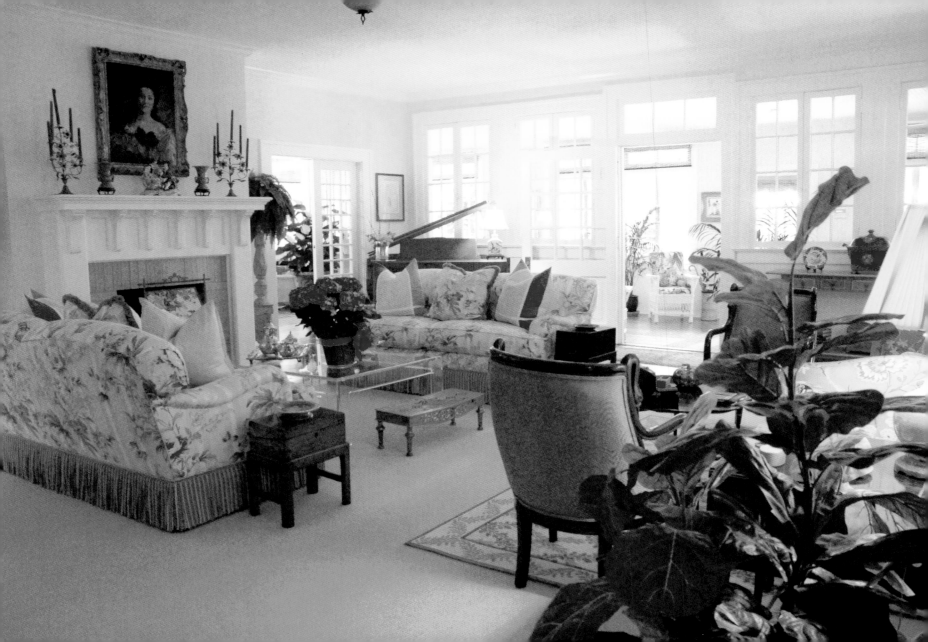

Westhaven

What magic do such wonderful historic homes have that cause us to fall in love with them?

Westhaven has such appeal. Linda Morris, the current owner with her husband, Robert, wanted the house because of its great "personality." She discovered the house when driving by it on her way to a birthday party in the Bahamas. When the house went on the market and she was able to visit it, there was a golden retriever's portrait over the mantel and Linda, a dog lover, said, "This is it!" The Morrises purchased the home on May 16, 2002.

A unique aspect of this home is the very large and gracious dining room. The ground floor also features a large living room, sunporch, kitchen, butler's pantry, and two original bedrooms, one of which has been converted to a library. Built of heart pine, the second floor still has the original pine bead-board walls and ceilings.

The Morrises added exterior back stairs and remodeled one of the first-floor baths; they gave the original claw foot tub to the Naples Historical Society. The colorful guesthouse and a three-car garage are accessible from the alley. A stunning terrace and pool area provide dramatic access to the guesthouse.

Westhaven's tropical garden features a spectacular silver Bismarck palm.

facing *Westhaven's warmly elegant living room opens to an airy sunporch.*

This elegant dining room speaks to the entertaining that occurs daily during Naples' "season," which starts up after Thanksgiving and lasts until Easter.

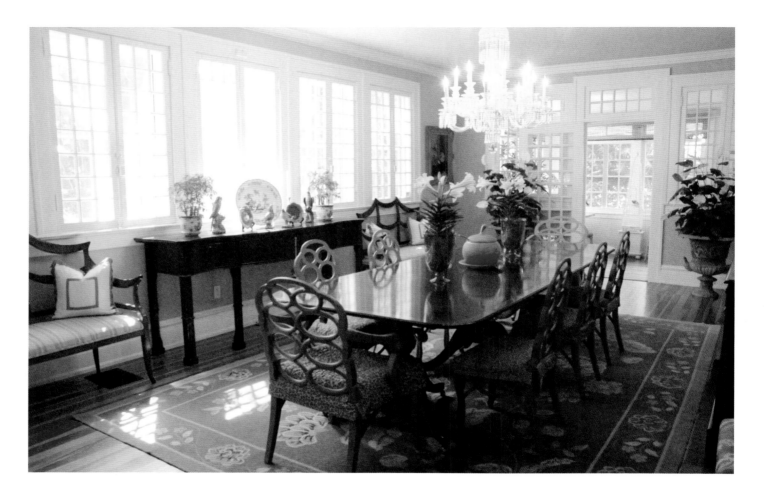

facing The sunporch is furnished with vintage wicker pieces, re-creating a scene from the past.

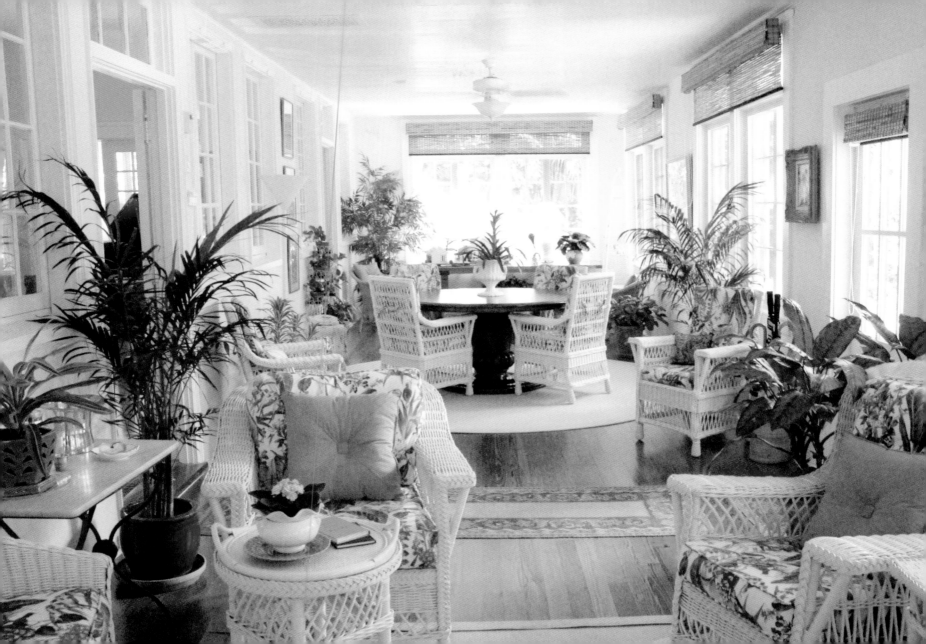

Set in the shed dormer, the
second-floor gathering room is
a favorite family nesting spot,
with its wonderful light-filled
interior.

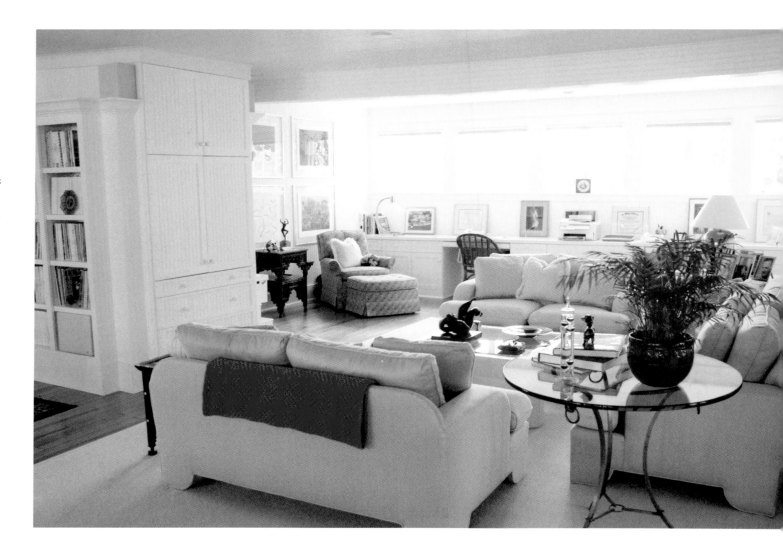

The Morrises have created a verdant garden around the home. In 2005, Hurricane Wilma leveled the front ficus hedge and destroyed one of the front live oaks. Eleventh Avenue is the only street in Naples with a linear arrangement of live oaks, so the loss of that tree was particularly sad. One of the live oaks on the front property is home to honey bees. A front brick parking entrance was added by the Morrises for street parking.

Jose R. Lombillo, archivist of the Naples Historical Society, provided the following history of the house. Colonel Robert West built the two-story bungalow on four and a half lots in 1920. Featuring a gable parallel to the street, the facade incorporates a shed dormer with multilight casement windows. A porch is inset under the main roof and supported by tapered piers.

Colonel West was an important social character in Naples. He was featured in the 1930 film *Bob West's Burgoo*, which depicts a frequently held event at the Naples Beach Golf Club. The event was a takeoff on the Kentucky custom of cooking "Burgoo Stew"—a combination of different meats, such as turkey, chicken, and game, and assorted vegetables, such as peas, beans, potatoes, okra, carrots, green peppers, and turnips, which was cooked for 24 hours. The most important seasonings were champagne and Kentucky bourbon whiskey. Two cups was the requisite serving to feel celebratory. The Naples Historical Society houses this film, created by Dr. Baum, in its archives.

Westhaven was sold by Colonel West to Clair B. and Erlene M. Gutchess, who owned the house until 1982. This couple

Westhaven entry framed by old live oak trees.

symbolizes the diverse geographical and cultural forces that came together to build the early community of Naples. Clair Gutchess hailed from an affluent self-made New York family and Erlene M. Storter Gutchess from a pioneer Everglades family that came to the area in 1881. Like the Gutchesses and other earlycomers to the town, the original cottages remaining in Naples embody an originality and diversity that characterizes this place—its people as well as its architecture. They are also tributes to the families who made their lives here in this amazing community.

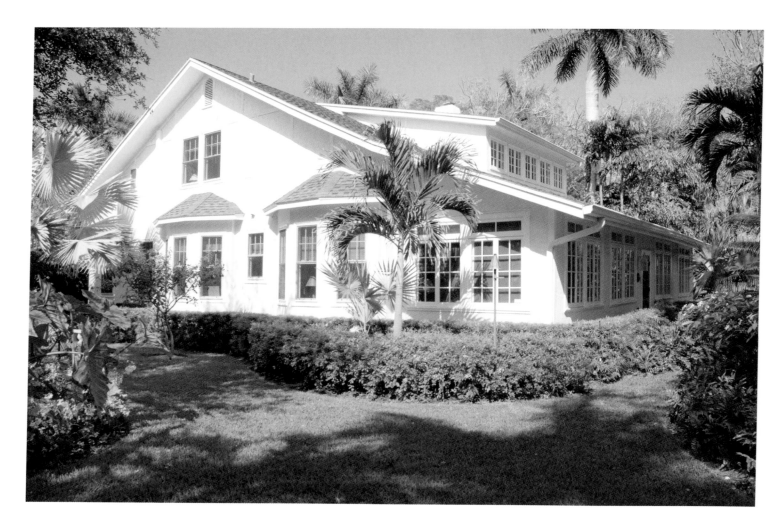

West side of the house, with a view of the shed dormer.

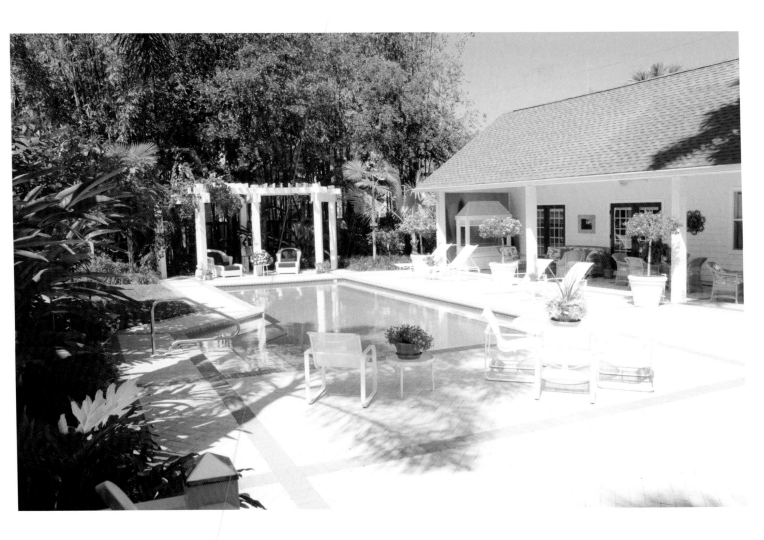

The pool and guesthouse
at *Westhaven*.

Winding Waters

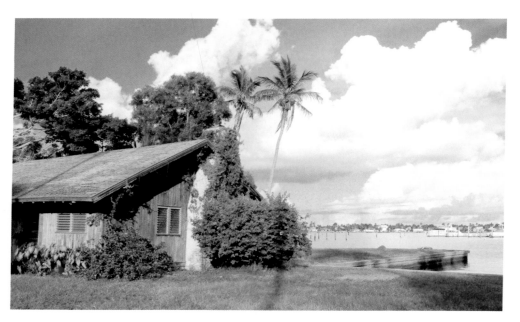

Winding Waters before it was torn down. Such a commanding view of Naples Bay!

Now gone, this circa 1940s cottage, built by Julius "Junkie" Fleischman and his wife, Dorette, was unique in that it sat on Naples Bay. Property owner Joan Tobin has many fond memories of the cottage from her childhood: "It was my favorite building and was built in the same style as our principal home on Gulfshore Boulevard, which was called Pepper Hedge. The entire house was built of pecky cypress, and one of the bedrooms extended out over the bay on pilings."

Designed by architect Carl Strauss, Winding Waters was situated to capture the bay breezes. The interior was cozy with pecky cypress walls and a fireplace with a massive log mantel. The cottage served as a guesthouse for the Fleischmans' many visitors. Joan recalls that her father's boats, always docked at the cottage, were successively named *Camargo* after the French ballerina who was the first to shorten her skirts to what would become regulation length.

While under trustee management, the home fell into disrepair. Sadly, the cottage suffered irreparable damage in a fire on August 24, 2003, and was torn down in 2009.

Wish You Were Here Cottage

Mary Jo and Peter Sharkey, owners of Pink Pearl Cottage, continued their historic preservation efforts on the 9th Street block in Old Naples with the revitalization of the Wish You Were Here Cottage. Facing east, this circa 1940s–50s cottage is located on the adjacent lot to the north of Pink Pearl. While there is little documented history on Wish You Were Here, its architecturally congruent renovation and its proximity to the circa 1930s Pink Pearl Cottage deserve recognition in this book.

Though Wish You Were Here retains its original floor plan and exterior footprint, the Sharkeys undertook an extensive renovation and construction project that lasted almost two years, from 2008 through 2009. The house has been completely rewired; new flooring has been installed over the post–World War II terrazzo floors; and a new kitchen features a pair of French doors that open to the pool area. The Sharkeys also had the interior woodwork painstakingly reproduced to match the woodwork in Pink Pearl Cottage. Originally stucco over concrete block, the exterior walls of Wish You Were Here have now been covered with new clapboard siding, and the Sharkeys have replaced the old roof. The added pool and garden links the main house to a new two-story guesthouse.

New two-story guesthouse at Wish You Were Here Cottage, with the poolside outdoor living room.

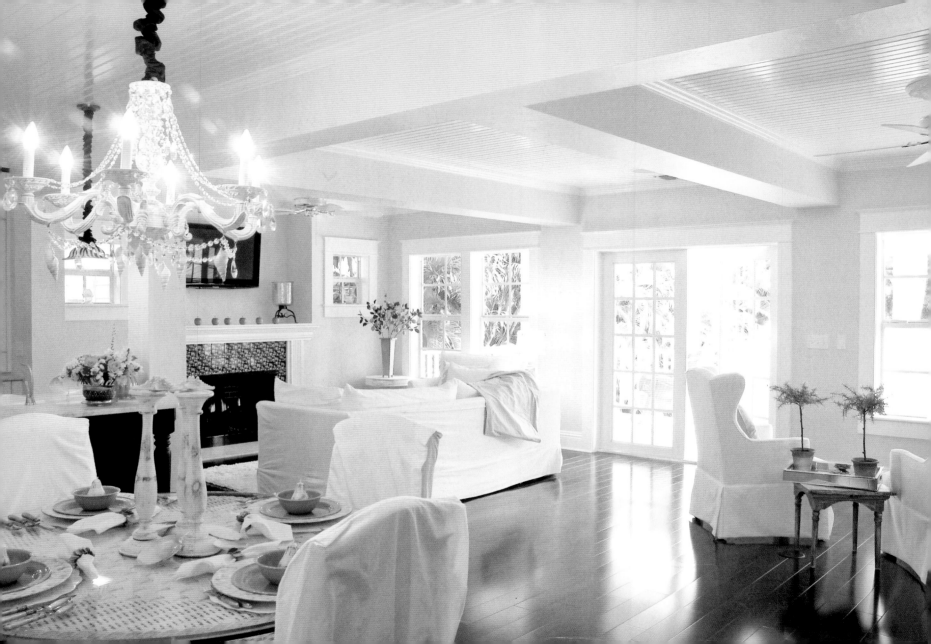

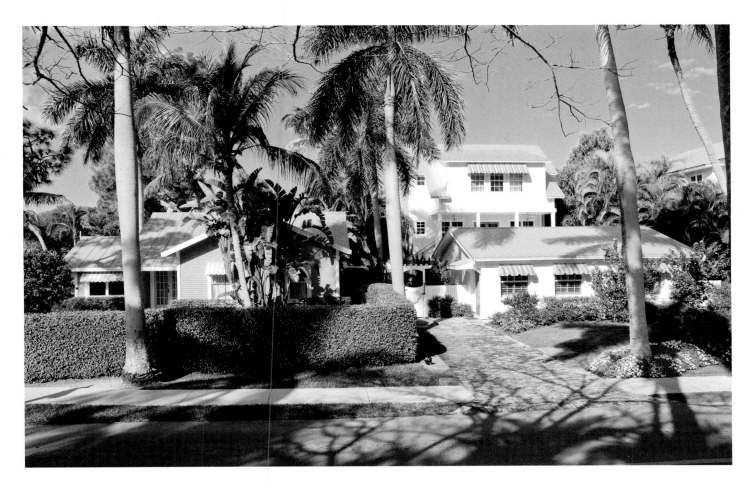

The four Sharkey cottages on 9th Street South. Wish You Were Here Cottage is on the right, with the two-story guest cottage showing over the main house roof top. Pink Pearl Cottage appears on the left, at the corner of the block; its guesthouse is visible from behind the left side of the cottage.

facing The second-floor living and dining rooms of the new guesthouse are refreshing, with their white high-gloss paint, gleaming wood floors, and happy colors.

left Retreat from the world . . .

right Beautiful hand-painted tiles accent the guesthouse kitchen.

With charming kitchens, the cottages are ideal for entertaining. This updated kitchen in *Wish You Were Here* Cottage opens to the pool.

Every vista from these
cottages provides a
wonderful visual memory.

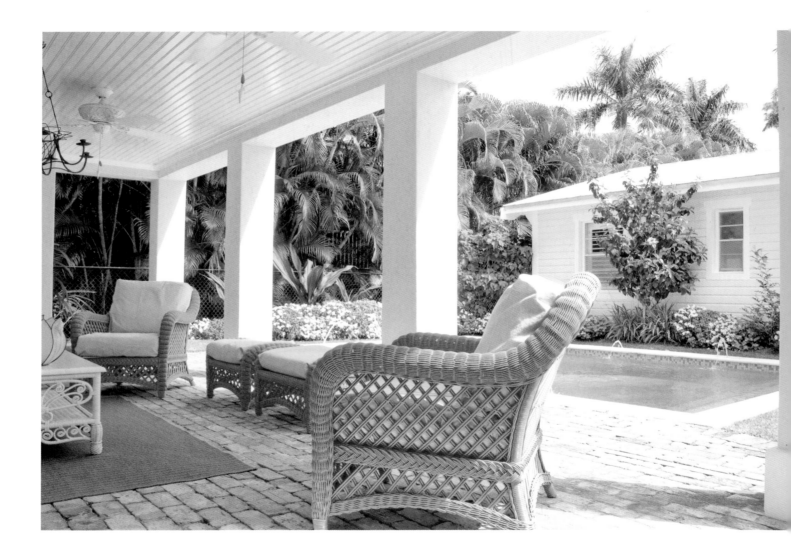

A beautiful way of life!

Peter Sharkey shared his passion for this extraordinary restoration project: "Mary Jo and I felt that if we could not only rejuvenate an individual structure, but facilitate the architectural cohesiveness of half of the block with four synergistic structures, two houses and two guesthouses, it would be worth all of our time and energy to create a powerful preservation effort in this corner of the community."

When the Sharkeys completed the project, they listed the property for sale in 2010. Now, other families will be able to enjoy this colorful compound that is part of the history of Naples.

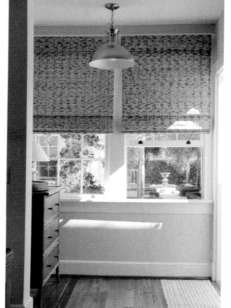

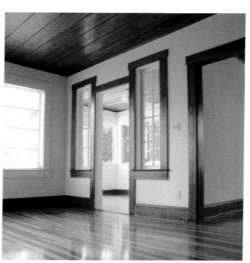

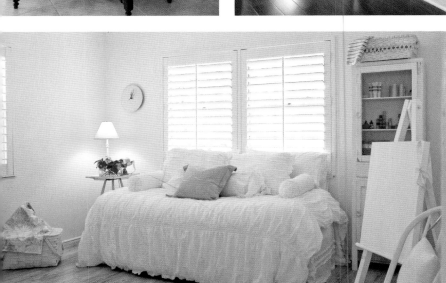

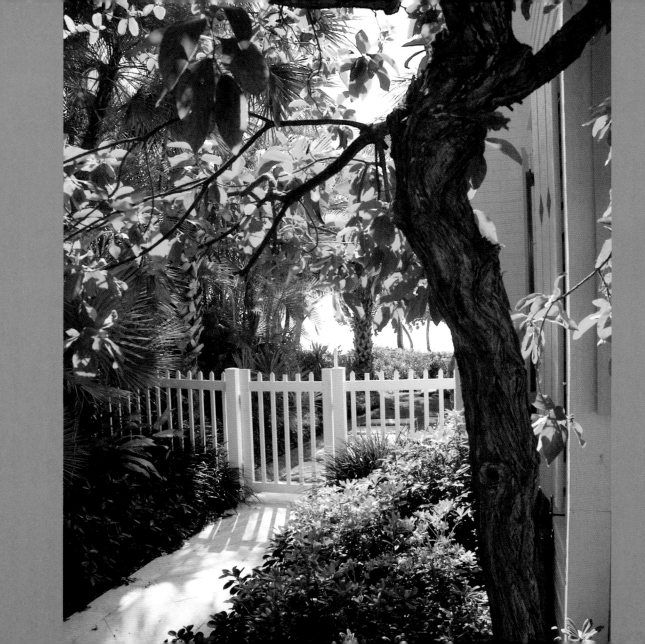

Cottage Addresses

Alamanda Cottage
1835 Gulfshore Boulevard South

Artist's Cottage
412 10th Avenue South

Bahama Cottage
87 6th Avenue South

Blue Water Cottages
284 and 290 10th Avenue South

Bone's Rest
210 11th Avenue South

Captain Parker House
680 8th Avenue South

Champney Bay Boat House
3777 Gordon Drive

Christmas Cottage
245 Broad Avenue

Coconut Cottage
91 Broad Avenue

Conch Chowder
144 10th Avenue South

Coquina Cottage
12 11th Avenue South

Cottage Row
660 8th Avenue South
(Foht Cottage)

732 8th Avenue South
(Quintessential Cottage)

750 8th Avenue South
(Hamilton Home)

756 8th Avenue South
(HaBayit)

Dolphin Weathervane Cottage
244 11th Avenue South

Dressmaker Cottages
1309, 1325, 1341
Gulfshore Boulevard South

Fisherman's Lodge
239 Broad Avenue South

Guest House #53
53 Broad Avenue

Haldeman House
(*Naples' oldest house*)
60 12th Avenue South

Honeymoon Cottage
88 Broad Avenue

Inn by the Sea
287 11th Avenue South

Jasmine Cottage
269 11th Avenue South

Leila Canant's Cottage
132 10th Avenue South

Lighthouse Cottage
67 8th Avenue South

Mandalay
1144 Gulfshore Boulevard South

Monkey Blue Cottage
Old Naples (*address unpublished
at owner's request*)

Morning Glory Cottage
281 11th Avenue South

New Orleans Girl
273 10th Avenue South

Palm Cottage
137 12th Avenue South

Palm Villa
110 Broad Avenue South

Pappy Turner's Houseboat Cottage
Ridge Street

Party House
75 Broad Avenue South

Periwinkle Cottage
123 11th Avenue South

Pier Pleasure
Pier Block, 12th Avenue South

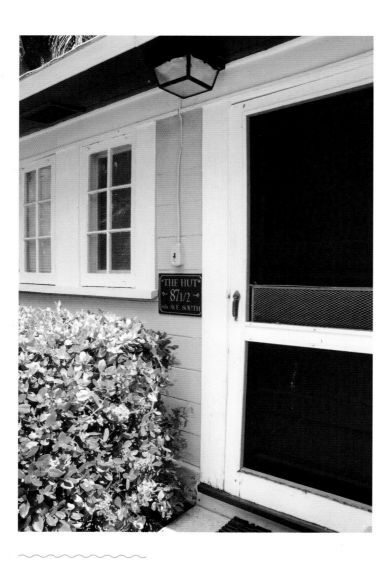

Pineapple Plantation
1111 Gulfshore Boulevard

Pink Pearl Cottage
794 9th Street South

Plantation House
9th Avenue South at the beach

Sagamore
194 14th Avenue South

Sand Dollar Cottage
187 Broad Avenue

Sandcastle Cottage
840 Gulfshore Boulevard

Sunset View
Corner of Gordon Drive
and Broad Avenue

Tackle Box Cottage
88 11th Avenue South

Teapot Cottage
230 11th Avenue South

Tecopa
1188 Gordon Drive

The Tile House
20 8th Avenue South

The Twins
344 11th Avenue South (Dover);
330 11th Avenue South (Wittenberg)

Tiffany's House
205 11th Avenue South

Tree House
10th Avenue South

Trophy Room House
107 Broad Avenue South

Turquoise House
207 Broad Avenue

Wedding Cottage
175 11th Avenue South

Westhaven
157 11th Avenue South

Winding Waters
Property adjacent to Naples City Dock

Wish You Were Here Cottage
770 9th Street South

Inventory of Historic Sites Located within the City of Naples, Florida

Baum House
Location: 107 Broad Avenue South
Year of Construction: 1947

Buchanan House
Location: 9th Avenue South, at the beach
Year of Construction: Early 1920s

Coquina Cottage
Location: On the beach, between 11th Avenue South and Broad Avenue South
Year of Construction: About 1908

Gutchess House
Location: 157 11th Street South
Year of Construction: 1922

Haldeman-Price House
Location: 60 12th Avenue South
Year of Construction: 1886–87

Jones-Kelly House
Location: 38 Broad Avenue South
Year of Construction: 1922

Mandalay
Location: 1144 Gulf Shore Boulevard South
Year of Construction: About 1908

Martha's Cottage
Location: 201 11th Avenue South
Year of Construction: Early 1920s

McKee House (Guest House #53)
Location: 53 Broad Avenue South
Year of Construction: 1928

"Old" Hewitt House
Locaton: 926 Gulf Shore Boulevard
Year of Construction: Unavailable

Palm Cottage
Location: 137 12th Avenue South
Year of Construction: About 1890

Sagamore
Location: 194 14th Avenue South
Year of Construction: About 1919

Sandpiper Cottage
Location: 1375 Gordon Drive
Year of Construction: 1920s

Sea Villa (Haldeman-Erday House)
Location: 40 13th Avenue South
Year of Construction: 1887

Schlesinger House
Location: 16th Avenue, at the beach
Year of Construction: 1930s

Sloan-Trout House
Location: 12th Avenue South at Gordon Drive
Year of Construction: 1918

Whayne House
Location: 88 11th Avenue South
Year of Construction: 1930s

Whiteside House
Location: 670 Gulf Shore Boulevard South
Year of Construction: 1930s

The information in this inventory is provided by courtesy of the Collier County Museum, Collier County Government Center, 3301 Tamiami Trail East, Naples, FL 34112.

Acknowledgments

Lodge McKee knows more about the history of the cottages of Naples than could be contained in several books. His generous gifts of time and knowledge have been invaluable, and without them this book would not have been crafted. Thank you, Lodge.

The unparalleled artistic talent of photographer Penny Taylor captures the magic of Naples in every image. Thank you, Penny.

Dwight Oakley generously measured and drew plans of four of the cottages. This was a painstaking endeavor and is a reflection of Dwight's commitment to maintaining the architectural integrity of Old Naples. Thank you, Dwight.

Dottie Vanderford formatted the manuscript for submission, a task that requires great patience. Thank you, Dottie.

The warm hospitality of Lynn Copper, Nancy Van Noppen, and Colleen and Pete Baus made my transition to Naples possible. Thanks to these remarkable friends.

This book could only have come to life with the help of the homeowners. It is a rare opportunity to be welcomed into the much-loved homes of total strangers, who generously share their private spaces and personal histories. I believe such hospitality is the essence of Naples, where there is a love of community and an appreciation of all things that are beautiful, charming, and lighthearted. Please accept my heartfelt thanks to all of you, my new and memorable friends.

Joie Wilson

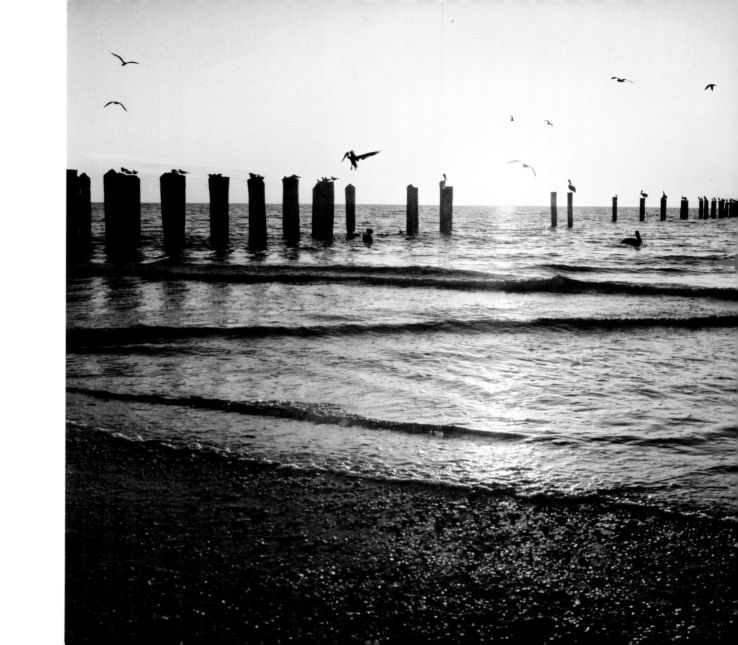

When Joie Wilson asked me to work with her on a book about Old Naples Beach cottages, I was astonished with my good luck. After living in Naples for over thirty years and watching the old town morph into something newer and grander, I was troubled by the speed of the change. Did this necessary and inevitable path of renewal mandate the automatic teardown of a structure? Photographing the homes for this book has opened many front doors and, more importantly, has opened my eyes to the commitment of these Naples property owners to renovate their older structures. The decision to restore rather than tear down has enhanced the authenticity of Naples by preserving a sense of place, and we owe these "mavericks" a debt of gratitude.

It is impossible to separate Florida from its abundant sunlight, and many of these early houses addressed the challenges presented by Florida's natural amenities. How did they manage the light: Did they embrace the light or redirect the light or filter the light or block the light? The duet between architecture and sunlight varies from home to home. It was always an adventure to walk through the front entry of each cottage for the first time.

Many, many thanks to the property owners who generously opened their doors and their hearts to this project by allowing me to photograph their personal spaces. Without their cooperation, this book could not have gone forward.

Thank you, thank you, Lodge McKee for recommending me to Joie. Your support of this project through all these months steadied our ship, and your knowledge of Naples history is unmatched.

To Jane Mjolsness, who illustrated the front map, thank you for your creativity and hard work. Your love of Naples and your immense talent have added so much. And to Marilu Holmes of G&H Printing, your technical knowledge and friendship brought excellence to the images in this book.

And finally to Joie, thank you, thank you for giving me the opportunity to photograph this project. Working with you over these past months has increased my respect for your creativity and your professionalism. Your humor, optimism and can-do attitude lifted my spirits on more than one occasion. It was a pleasure, indeed!

Penny Taylor

The preservation of Old Naples began with Palm Cottage.

This story started with a dedicated and passionate group of individuals who, in 1978, with no identified funding, launched a campaign to save a historic home slated to become a city parking lot. Their compassionate courage exemplifies the visionaries that Naples has attracted through the years. Naples' history lovers have several philanthropic champions, and chief among them are Lester and Dellora Norris—founders of the Conservancy of Southwest Florida—and their daughters Lavern Gaynor and Joie Collins. Their support of the Palm Cottage rescue, from its beginning, secured this cherished treasure and ensured that it will always be here to be admired by future generations. The Norris's love of Naples, always expressed humbly and quietly, can be seen throughout our city in places such as the Naples Pier, which they generously rebuilt after it was decimated by Hurricane Donna in 1960 and Hurricane Celia in 1970, and in the Norris Center at Cambier Park.

The vision of this gracious family has touched the lives of everyone who lives in and visits Naples.

It takes a great deal of courage to say no to the development opportunities in a coastal community like Naples, even more so as there are no regulations governing the preservation of Naples' historic structures.

The owners of the homes featured in this book have not only preserved these charming and irreplaceable dwellings, they have found ingenious ways to improve them and make them truly functional for modern lifestyles. These passionate homeowners have given evidence of the undeniable truth that these precious and historic homes not only have an important legacy in the history of South Florida, but also a viable and exciting future. These stewards of Naples have shown how historic preservation can be done: not with regulations and restrictions, but as individual gifts to a community and its history. We have been honored to be a part of their story.

Publication of this book was made possible through the significant support of Mrs. George H. Gaynor. Juliet Sproul also made a generous contribution. Exemplary community support also came from Olga Hirshhorn, Thomas Riley Artisans' Guild, the William Scherer family, Jeannie Scott with SunTrust Mortgage, and Thomas G. and Barbara S. Wilson, the author's parents. The enduring vision and financial assistance of homeowners Robert W. and Linda P. Morris, Peter and Mary Jo Sharkey, and Chris and Gail Camalier facilitated this publication.

Selected References

Baum, Earl L. *Early Naples and Collier County*. Naples, Fla.: Collier County Historical Society, 1973.

"Cracker Farmhouses, 1840–1920." *The Old House Web*. Edited by Lucinda O'Neill. http://www.oldhouseweb.com/architecture -and-design/cracker-farmhouses-1840-1920.shtml.

Haase, Ronald W. *Classic Cracker: Florida's Wood-Frame Vernacular Architecture*. Sarasota, Fla.: Pineapple, 1988.

Jamro, Ron, and Gerald L. Lanterman. *The Founding of Naples*. Naples, Fla.: Friends of the Collier County Museum, 1985.

John Singer Sargent Virtual Gallery. Directed by Natasha Wallace. http://jssgallery.org/.

Stone, Maria. *Ochopee: The Story of the Smallest Post Office*. Naples, Fla.: Butterfly Press, 1989.

Sully, Susan. *The Southern Cottage: From the Blue Ridge Mountains to the Florida Keys*. New York: Rizzoli, 2007.

Joie Wilson is an interior designer and a professional member of the American Society of Interior Designers. She has worked in historic preservation with the North Carolina Office of Archives and History on a statewide architectural survey, and in 2003 she renovated and restored a landmark property in High Point, North Carolina. Her 1920s villa there, Villa Valencia, is listed on the National Register of Historic Places.

As Joie explains, her design background figures prominently in the genesis of this book: "My career in the furniture and design industry has allowed me to travel across the United States and have an insider's view of some of the most fabulous homes in America. This is a country that is blessed economically and with an artistic sensibility most frequently expressed in our dwellings."

Joie has spent most of her life in Florida, in seaside communities including Naples, Sarasota, and Largo. Her personal decorating style captures the colorful kaleidoscope of the tropics.

Penny Taylor established her photography studio in Naples, Florida, in 1983 specializing in commercial, portrait, and editorial photography. A self-taught photographer, Taylor began her profession as an apprentice to photographers in New York City. After moving to Naples she worked as a staff photographer for the *Naples Daily News* (with a circulation of 35,000). Her photography has appeared in several national publications, including *The New York Times* (front page), the *Chicago Tribune*, *Modern Health Care* magazine (cover), and *American Lawyer* magazine. She has had numerous one-man and group exhibitions in the Naples area.